ACKNOWLEDGEMENTS

The pleasure I got from all the 'Fridas' represented in folk art is something I shared with many of my friends. They also pointed out facets of her that had so far escaped my attention. Some objects in this book were gifted to me by family and friends, as a loving—and yes, sometimes slightly ironic—gesture.

I would also like to express my gratitude to Niko, Rainer and Teresa Huhle, Andrea Kettenmann, Gerhild Schiller and especially to Cristina Kahlo, who generously contributed pictures and the text *Frida Teen* to this book.

A special thanks goes to Rafael Doniz for his fantastic hunt for images in Mexico, and to all the others who contributed pictures which help to make these tributes to Frida come alive in their diversity: Carolina Sandretta, Corinna von der Groeben, Gita Wolf, Moritz Krawinkel, Rainer Huhle, Reinhard Schmidt, Santiago Alegre. For their critical feedback on the manuscript I thank V. Geetha, Elena Rittinghausen, Josefine Liesfeld and Gita Wolf.

FRIDA FOLK

Copyright © 2018 Tara Books Private Limited

For the text: Gaby Franger
For the photos in Section Three: Rafael Doniz

All photos by Gaby Franger unless otherwise mentioned.

Design: Ragini Siruguri

For this edition:
Tara Books Pvt. Ltd., India <www.tarabooks.com>
and
Tara Publishing Ltd., UK <www.tarabooks.com/uk>

Production: C. Arumugam
Printed in India by Canara Printers and Traders Pvt. Ltd.

ISBN 978-93-83145-97-3

FRIDA FOLK

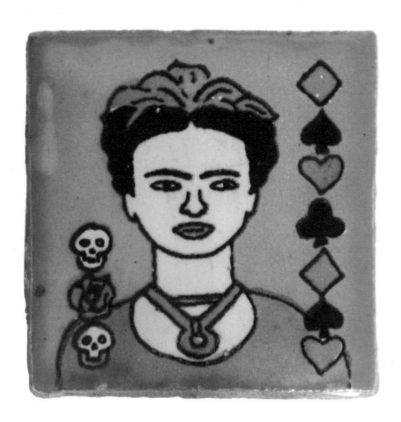

GABY FRANGER

Translated from the original German by Gita Wolf
Chief photographer: Rafael Doniz | Guest author: Cristina Kahlo

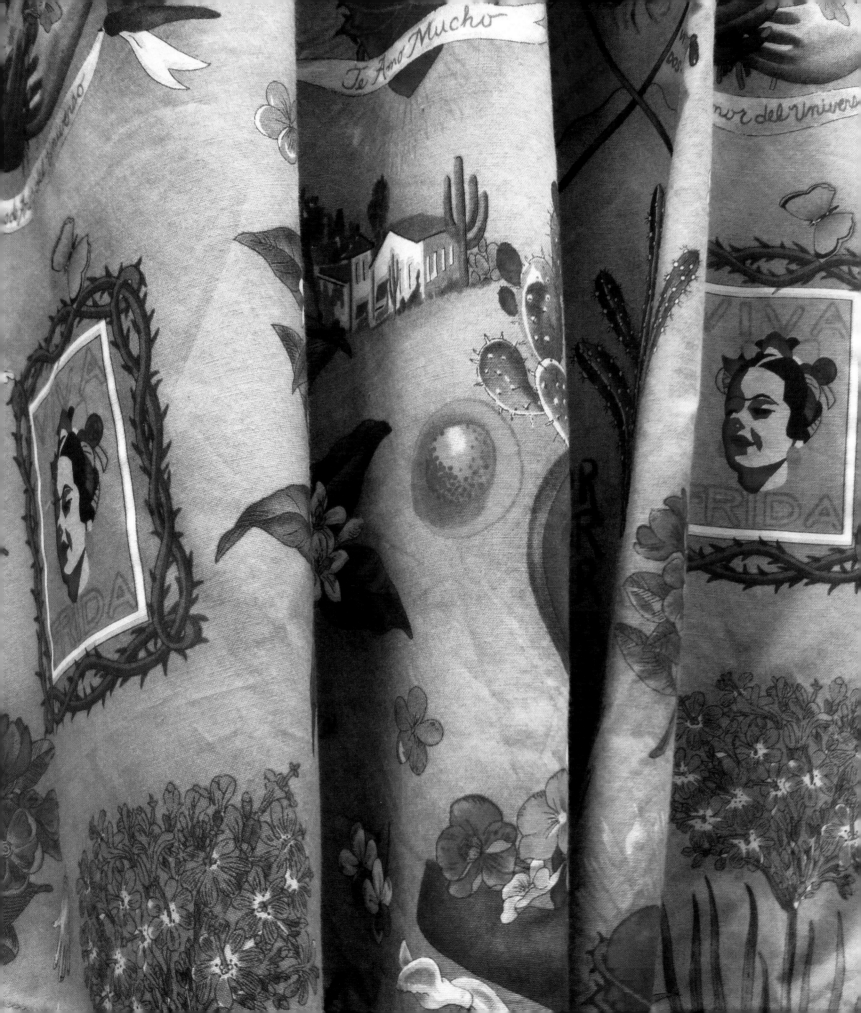

Contents

On Frida's Trail:
The Many Avatars of Frida

So HERE'S ANOTHER BOOK about Frida Kahlo, and this one doesn't feature even a single original painting. What it does contain are encounters with her—curious, moving, or just fun—from around the world. These are encounters of a special kind, and while they are very varied and different, they are all centred on one particular theme: the countless souvenirs, images and mementos that keep Frida alive in popular memory. I'm an avid collector of these quirky and wonderful objects myself, and most of what is presented in the book comes from a decade of amassing Frida memorabilia.[1]

Writing this book has allowed me to order and think through what I've accumulated, and come up with an interpretation and a narrative. It is by no means an overarching 'theory'—and neither is my collection encyclopaedic, which would be impossible in any case. What I have tried to do is explore some new and interesting directions, in a suggestive way, which hopefully infects the reader with the desire to delve into the multilayered cosmos that is Frida Kahlo. To go back a bit: my first "encounters" with Frida—or rather the edifice and interpretations flourishing around the artist and her work—were of a cursory nature. Of course, I was aware of her, icon that she was of the 1970s feminist movement. Which always brings up the question: was Frida really a feminist? A rather pointless controversy, in my opinion, since her iconic status

for women—feminists and non-feminists alike—is singular. It is a phenomenon that I touch on, in this book.

My own fleeting interest in Frida took a new turn in 1988, when the first pioneering edition of her work was published in German, edited by Andrea Kettenmann, Helga Prignitz-Poda and Salomon Grimberg. It was brought out by the publisher Neue Kritik, and was a significant addition to my book collection. But it was my research on the photographer Guillermo Kahlo, Frida's father, which actually brought about the decisive impulse to go see a Frida Kahlo exhibition. And once I had seen her 2005 exhibition at the Tate Modern in London, I was completely under her spell. And exactly like many other—mostly female—visitors, I returned home with one of the pieces of merchandise bought from the museum shop. These keepsakes were admittedly poor substitutes for a real Frida painting, but still better than nothing—and they were great reminders of the blissful hours spent with her. And to be honest, I already owned some Frida memorabilia: tin boxes with her image, earrings made of crown caps, small Mexican votive panels and a wonderful "Fridita"—a very particular Mexican clay figurine of Frida.

This early collection came from my abiding interest in folk art: and when I encountered Frida's work, I was completely taken up with the Mexican folk adaptations of

her work. I was of course aware of Frida's own close connection to the folk art of her country, and the inspiration she drew from it—all of which was researched and documented during the early days of Frida research. This facet of the artist's work receives much less attention now. Current art history tends to look at Frida Kahlo in a way that strips the stigma of 'the naïve' away from her work—the emphasis tends to be more on her cosmopolitan education, as well as the perceptive artistic 'quotations' from various forms and periods of European art which pepper her work.[2]

Here, I've chosen a diametrically different approach: my narrative is based on the various appropriations of Frida in current popular and folk art, forms that are mostly produced in large numbers. Loosely defined as something intended for and appreciated by ordinary people, these countless—and often contradictory—identifications with Frida come from traditional as well as urban contexts.

My approach is to trace Frida's own connection with such forms of expression, and I especially go into elements in Frida's biography which indicate a unique bond between her and those who—for a variety of reasons—reinvent her as an idol. People have always been fascinated by Frida's ability to stage herself as a universal piece of art and, just like Frida herself, her work stood in for Mexico's political and artistic avant-garde.

I'm aware that a book which only features imitations, copies and re-definitions of Frida could seem sacrilegious to some art critics. Most catalogues of international Frida exhibitions regularly talk about the way in which urban artisans, graffiti artists or mass-produced objects "take possession" of Frida. However, this phenomenon is mostly presented as a bizarre side effect.

Much of classical feminist discourse also tends to regard folk art as "a lesser form of art". So what I would like to achieve, with my shift in focus, is to put into question, once again, notions of 'high art' and 'artisanship'.[3] This in itself is not a new idea. Diego Rivera himself grappled with the issue, and even though his own artistic style was completely opposed to Frida's, he was an unreserved admirer of her art and a sharp critic of the arrogance and ignorance of art elites. In another context, my publisher Tara Books has worked on teasing out the relationship between art and

artisanship for many years, at multiple levels. So what is new in this book is the unique context I have created for exploring these connections, and I hope the implications have a much wider resonance. I would also love to spark new discussions about the relationship between feminism and folk art.

With this collection of fun—at times ironic, at times touching—pictures and objects, I'd also like to pay a tribute to the folk artists whose name we seldom know or acknowledge. I'd like to honour them for their creativity, their joy of life, and the way in which they put themselves and us in touch with a Frida who is constantly being reinvented. What I have also tried to do, in this book, is embed them in a history and context.

This book is associative rather than comprehensive, but I do follow a logic of argument: the first part looks at the myths associated with Frida, and the ways in which she is glorified. Some of these myths are rooted in her exceptional suffering, while others can be traced to her own skillful self-staging. The other question I examine relates to why Frida offers so many points of connection to rebellious movements of every description. I illustrate this broad topic through objects which cite, copy or creatively reinterpret Frida and hope that these associative links open up a broad spectrum of meaning which can be—and are in fact—attached to her.

Other chapters are dedicated to Mexican folk art, and how it was taken up by Frida, who integrated its form and content into her work, as did many of her contemporaries. It is fascinating to observe the constant back and forth between Frida and folk art. On one hand, Frida's work was inspired by religious as well as folk traditions— some of which were reinterpreted in keeping with post-revolutionary thought in Mexico. These included votive offerings, *ofrendas* (family altar), skeletons and skulls. Folk art, in return, not only comes up constantly with souvenirs and mementos, but in the process, incorporates Frida into its symbolic cosmos: Frida merges with national heroes of the Mexicanidad, for example, or embodies the religious dimension of Mexicanidad, the Virgin of Guadalupe.

The Mexican Aguilar sisters and their charismatic clay figurines called "Friditas" have their very own chapter. The central part of the book has an entirely visual section

dedicated to Frida as she lives on: in the city and in the countryside, in craft markets in Bogotá, Buenos Aires and Santiago de Chile; she's there in small craft shops and folklore boutiques in New York, Boston and Sevilla. These shops cater not only to Mexican travellers, but also tap into the nostalgia of Mexican migrants. The images testify to the fact that the 'Frida Icon' is alive in many, sometimes completely unexpected, places.

For the last ten years, I seemed to bump into Frida wherever I went: when I visited friends and colleagues in Latin America, Frida would already be there waiting for me—in the form of a magnet sticking to a fridge or painted on a small wooden box. I would find her at market stalls that sell urban folk art and Christmas presents to tourists, or spread out on the blankets of nomadic street artists in big cities, at music festivals, in political demonstrations... Frida is omnipresent.

The wonderful photographs taken by the Mexican photographer Rafael Doniz on his walks through Mexico City testify to this in a poetic way, and have been given their own space. Rafael Doniz also has a very special connection to Frida, who he has endlessly encountered on his expeditions through cities.

I asked many artisans during the course of my Frida journey: why Frida? What was so special about her? Because she was strong, because she spread joy, because she is beautiful, because she sells well, because we are proud of her—these are the answers I got. And they were the same in places as diverse as Mexico, Colombia, Chile, Spain or Turkey. Frida unlocks doors and hearts: when I go through the security check at an airport, for instance, and take my laptop out of its Frida case, even taciturn staff smile and say: "Isn't that... Frida... Frida Kahlo?"

Juan Coronel Rivera, a grandson of Diego Rivera, puts it well: "We all find something of ourselves in Frida, because we're all somewhat inhibited, because we all dream of living as a painter and long for social recognition."[4] We could also say that we identify with Frida because we feel her joie de vivre, and because she's a strong role-model for girls, young women, elderly women, feminists, artists and political activists. There are very few women who make other women happy the way Frida does. And so the message from Frida that I conclude this book with is a seemingly simple but very important one:

Viva la vida—let's celebrate life.

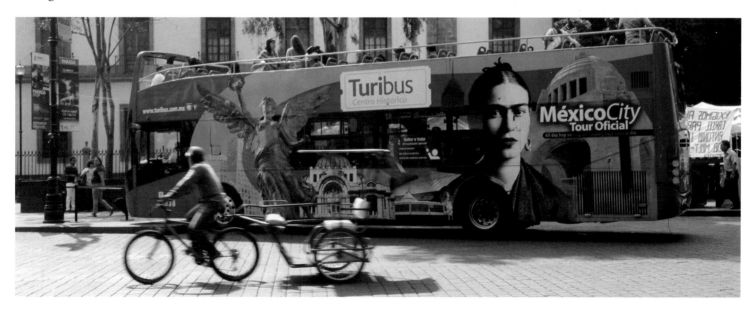

◀ PREVIOUS PAGE:
Frida and Me is not just a popular literary subject. In 2014, a small café in Budapest hosted a mini-exhibition featuring Nickolas Muray's portrait of Frida. Within the time it takes to drink an espresso, five tourists had taken their pictures with Frida.

▲ With her portraits everywhere, Frida is omnipresent in Mexico City—as on this tourist bus which features a colossal image of her.
Seen in the centre of Mexico City, 2013

Te amo Frida

1

FRIDA,
I LOVE YOU

Frida Kahlo is the greatest of Mexican painters, and her work ought to be reproduced in quantity. If it doesn't speak from the walls, it will speak to everyone from the books.
—*Diego Rivera*[5]

The Stuff
of Legends

No myth is invented without its consent.
—*Carlos Monsiváis*[6]

"I'VE GOT TO BE CAREFUL OF THE HANDRAILS!" whispered Sara, encouraging herself over and over. The 22-year-old cleaning woman from Central Sweden was on board an unmanned "ghost train" when it slammed into a residential building in Stockholm at 80 kilometres an hour. It all happened within a space of three minutes, and she remembers only bits and pieces. But after she had tried in vain to turn the ignition key off in the driver's cabin, she suddenly thought of Frida Kahlo... that she had to pay attention to the handrails. "She was in a bus accident and the same kind of rod pierced her pelvis, after that she could never have any children."[7]

Frida Kahlo as guardian angel and saver of lives—Frida herself would have undoubtedly loved this new sphere of influence. She enjoyed all the myths—old and new—that surrounded her person, weaving her own strands into them with great gusto. Left to her, we'd be associating her birthday with the anniversary of the Mexican Revolution or expecting to find her paternal ancestors in Hungary.[8]

September 17, 1925—the day a bus and tram collided, hitting Frida Kahlo, who was pierced by a steel rod and crippled—shaped her life and art. For a long time afterwards, she was literally shackled to her bed—and it was during this time that she turned herself into an artist. She had to give up the plans she had of studying medicine.

Frida was the third daughter of Matilda Calderon from Oaxaca, and Guillermo Kahlo, an immigrant from Pforzheim in Germany. She was born on July 6, 1907. Her father was a distinguished photographer of Mexican architecture—of baroque churches as well as contemporary city architecture. He was a sensitive portrait artist and naturalist who travelled to the most remote areas of Mexico. Frida's father taught her how to handle a camera, develop film, and use the fine brush with which he retouched photos. Frida watched him when he painted his watercolours, and he taught her nature observation during walks in the park. Much later, she was to reminisce about this formative period:

"For years, my father had a paintbox with oil paints in his photo studio, along with a palette and bristle brushes, which stood in a vase in the corner. As a pastime, he would sometimes paint natural scenes along the river Coyoacán. He painted landscapes and genre scenes; occasionally, he would also copy coloured prints. Apparently, I seem to have had my eye on this paintbox right from childhood, without quite knowing why. So now that I've been bedridden for so long, I took the chance to ask my father whether I could paint with his materials."[9]

Frida had begun a graphic arts course in 1925, before her accident. After the mishap—almost motionless—

with a mirror above her bed, she began to portray herself, expressing her feelings and injuries, both physical and mental.

In 1910, when Frida was just three years old, the dictator Porfirio Díaz—in power since 1877—was overthrown, and a long, bloody process of revolution gripped the country, which was not to stabilise until the early 1920s. From 1921, under the presidency of Alvaro Obregón, a comprehensive re-education programme for Mexico began to be developed, with the aim of creating a new national identity. Leading artists were won over to this project, and went on to create magnificent frescoes that redefined Mexican history—the most famous artist among them being Diego Rivera, the man Frida married in 1929.[10]

Mexico, during this period, was the chosen destination of countless intellectuals, revolutionaries, photographers, filmmakers and artists from all over Europe and North America. Leon Trotsky found asylum in Mexico until the time he was murdered there, and some time later, the country took in persecuted people from countries such as Spain and Germany.

Frida was part of this reawakening, and responded to the richly cosmopolitan context of her environment. Her house—Casa Azul, the Blue House—in which she lived for a long period with Diego, was open to intellectuals, political activists and artists who lived in Mexico or came to visit.

Frida attracted the attention of the famous photographers of her time. Years later, distinguished Mexican authors like Carlos Monsiváis and Carlos Fuentes would talk about how lucky they felt to have seen Frida, if only from a distance.[11] She was not only a sought-after photo model in her own right, but was also pursued by celebrities who wanted to be photographed with her—like the famous beauty moghul and art patron Helena Rubinstein, who bought a number of Frida's pictures.[12]

▲ ABOVE:
Frida's father often took photos of her.

Cut-out from a 1926 portrait, printed on a log of wood (9x12x2 cm)

Found in Tucson, USA, 2012

▲ **Dressed as a dandy in a suit, 18-year old Frida stands surrounded by relatives; in the front row is Frida's mother and her sister Matilde is behind her.**

Printed on a wood coaster (9x9 cm)

Found in Mexico City, 2013

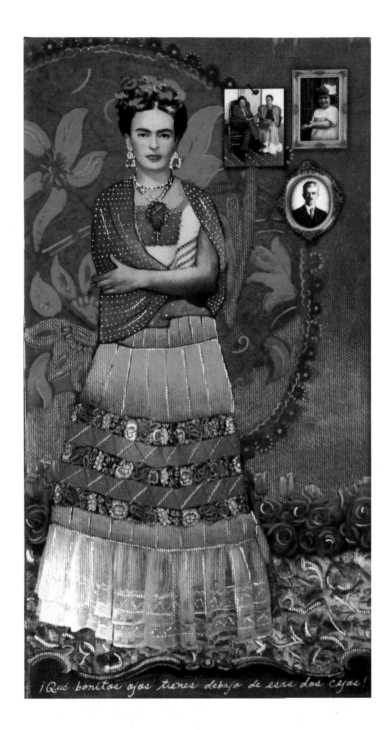

▲ *I Have a Huge Heart*

Frida is featured along with three family photos:
Frida and Diego, photographed by Manuel Álvarez Bravo;
Frida as a three-year-old, photographed by her father
Guillermo Kahlo; a self-portrait of Guillermo Kahlo.

Caption along the lower edge of the picture reads:
Que bonitos ojos tienes debajo de esas cejas
(How nice are your eyes under these eyebrows).

Digital art and acrylic painting (16.5x31.5 cm)
by Maria Carmina García de León y Mier

Found in Mexico City, 2016

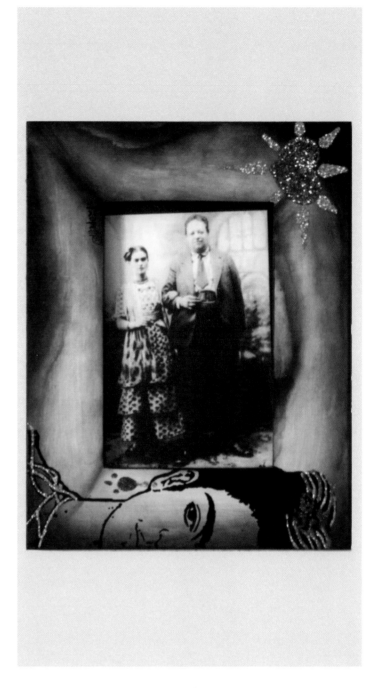

▲ In 1929, the wedding of "the Elephant and
the Dove" received a lot of public attention in
Mexico. This is the reproduction of Frida's wedding
picture featured in the newspaper *La Prensa*, with
the caption: "The bride dressed ... in very simple
street clothes, and the painter Rivera dressed 'de
Americana' and without a vest."

Reprint placed in a painted wooden frame
(with a cropped Frida portrait)

Found in Puebla, Mexico, 2009

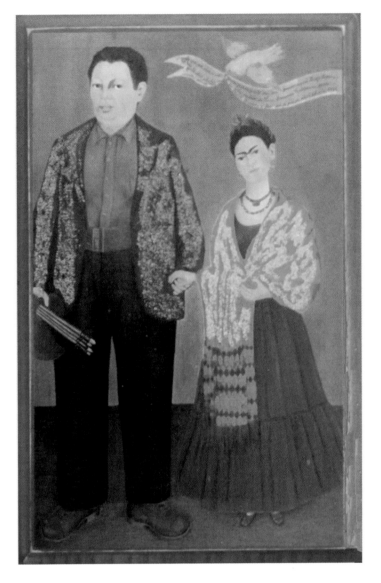

▲ ABOVE LEFT:
Photo of Frida by Guillermo Kahlo. It was taken shortly after the death of Frida's mother in October 1932.

Print on a silk bag (36x29 cm)

Found in Mexico City, 2016

◀ Pillowcase printed with elements from different paintings by Frida: love bird with the banner from the painting 'Frida and Diego' (1931) featured along with 'The Broken Column' (1944).

Print on artificial silk (45x45 cm)

Found in Mexico City, 2016

▲ The love bird featured in this reproduction of Frida's painting, 'Frieda and Diego', holds a banner that says: "Here, you see me, Frida Kahlo, together with my beloved husband, Diego Rivera. I painted these pictures of the beautiful city of San Francisco, California, for our friend Mr. Albert Bender, in the month of April 1931."

Reproduction of Frida's painting 'Frieda and Diego' (1931) mounted on wood (16x23 cm) by Christine Koenen
(www.ddcodesign.com)

Found in Tucson, USA, 2012

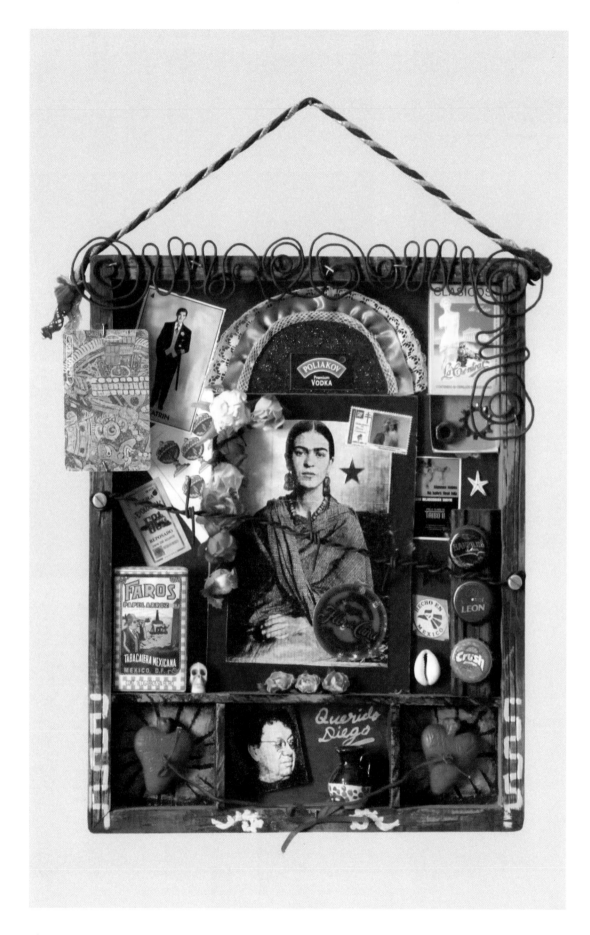

◀ Collage assembled within
a wooden frame, dedicated
to the lovers Frida and Diego,
with a photo of Frida taken by
Imogen Cunningham, placed in
the centre (27x33x2 cm).
Found in Mexico City, 2006

Nickolas Muray's Frida

In the first half of the 20th century, the Hungarian Nickolas Muray (1892-1965), was one of the most important portrait and fashion photographers in the USA. He photographed world-famous stars for magazines like *Vanity Fair*, *Vogue* and *Time*. This pioneer of colour photography was also an internationally known fencer and pilot—he also loved women, especially Frida. He met her for the first time in 1931, and they had a passionate but ultimately unhappy affair which lasted ten years. He photographed Frida more often than anyone else. His intense portraits of Frida seem to penetrate her essence like no other—and are a particularly significant building block in Frida's iconicisation. These portraits are the basis for countless copies and prints, transformed into all kinds of pop-art and craft objects.[13]

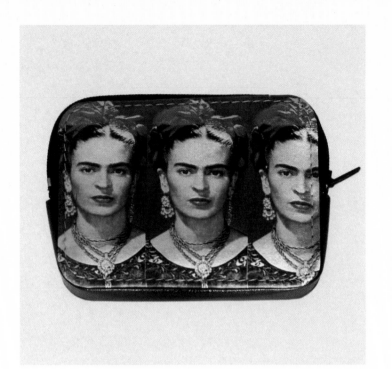

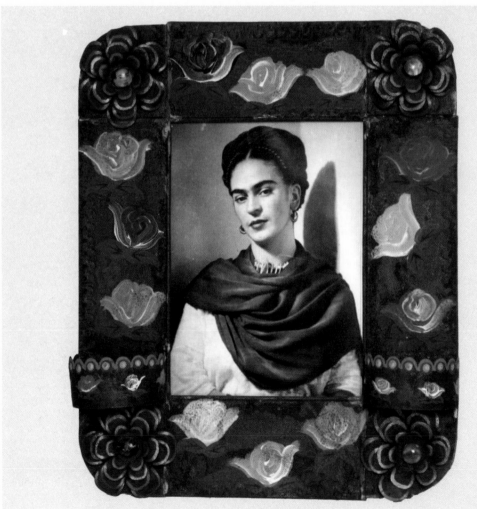

▲ ABOVE LEFT:
Portrait from 1939, repeated
thrice on a leather wallet
(10x6 cm)
Found in Usaquén, Bogotá,
Colombia, 2010

▲ Collage of digital prints
of Frida's paintings and
portraits (20x30 cm)
Found in Usaquén, Bogotá,
Colombia, 2011

◀ Muray's *Frida with Magenta
Rebozo* (1939) is one of the most
copied pictures of Frida.
(A rebozo is a Mexican shawl.)
Print placed in a rusty iron frame,
decorated with flower blossoms,
with candle-holders on the sides
Found in Cambridge,
Massachusetts, USA, 2011

◀ Ricardo Aguirre and Rosa María Marín choose pop icons from all over the world for their collages. Frida is Rosa María's favourite, because young women admire her. Collages that feature Muray's portraits sell well no matter how large. On the top right of the collage is a picture of Frida with a magenta rebozo around her head.

Digital print on canvas (100x48 cm)

Found in Usaquén, Bogotá, Colombia, 2013

◀ Frida in her magenta rebozo is foregrounded in this collage, featuring photos and images of her work—and which has been used to cover a box. María Elena Torres Ortiz covers wooden boxes and small chests with pictures of artists and their work. She is especially interested in Frida, because "her life is even more interesting than her anarchistic-surrealistic art".

Wooden jewelry box (26.5x15.5x4 cm)

Found in Usaquén, Bogotá, Colombia, 2013

Photo: Rainer Huhle

▶ Frida's portrait on the cover of this box has been put together from two original photographs by Nickolas Muray.

Lacquered cardboard box with six coasters

Found in Mexico City, 2016

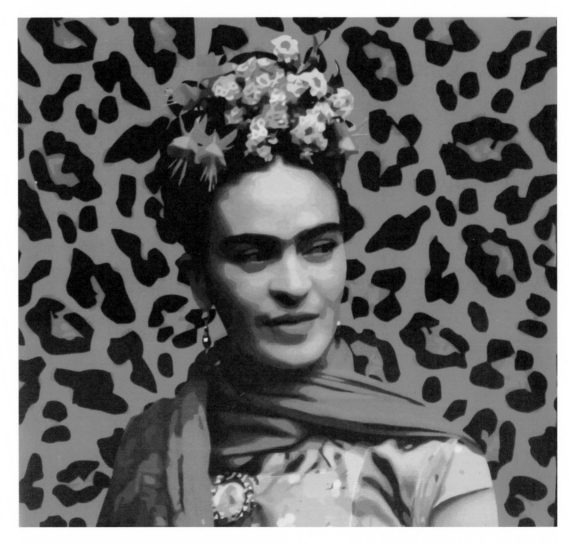

▶ Cut-out from the photograph *Frida, Coyoacán* (1938)

Printed on to a lacquered wooden box (15x15x8 cm)

Found in Mexico City, 2016

◀ Nickolas Muray's photos of Frida have been combined with two of Frida's paintings, 'The Two Fridas' (1939) and 'Self portrait with Thorn Necklace and Hummingbird' (1940).

Digital print on a laptop case (33x25 cm)

Found in Bogotá, Colombia, 2013

▼ Laptop case

Spotted at the Museo Estudio Diego Rivera y Frida Kahlo shop, Mexico City, 2013

Photo: Rainer Huhle

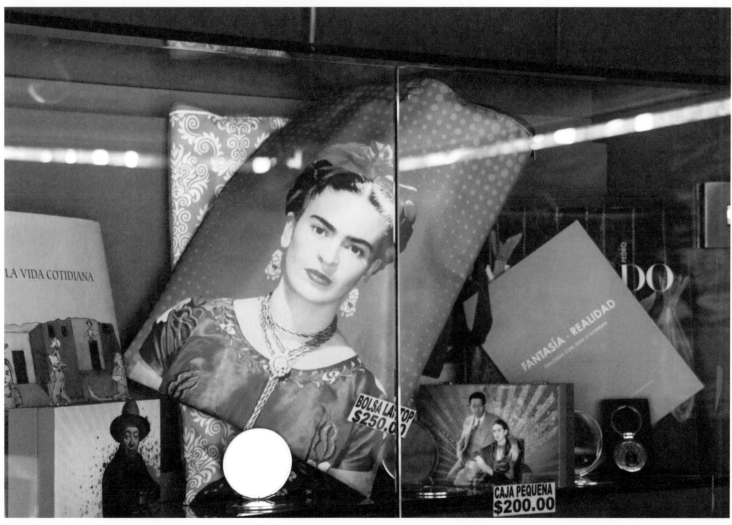

The Self-Portrait

*To feel in my own pain the pain of all those who suffer and
inspire me in the need to live in order to struggle for them.
—Frida [14]*

FRIDA CREATED MUCH OF HER WORK in the 1930s and 40s, which turned out to be an extremely eventful period for Mexican art and politics. Diego Rivera was becoming world-famous through his gigantic wall murals, taking on capitalist and imperialist history by contrasting it to the values inherent in Mexican culture and social movements. Frida's art, on the other hand, was apparently more rooted in the private sphere, revealing key events in her life through her "shocking self-portraits".[15] Her artist friends called her work surreal, but to Frida herself, this unique rendering of her inner reality merely collapsed the border between inside and outside.

In 1930, she travelled to the USA for the first time with Diego Rivera. With this journey began a phase of intense artistic work, and in 1931, Frida was able to present one of her drawings for the first time at the Sixth Annual Exhibition of the Society of Women Artists in San Francisco, one of the oldest art organisations in California, which had created a dedicated space for women artists and photographers.[16]

Interestingly, Frida's contribution to the exhibition was a work titled 'Frieda and Diego Rivera'. The painting plays with the couple's unequal appearance which was the cause of a lot of attention among their circle of American artists and patrons, whenever they appeared together.

In the painting, Frida, a young and naïve girl in Mexican clothes, is standing next to the expansive Diego. Her gaze, however, makes it clear: this young woman is not naïve...

Frida's reputation as an artist grew steadily in the 1930s. In 1937, four of her works were presented in a group exhibition at the University gallery in Mexico City, followed by her first solo exhibition in 1938 at the Julien Levy Gallery in New York. Twenty-five of her paintings were exhibited, and almost all of them were sold. Her participation at the Mexico exhibition in France in 1939—although badly organised by Andre Breton [17]—was another big success for Frida. Because of the growing recognition that she received, she was invited in 1942 to teach at La Esmeralda, the National Art Academy of Mexico. Her students proudly called themselves "Los Fridos".[18]

In 1946, the Ministry of Education awarded her the National Prize of Arts and Sciences.[19]

How are we to understand her work and its continuing popularity? Frida challenged the art world through her paintings—and continues to do so today. Bearing witness to key events in her life, her art depicts her innermost self, her physical suffering, as well as the suffering caused by her relationship with Diego. But her work is far more than self-depiction. Her magically inventive paintings appear seemingly naïve and purely aesthetic, but

they are in fact referring to European art traditions, and to the modernist avant-garde. Frida presents herself in many roles, never repeating even the smallest detail—"no stroke of her paintbrush is meaningless."[20]

Despite the number of self-portraits she produced, Frida's work was always more than self-staging and self-depiction. She may have depicted suffering, physical and mental distress, but she never portrayed herself as a helpless victim, as Carlos Monsiváis so aptly puts it: "From someone who is ill, one doesn't expect such an explosion of vitality... That was Frida's great scandal. Not what she said or who she slept with. But rather a sick person, who refuses to resign herself to be covered with the veil of pity."[21]

Her admirable strength and resilience were nowhere more in evidence than at her first solo exhibition opening in Mexico, in April 1953 at the Gallery of Contemporary Art in Mexico City. Frida was very ill by then, her physical condition having steadily deteriorated in the 1940s, with one operation following another. Despite everything, she still attended the opening—lying in her bed, dressed in the traditional costume of *Tehuana* (from the Isthmus of Tehuantepec) women. Her presence also testified to the fact that in her case, art and life depended on each other, linking the work of art with the art of living.

Anita Brenner, a friend of Frida's who was a journalist and photographer, described this incredible moment: "The room was filled with energy, all of it focused on Frida, who drew it in like oxygen. People lined up to greet her, pay her homage, but there was also a feeling they were saying goodbye."[22]

It was this exhibition opening—and finally the circumstances of her death—which turned Frida into a legend. Ill with pneumonia in early July 1954, Frida nevertheless took part in a demonstration against USA intervention in Guatemala. The demonstration exhausted her completely, and a few days later, on July 13, 1954, she died. Her ashes remain in Casa Azul, the house her father had built, in which she was born and in which she had lived for many years with—and apart from—Diego Rivera.

After her death, Frida Kahlo's popularity—as an artist, a fashion model, a style icon, and a symbol of suffering, resilience and rebellion—continues unabated. The ways in which she is repeatedly re-labelled and re-invented is unprecedented in the world of art. Each of these labels serves one of the many facets of her personality: she is an icon of Mexican popular culture, a surrealist, a classic modernist painter, a bisexual feminist, and a revolutionary.

Frida made herself the subject of her own art, not in a naïve sense, but in the context of her knowledge of both Western and Mexican art traditions. As Florian Steininger, an Austrian art historian, puts it: "Her self-portraits with an imperious stare are among the great icons of the history of figurative painting." Through them she created the template for her archetypical image, the 'Frida Icon', which has mutated into a phenomenon that can be called "a Mexican saint with pop character".[23]

Frida Kahlo's art and life came to have tangible benefits for women as well. As early as two years after her death, it enabled the work of other women artists to come to the fore in the male-dominated world of art.[24]

Raquel Tibol[25] described the first women's art exhibition in Mexico in 1956, titled, "The Frida Kahlo Salon" as heterogeneous, but nonetheless imbued by a certain gender awareness "united by Frida's catalytic power".[26]

Frida Kahlo was 'rediscovered' at a moment when the time was ripe for a re-assessment of the role of women artists, and the feminist movement of the 70s chose her as the icon to affirm this.[27]

Frida's life and art also became rich material for all kinds of critical and artistic explorations. There are countless essays by famous writers who try to get close to her.[28] Her life and suffering has become the stuff of opera[29], is danced as ballet[30], and innumerable experimental and not so experimental theatre performances in the world all get "their Frida".[31] Frida herself laid these trails, staging her life as a universal piece of art. Her paintings are a fusion of myth and personal history, a weaving together of fact and fiction—allowing the viewer to pick the part she chooses, to create her very own version of Frida.

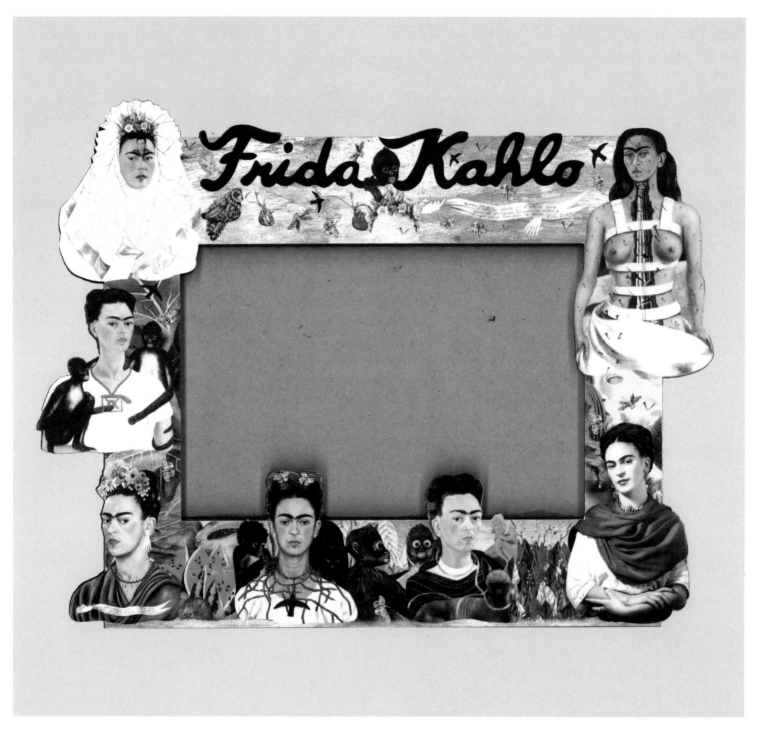

▲ Some of Frida's well-known self-portraits, along with one of Nickolas Muray's pictures decorate this wooden photo-frame.

Found in Puebla, Mexico, 2009

▶ FACING PAGE, ABOVE:
Here are Ivonne Moralo Roco's reproductions of four of Frida's self-portraits: from the left, 'Tree of Hope, Remain Strong' (1946), 'Self-portrait with Loose Hair' (1947), 'Me and My Parrots' (1941) and 'The Frame' (1938).

Reproductions on wooden panels decorated with silver glitter

Found in Usaquén, Bogotá, Colombia, 2016

▶ BELOW LEFT:
'Self-portrait with Cropped Hair' (1940)

The musical score on the mousepad reads: "See, if I loved you, it was for your hair. Now you're bald, I don't love you any more."

Reproduction on a mousepad

Found in Berlin, Germany, 2012

▶ BELOW RIGHT:
'Self-portrait with Loose Hair' (1947)

Reproduction on wood inlaid with tiles

Found in Puebla, Mexico, 2009

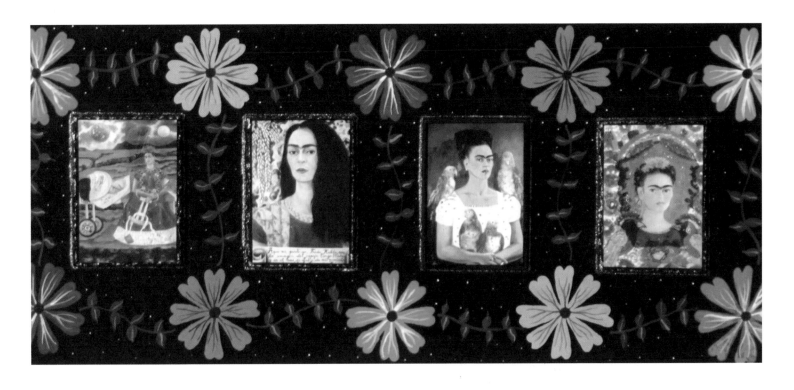

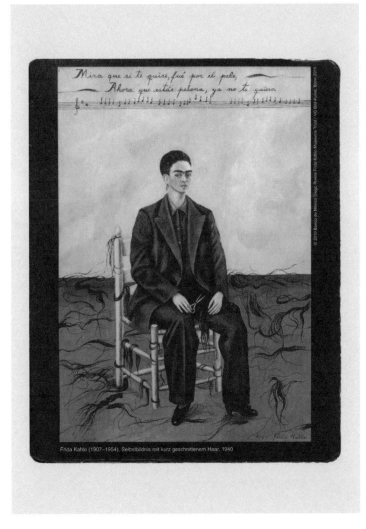

Frida Kahlo (1907–1954), Selbstbildnis mit kurz geschnittenem Haar, 1940

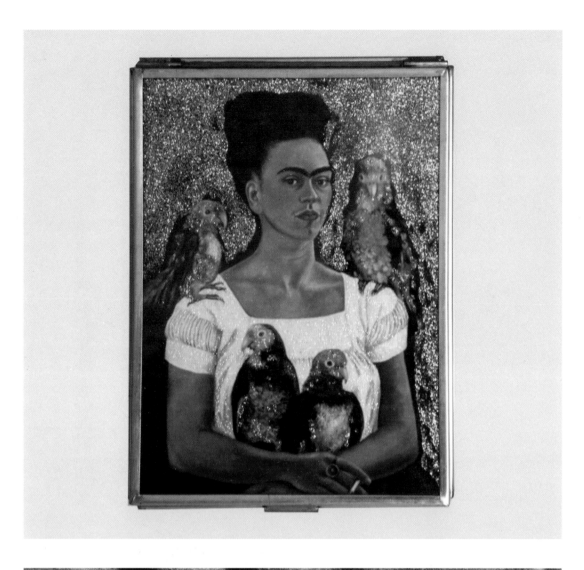

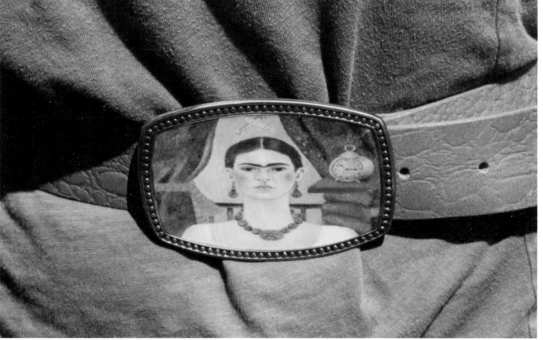

◀ 'Me and My Parrots'
Paper-print with glitter on the glass lid of a studded silver chest (11x15 cm)
Found in Mexico City, 2009

▼ Reproduction of a cut-out of the self-portrait 'The Time Flies' (1929) on a belt-buckle.
Found in Usaquén, Bogotá, Colombia, 2011

FACING PAGE

▶ ABOVE:
Leather purse (12x6.5 cm) made by Fridakaturas (a design store, inspired, among other things, by Frida's art)
Found in Mexico City, 2013

▶ BELOW LEFT:
Cut-out from 'Self-portrait with Monkey' (1940) on a lacquered drawer (14x14x5 cm)
Found in Sevilla, Spain, 2014

▶ BELOW RIGHT:
Why Feet, when I have Wings? This is a creative interpretation of Frida's famous saying, often understood as a poetic slogan of hope.
Silver earrings
Found in Mesilla, New Mexico, USA, 2012

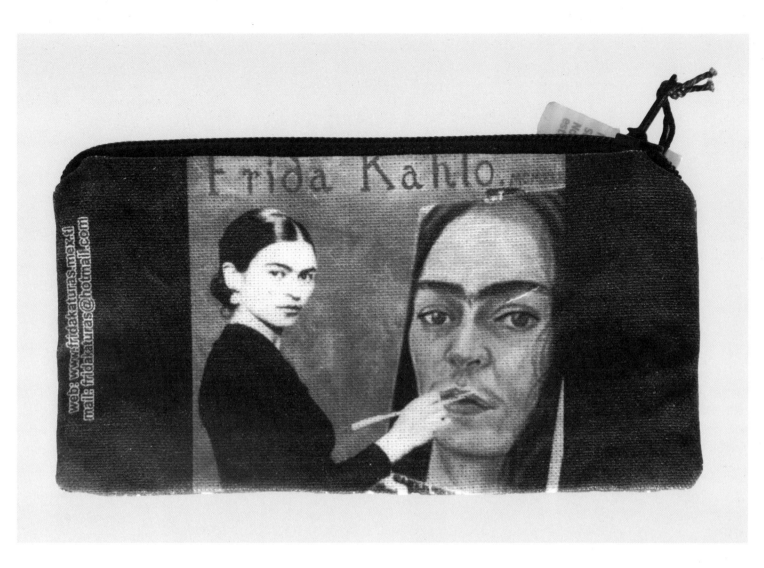

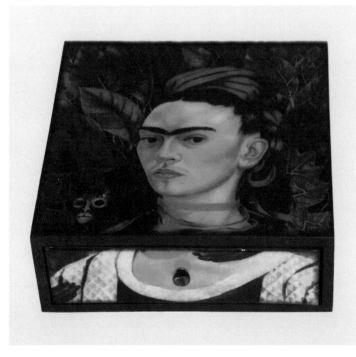

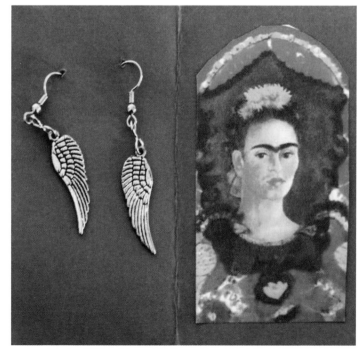

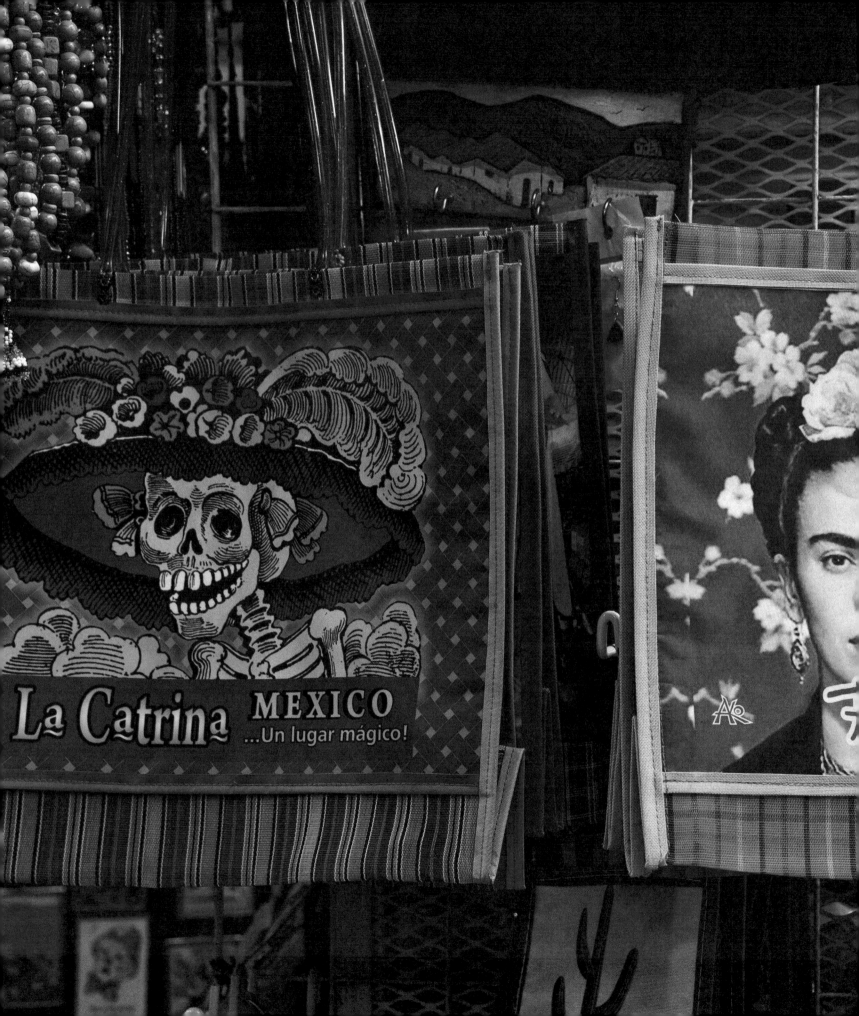

The Spirit of Mexico

I wish to be worthy, with my painting, of the people to whom I belong and to the ideas that strengthen me... I want my work to be a contribution to the struggle of the people for peace and liberty.
—*Frida Kahlo*[32]

JUST LIKE OTHER PROGRESSIVE ARTISTS, painters, poets and writers of her time, Frida felt attracted to the Mexican Revolution. Her attachment went so far as to make her change her year of birth to 1910, the year of the Revolution. Diego Rivera revered her and, making her the subject of his wall paintings, contributed to making her a heroine of Mexican history. He portrayed her in a number of paintings: Frida as a revolutionary, Frida as socialist... The monumental *The Ballad of the Revolution* mural in the main building of the Secretariat of Public Education in Mexico City shows Frida in a fiery red blouse, with a red star on her chest, handing out rifles to the workers in the middle of a weapons arsenal.[33] The great mural, *History of Mexico*, has Frida and her sister Cristina act as socialist educators, in the section called "Mexico Yesterday and Today".[34]

The decisive moment for the outbreak of the revolution came when enormous amounts of land began to be accumulated by large landowners during a period called the 'Porfiriats'.[35] This was a period of economic expansion, when agriculture became export-oriented, and the railway network and industrial facilities began to be expanded through foreign investment. Frida's father, Guillermo Kahlo, was the most important documentary photographer of this era who recorded the architectural expressions and industrial developments of the time.

The bloody uprisings against the Mexican President Porfirio Díaz gripped the entire country until the 1920s. In the north of Mexico, the fighting was led by Pancho Villa. In the south, the peasants were led by Emiliano Zapata: fighting under the slogan of "Tierra y Libertad"—land and freedom—for indigenous collective rights and libertarian socialism. Their demands were ultimately never enforced, despite extensive social reforms in the 1930s.

The post-revolutionary elite of the 1920s—intellectuals and artists—shaped a new iconography, and held it up against the educational system, industrialisation and ideological disputes about new values. In all forms of art, revolutionary characters were embodied by peasants, the military, and workers. The closeness of their art to the "masses" was to be rendered in a "distinctly Mexican" way of expression—and this came through especially in the works of the great muralists José Clemente Oroszco, Diego Rivera, and his adversary David Alfaro Siqueiros.[36]

Frida herself was member of the Communist Party of Mexico, off and on. Leon Trotsky sought asylum in her house, and during this period, she had a brief affair with him. The last photo that exists of her shows her attending a demonstration against the CIA, then accused of targeting the Guatemalan president, Jacobo Árbenz Guzmán. Frida, heavily marked by illness, sits in a wheelchair. She clenches

her fist while she holds a banner with a peace dove and the letters "Por la Paz"—for peace—in the other hand.[37]

And when she passed away, everyone came to say farewell: revolutionary nationalists, progressive officials, artists, writers, communists—and ordinary people. They sang *Corridos*, sentimental traditional songs, and old anti-imperialist melodies. Frida was cremated to a rendering of the *Internationale*. It was a rousing moment: even at her own funeral, Frida's rebellious spirit seems to have emerged against all odds to inspire and uplift the funeral guests. It was a legacy that was to endure in the decades to follow as the Mexican author and journalist Elena Poniatowska expressed so poetically:

"Frida of the demons. Frida of the blood-covered paintbrush dipped in her own blood, Frida of the necklaces of clay and silver, Frida of the rings of gold: the sorrowful, the critical, the vivacious. Frida, covered in the end by the red and black flag, the red hammer, the red sickle and the white star, continued to be an absolutely passionate communist in heaven.

One Frida has gone, the other is here. The one who stays has a pure brow, full lips and a profound gaze. No one has been more cowardly than she, no one has been more valiant. Never has there been a woman more vital, never a woman so abandoned, so cruel, and so generous. Friduchita, Friduchin, Frieda, the little Fisita girl."[38]

▲ Wall mural in the entry hall of the University Autónoma de Coahuila, Campus Arteaga, Saltillo, Mexico.

Spotted in 2017

Photo: Rainer Huhle

Frida Tehuana

Traditional Tehuana costume consists of a heavy pleated headpiece [39], with flowers and ribbons. A short blouse called *huipil* is worn with a long skirt, and a lot of jewellery. Images of Frida as a Tehuana woman are very popular souvenirs.

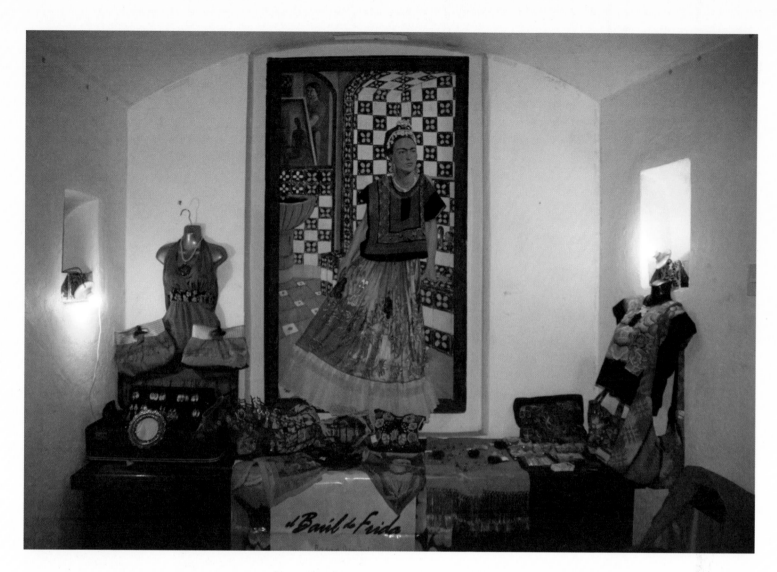

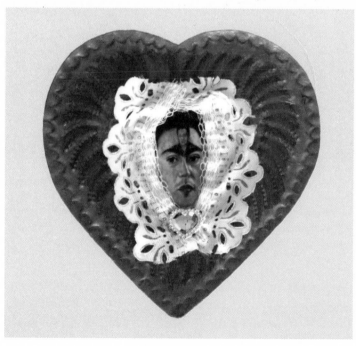

▶ 'Tehuana or Diego
in My Thoughts' (1943)
Framed by lace and glued
on a heart fashioned out of
coloured tin (11x11 cm)
Found in Mexico City, 2009

▲ *Frida's Clothes Chest*
Display spotted at the event
"Frida meets Indio Fernandez"
in Coyoacàn, Mexico City, 2013

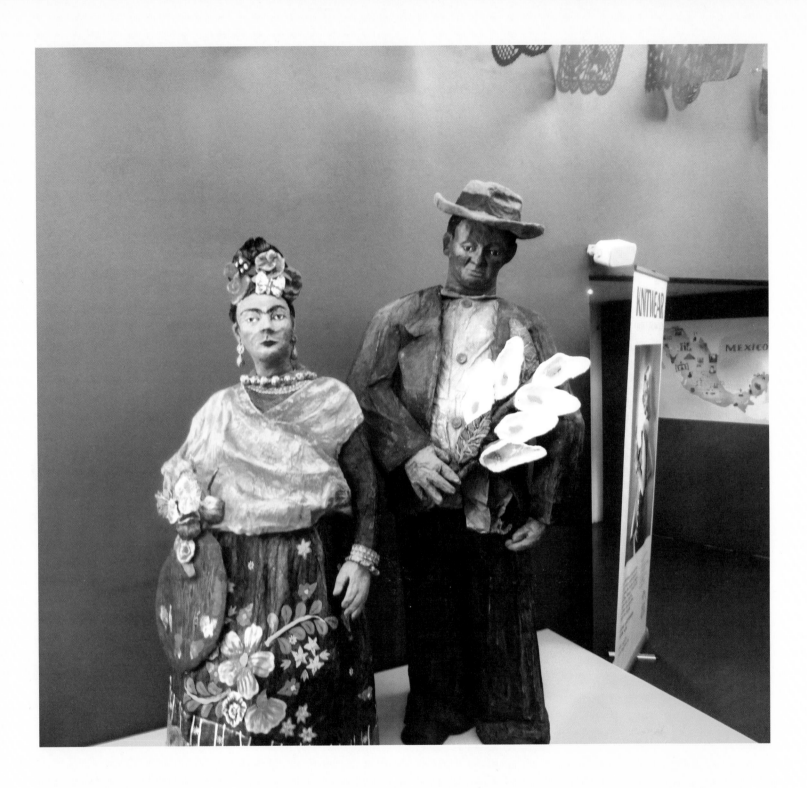

▲ Carved wooden sculptures
of Frida and Diego, in the
foyer of the exhibition "Made
in Mexico. The Rebozo in Art,
Culture and Fashion",
London, UK, 2014
Photo: Rainer Huhle

▶ FACING PAGE, ABOVE:
Frida Tehuana images
Spotted in Ciudadela,
Mexico City, 2009

▶ BELOW LEFT:
'Tehuana or Diego
in My Thoughts'
Painted and decorated image
on a matchbox (6.5x11 cm),
embellished with glossy paper
and glitter
Found in San Angel,
Mexico City, 2009

▶ BELOW RIGHT:
Frida mannequin
Spotted in Mexico City, 2011
Photo: Gita Wolf

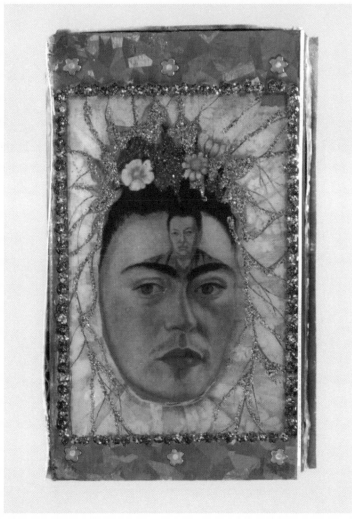

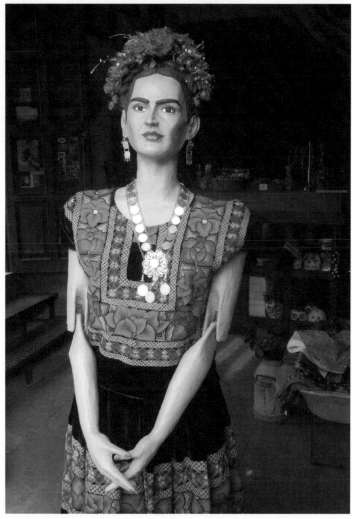

▲ A collection of keychains, powder boxes and other knick-knacks featuring Frida Tehuana.

Spotted at the shop in the Museum of Modern Art, Mexico City, 2013

Photo: Rainer Huhle

▶ Frida re-invented: this is a photo composition in which Frida's face has been attached to another woman's body. Echoing Frida's 'Self-portrait with Monkeys', there is a lone monkey featured in the photograph.

Printed fabric on a wooden tablet (24x35 cm), decorated with braids, sequins, and (along the bottom of the portrait) hooks with red glass buttons

Found in Bogotá, Colombia, 2017

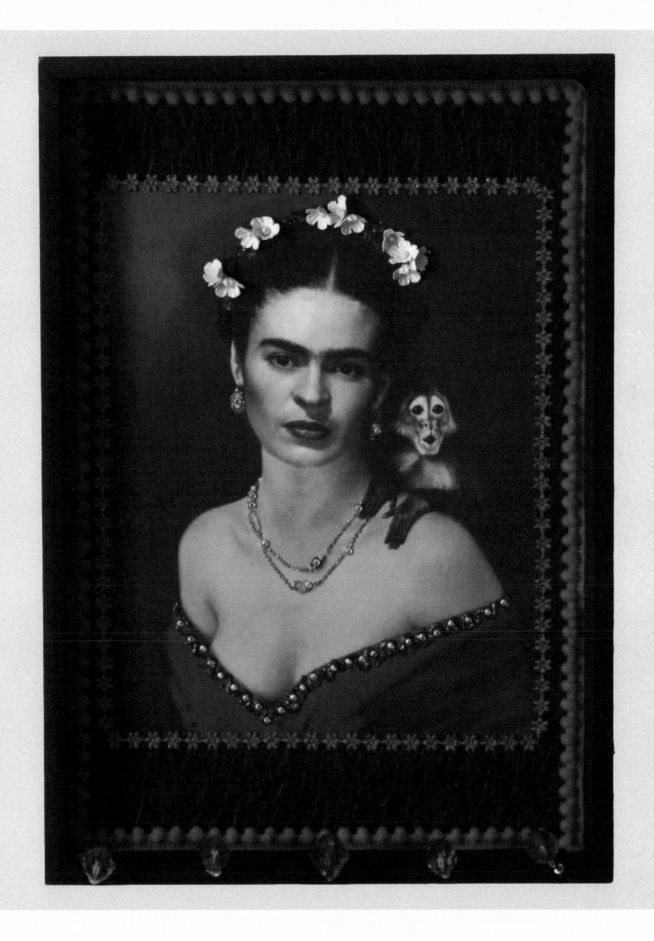

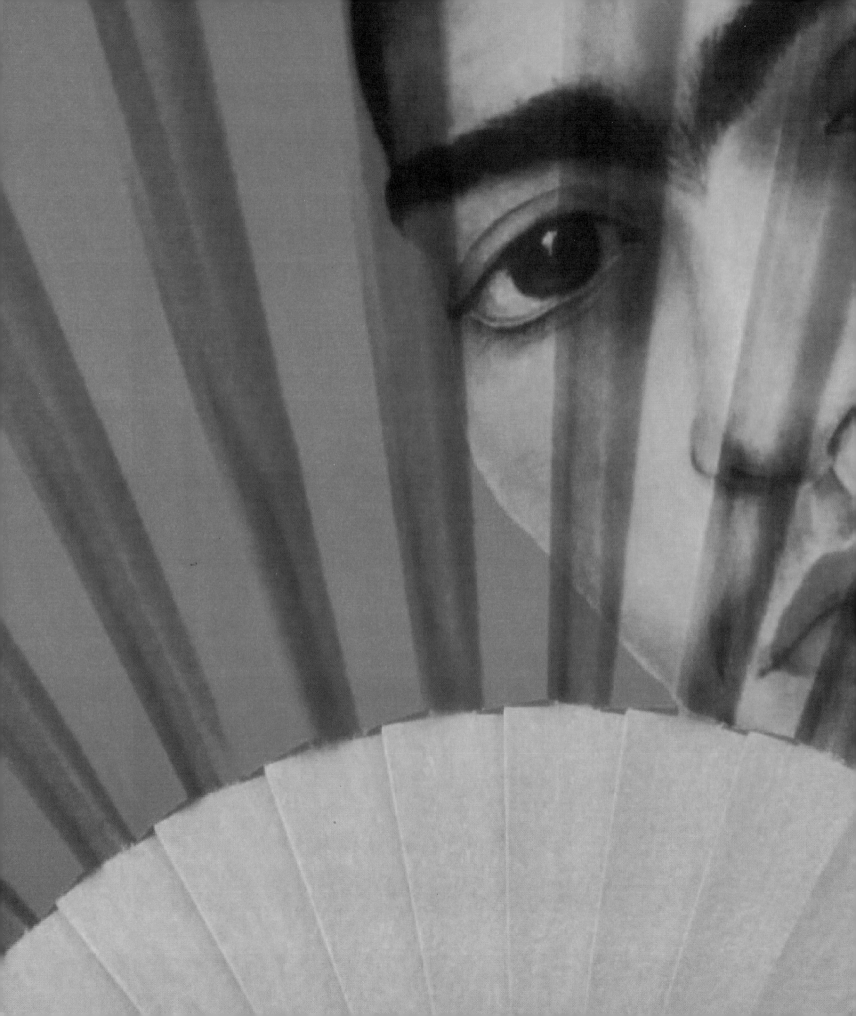

Creating
an Icon

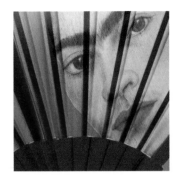

Did you see Vogue? *There are three reproductions,*
one in color—the one that seems swellest to me.
—Frida Kahlo, Letter to Gómez Arias [40]

WHEN FRIDA KAHLO, the newly wed young bride of the celebrated Diego Rivera accompanied him to the United States for the first time, she was mainly seen as an attractive, exotic Mexican—part of the set-up, as the *Brooklyn Daily Eagle* reported in 1930:

"Frida, Diego's beautiful young wife, is a part of the picture. She wears the native costume, a tight-bodied, full-skirted muslin dress, the classic rebozo [41] draped about her shoulders and a massive string of Aztec beads about her slender brown throat. She, too, is an artist and has her studio next [to] her husband's. She has a charming naïve talent and is only another example of the spontaneous artistic expression inherent in the Mexican temperament." [42]

Frida, for her part, revelled in the attention that her exotic dress and appearance invariably created. In a letter to her mother in 1930, she says: "The *gringas* [White American women—editor] really like me a lot and take notice of all the dresses and rebozos that I brought with me, their jaws drop at the sight of my jade necklaces and all the painters want me to pose for them." [43] This distinctive look was something that she cultivated carefully over the years.

The famous photographer Edward Weston celebrated her appearance as the embodiment of 'The Mexican Woman':

"[...] petite, a little doll alongside Diego, but a doll in size only, for she is strong and quite beautiful, shows very little of her father's German blood. Dressed in native costume even to *huaraches* [Mexican footwear—editor], she causes much excitement on the streets of San Francisco. People stop in their tracks to look, in wonder." [44]

But was Frida's purpose in carefully choosing her clothes and accessories just to get attention? How and why she presented herself in a certain way to express her identity was much more complex. Frida chose the clothes of the Tehuana women, which she combined with clothing from other regions such as Guatemala, along with Spanish cotton or French silk. This was not just because it was the most vivid picturesque attire, or even the most authentic pre-Spanish attire. Tehuana women personified a powerful matriarchal culture, and in post-revolutionary Mexico, were considered as the true embodiment of strong pre-colonial Mexican women.

From as early as the beginning of the 1920s, Diego Rivera made numerous sketches of the women of Tehuantepec. In the late 1920s, the revolutionary photographer Tina Modotti created a series of photos of them. [45]

Frida's choices can be seen as a simultaneous affirmation of the position of women, as well as that of indigenous pre-colonial culture:

"In a culture where sexual metaphors are frequently used to convey racial and political conflict, the Tehuana represents that aspect of Mexico's indigenous tradition unbowed by centuries of colonial and male rule. Kahlo's adoption of Tehuana dress, while being an attractive disguise of what she saw as a less than perfect body, asserted both a feminist and an anti-colonialist position."[46]

But it meant much more: whether she was dining with Rockefeller in New York or demonstrating in Mexico City, Frida stood for the power of Mexican village women. In the process, she collapsed the dress codes which distinguished social classes, for the fact that she dressed like an indigenous woman made her suspect—since the upper classes did not mingle with "the Indios". Dressing as she did in those clothes to attend a reception at the embassy, for instance, could well be seen as a provocation.[47]

And as much as Frida enjoyed being personified as the exotic Mexican who instigated demonstrations, she also expressed this side of herself as an artist in her work. 'My Dress Hangs There'—her 1933 oil painting in the form of a collage—could be interpreted as the "intelligent revenge of surrealism against the disgrace of civilisation".[48] The painting shows Frida's Tehuana dress hanging on a coat hanger from a washing line, between a toilet bowl and a mythic pillar—right under the skyscrapers of New York City. Elements in the background—like a Mae West poster, the Statue of Liberty, newspaper cut-outs and quotes from Marcel Duchamp to Agit Pop—add to this, illustrating the class struggle. Is this an interpretation of the metropolis from the perspective of a traditional migrant from rural Mexico? Does it reflect American capitalism and its implications for people? The dress becomes a political statement.

Subversive politics were certainly part of Frida's dress codes, but adorning herself played another important role in Frida's life: it was a powerful antidote to feeling low, and during periods of intense suffering, she would bedeck herself even more.

And of course there were simpler and more straightforward impulses as well. Frida was always fond of dressing up, and adept at choosing clothes which highlighted her advantages and played down her physical shortcomings. She spent a great deal of time and effort in putting together her eclectic mix of clothes, jewellery and accessories, which she acquired from places as varied as New York's Chinatown and street vendors in Mexico.[49] She also went directly to weavers and embroiderers living in the provinces, to look for fabrics.[50]

"From the bright, fuzzy, woolen strings that she plaits into her black hair and the color she puts into her cheeks and lips, to her heavy antique Mexican necklaces and her gaily colored Tehuana blouses and skirts, Madame Rivera seems herself a product of her art, and, like all her work, one that is instinctively and calculatingly well composed. It is also expressive—expressive of a gay, passionate, witty, and tender personality."[51]

Frida elevated the act of dressing up into a statement and an art. Julien Levy, the New York gallerist who exhibited Frida's work in 1938, described her clothing as though she herself were part of the performance:

"She used to do her hair with things in it. When she unbraided it, she'd put these things in a certain order on her dressing table and then braid them back in. The hair preparation was a fantastic liturgy. I wrote a poem to her about it, and sent her a Joseph Cornell box. I gave Cornell a lock of Frida's hair, my poem, and a photograph of Frida, and he put together a box with blue glass and mirrors in the presence of Frida."[52]

As far as the fashion world was concerned, it was her distinctive style which was exciting—at least as interesting as her art. This was evident at Frida's exhibition at the Galerie Pierre Colle in Paris in 1939, in which her work was shown together with the legendary Mexican photographer Manuel Álvarez Bravo—Mexican folk art was part of the exhibit. The show triggered unforeseen excitement in the fashion world, and the chic fashion designer Elsa Schiaparelli then went on to create the so-called *La Robe Madame Rivera*.[53]

With it began a fashion craze featuring extravagant and effusive creations that quoted or reconstructed Frida. The trend went up and down, over the decades, but was given an unexpected new impetus in 2004: Frida's bathroom was opened during that year, and led to the discovery of innumerable garments, documents, medicines, corsets and crutches.

The fashion industry was enthralled, and began to come up with all kinds of extravaganzas: Frida's sneakers with varying high heels led to a collection of basketball shoes[54], her corsets energised the production of extremely expensive underwear[55], and evening gowns began to feature bodices.[56] With huge profit margins, this high end fashion production was unfortunately less about echoing Frida's ethics or vision, and more about cashing in on a strong style icon.

Yet even the extravagant exalted creations that quote or reconstruct Frida show a deep fascination for their ability "to transform their insecurity and weakness into a fashion tool, proving that how much one wears something is more important than what one wears."[57] And Frida's presentation of herself included many aspects: politics, performance, ritual, and self-expression. But—because of the depth of her engagement with the world around her—it was far from being mere narcissism.

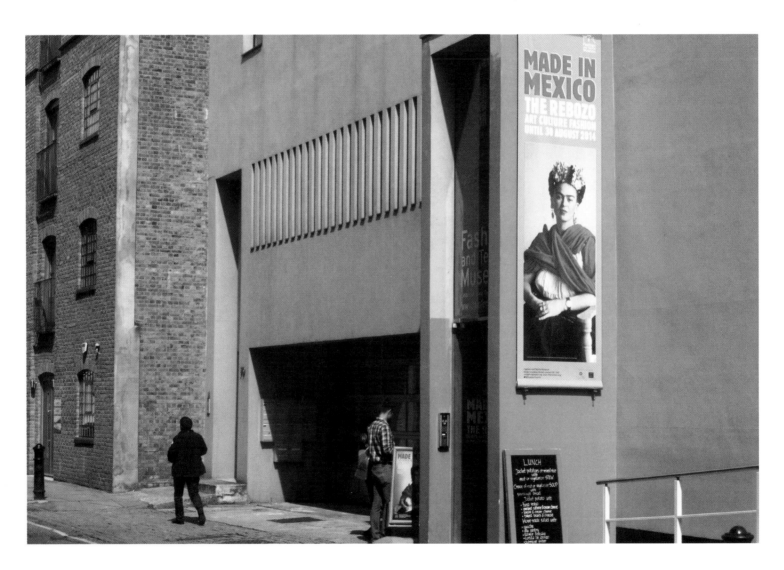

▲ "Made in Mexico" exhibition dedicated to the rebozo, at the Museum of Art and Fashion, London, UK, 2014
Photo: Rainer Huhle

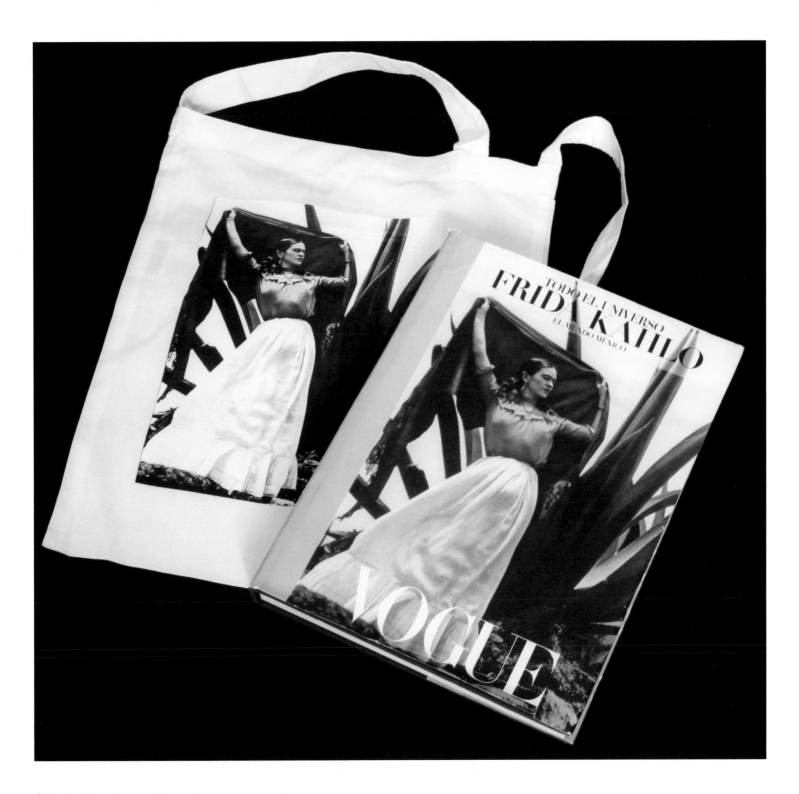

▲ In the *Vogue* issue of November 1937, Frida was portrayed as the embodiment of the exotic Mexican by the photographer Toni Frissell.

Cloth bag printed with the *Vogue* image, found in Nürnberg, Germany and featured in the catalogue "The Entire Universe. Frida Kahlo. The World of Mexico", *Vogue*, Mexico City, 2013

Frida
Popular Fashion

Apart from haute couture, Frida's persona gave rise to fashion trends which had several facets: from a political statement, adapted by feminists, to variations on ethnic-fashion. These again range from poignant hand-knitted socks, to contemporary riffs on traditional folklore, or just cheerful colourful clothes. Pop clothes and accessories tend to directly use iconic images of Frida. But they all point to a Frida who created her own clothing style from the variety of regional costumes she valued.

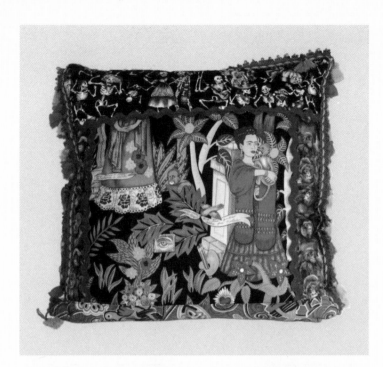

◀ Cotton cushion cover, printed with *Frida with Monkeys in the Jungle*, surrounded by skulls.
Found in Schwäbisch Hall, Germany, 2012

▼ **BELOW LEFT:**
Wallets
Spotted at Diseño Nuevo, Mexico City, 2016

▼ **BELOW RIGHT:**
Stockings
Found in San Telmo, Buenos Aires, 2015

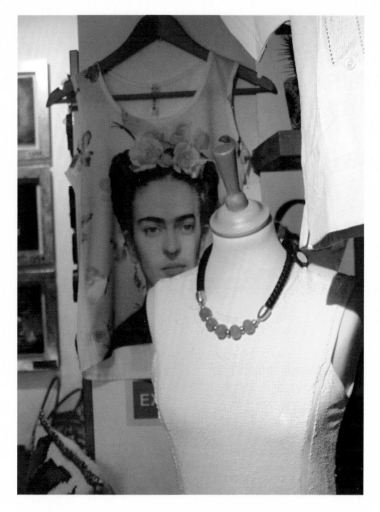

FACING PAGE:

◀ ABOVE LEFT:
Frida pop-art bracelet
Spotted in Boston, USA, 2011

◀ MIDDLE:
Frida watch and
mobile phone case
Spotted at Casa Azul,
Mexico City, year unknown
Photo: Carolina Sandretto

◀ ABOVE RIGHT:
Frida's dress flickering in the
wind on the wall of the Moixa
boutique in London
Found in 2014
Photo: Rainer Huhle

◀ BELOW:
Cloth, skirts, aprons,
notebooks and tortilla covers
with Frida motifs
Found in Mexico City, Buenos
Aires and Berlin, over the years

▲ T-shirt
Found in Sevilla,
Spain, 2014

◀ Frida tattoo
Spotted in Barcelona, 2016
Photo: Gita Wolf

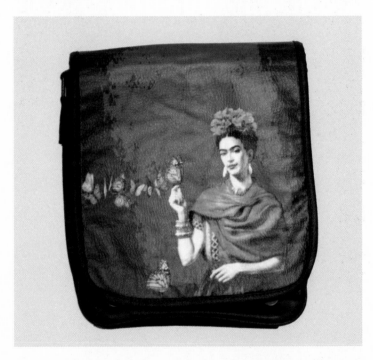

▲ ABOVE LEFT:
Frida stockings knitted in 2015 by Beate Weigle, following instructions in the magazine *Verena* ("80 Socks Around the World")

▲ ABOVE RIGHT:
Fan made of fabric with a cut-out from Frida's 'Self-portrait with a Necklace' (1933)

Found in Schwäbisch Hall, Germany, 2012

▲ BELOW LEFT:
Gloves

Found in Santiago de Chile, 2010

▲ BELOW RIGHT:
Purse made of fake leather

Found in Istanbul, Turkey, 2016

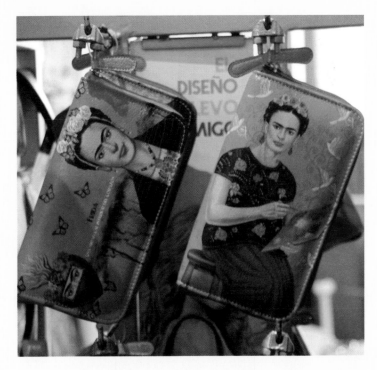

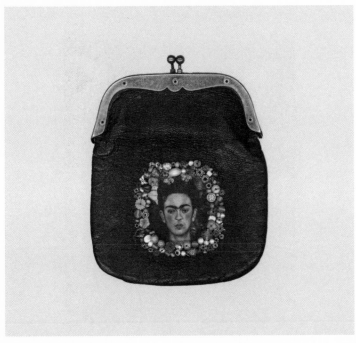

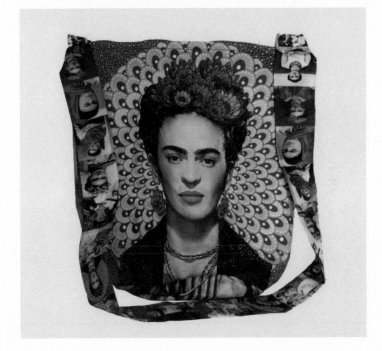

▲ **ABOVE LEFT:**
Earrings
Found in Mexico, Colombia,
and the USA, 2009-2015

▲ **ABOVE RIGHT:**
Wallets
Spotted at Diseño Nuevo,
Mexico City, 2016

▲ **BELOW LEFT:**
Vintage clutch from the 1930s,
made out of leather with appliqued
photo of Frida, and old and new
pearls and buttons from Germany,
Czech Republic, Africa and Asia;
created by Katharina Sturm
(El-Frieda Unique Copies)
Found in Schwäbisch Hall,
Germany, 2012

▲ **BELOW RIGHT:**
Printed shoulder bag
Found in Bogotá,
Colombia, 2017

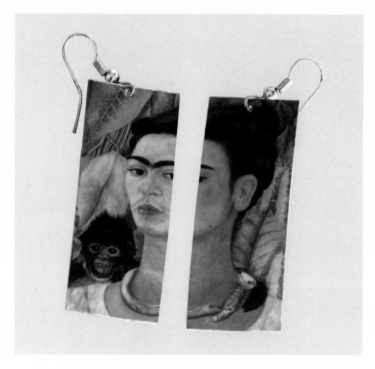

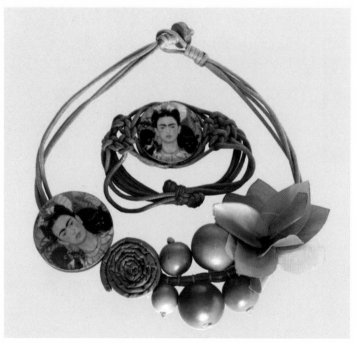

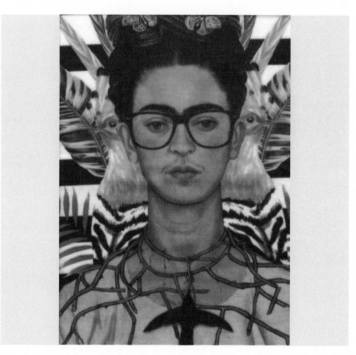

▲ **ABOVE LEFT:**
Brooch from Cuca Joyería
Found in Barcelona, 2008

▲ **ABOVE RIGHT:**
Earrings
Found in Bogotá,
Colombia, 2017

▲ **BELOW LEFT:**
Jewellery
Found in Santiago
de Chile, 2016

▲ **BELOW RIGHT:**
Frida Postmodern: thorn necklace,
three hummingbirds and glasses
Print on a T-Shirt
Found in Mexico City, 2016

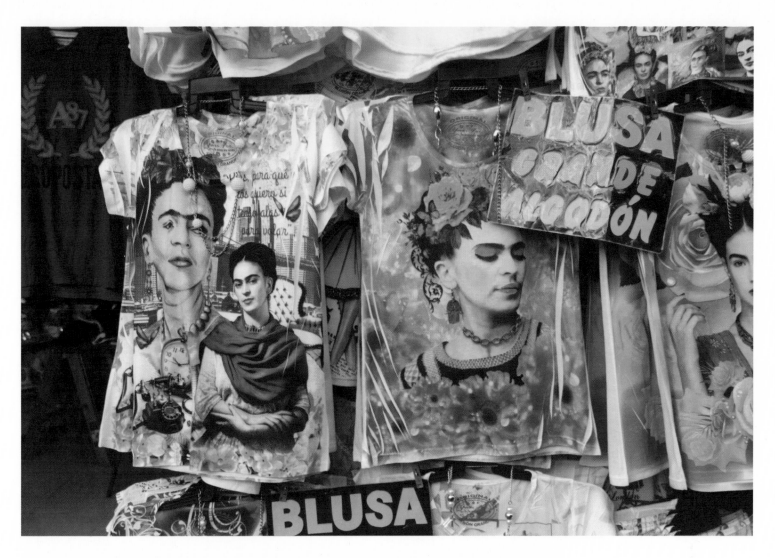

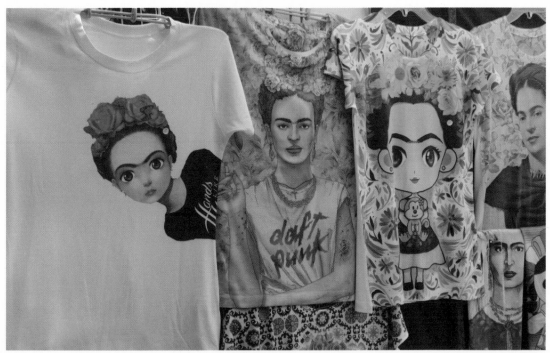

▲ T-Shirts in a street market
Found in Mexico City, 2016

Girl Power

Frida's image, in all the ways that it appears, is
iconic because has great symbolic value: it stands
for a strong and resilient woman, who made a
mark on the world. Women everywhere see her as
an inspiration, but her attraction is particularly
strong for young women, as a role model who is
rebellious, stylish and confident.

◀ Frida amulet, bought by Daniela, 11-years old: "I bought the amulet because I think Frida really conquered all her problems with a lot of strength".

Met Daniela in Boston, 2011

▼ **BELOW LEFT:**
When young Agostina had to stay in bed after an accident, her grandmother Federica told her Frida's story. Agostina and her little sister Coco were inspired to take up painting.

Frida doll for sick girls (24 cm)

Found in Montevideo, Uruguay, 2017

▼ *My Room*: this is a drawing from the virtual Girl Museum, and a tentative answer to the question "What does it mean to be a modern girl?". Based on the rooms of five employees it represents the museum's basic concept. As a strong woman and artist, Frida is a part of this room for girls, always providing inspiration.

Project from 2015

Photo: Girl Museum

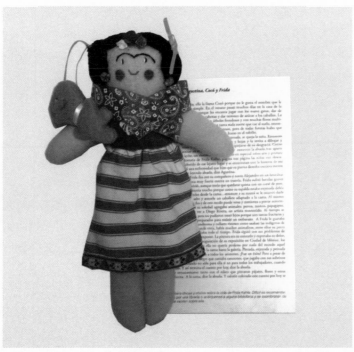

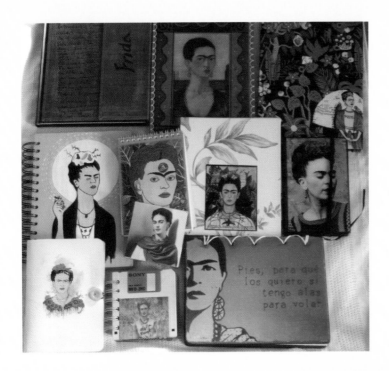

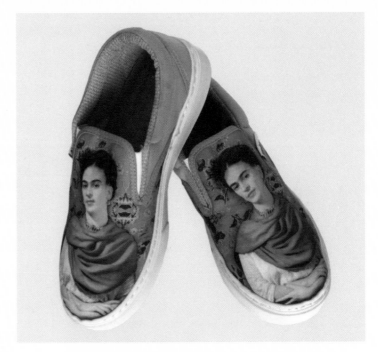

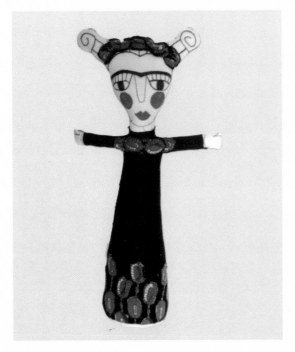

▲ ABOVE LEFT:
Exercise books, notebooks, photo albums and different envelopes made of fabric, cardboard, wood, plastic or old floppy disks
Found in Buenos Aires, Berlin, Bogotá, Mexico City, Istanbul, Santiago de Chile, 2011–2017

▲ BELOW LEFT:
Painted and appliqued rag doll (33 cm) by Anhusca
Found in La Colonia, Uruguay, 2016

▲ ABOVE RIGHT:
Sneakers for girls
Found in Mexico City, 2016

▲ BELOW RIGHT:
Notebooks with Frida motifs on wooden binder, with customised Frida quotes
Found in Coyoacán, Mexico City, 2017

▶ FACING PAGE, BOTH IMAGES:
Myth Frida Kahlo and the re-staged *Myth Frida Kahlo*

The German-Mexican Scholarship programme "Frida Kahlo" by the German Academic Exchange Service (DAAD) and the Mexican Foreign Ministry supports and awards upcoming young artists— where Frida is featured as a patron for these artists.

These two pieces are by the 2014 awardee Corinna von der Groeben.

Photos: Corinna von der Groeben

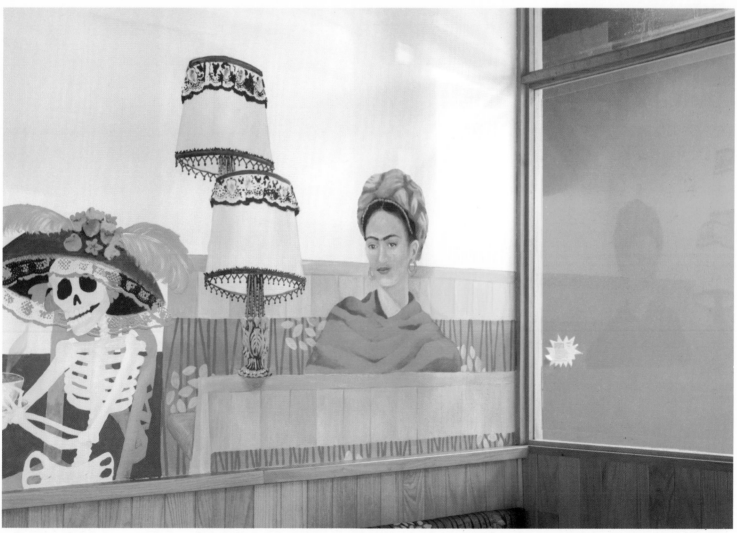

Frida Teen
by Cristina Kahlo

The identification with Frida Kahlo is related to the rebellious tendencies of adolescence, a rebellion which refuses to give in to mediocrity, a rebellion which forms our identity.
—*Cristina Kahlo*

I FIRST ENCOUNTERED FRIDA KAHLO'S WORK when I was a little girl, just eight years old. We'd just moved into a house in Coyoacán, which had an amazing library, and windows opening out into the garden. Among the many books lined up on the shelves was a copy of *Cinco pintores mexicanos* (*Five Mexican Painters*) by Raúl Flores Guerrero. This book, published in 1957 by the Universidad Nacional Autónoma de México, contained reproductions of works by Guillermo Meza, Juan O'Gorman, Julio Castellanos, Jesús Reyes Ferreira and—of course—Frida Kahlo. I don't remember why, but the book made me really curious and I took it down right away. I started leafing through it, very carefully and with great respect for the book, in the way we'd been taught.

I already knew at that time that Frida Kahlo was one of my grandmother Cristina's sisters, and my father's aunts had told us delectable stories about the famous aunt Frida.

Browsing through the book, I came across a colour reproduction of 'La columna rota' ('The Broken Column') which Frida Kahlo painted in 1944. I remember feeling a little ashamed about the picture, which showed my father's aunt stripped to the waist. Through her open body, pierced by nails that looked like tiny arrows which were wounding her arms, you could see her spine, broken in many pieces. Tears ran down her cheeks in this wonderful self-portrait.

I remember closing the book thinking I had seen something really terrible. It made me sad to think how much someone must have suffered, to paint something like this.

This was a very different image of Frida Kahlo from the one I always got from my father, Antonio. It was the discovery of the tragic parts of a person's life, someone who was part of our family, someone my father used to recall with such affection.

There were other images in black and white: 'My Nurse and I', 'Portrait of my Father', 'The Little Deer', 'The Two Fridas', 'Thinking About Death' and 'Tree of Hope'. These works filled my childish self with a mixture of fascination and aversion. Over time, I learned more about Frida Kahlo's life and understood the source of the symbolism which is at the heart of her work. It was as a teenager that I realised how her paintings reflected her inner self—they offer us a mirror to look into, through which she shares her story with us. A story which—through vicarious sharing—makes us accomplices and confidants. Today, it is hard to keep track of all the group and solo exhibitions around the world which feature the work of this Mexican artist.

In some museums, Frida exhibitions have managed to attract more visitors than any other previous show, one example being the anniversary exhibition of Palace of Fine Arts (Palacio de las Bellas Artes) in Mexico City in 2007.

The American city of Philadelphia even changed its name to "Frida-delfia" for the duration of a Frida Kahlo show at the Philadelphia Museum of Art.

It is equally impossible to keep track of every publication, catalogue, film, play or folk art object which is inspired by her life, work and public image. What used to be called "Fridomanía" during the 80s has now been re-labelled "Fridolatría", a term which describes the fascination with which the Mexican artist is idolised around the world.

I was recently invited to a conference in Edinburg, Texas, which revolves around the life and work of Frida Kahlo. The conference was within the framework of a festival called *Fridafest*. This festival celebrating the artist is hosted by the Dustin M. Sekula Memorial Library and is part of the Edinburg Arts programme organised by Leticia S. Lejia and Magdiel Alfonso. The two-day festival has been held consecutively in the last three years in this town located close to the Mexican border, and it has become immensely popular. You can find lectures, music, Mexican food, and stalls selling handicrafts, but the main attraction is a Frida look-alike contest. It is split into two categories: in the morning, girls compete for the best characterisation of Frida Kahlo, and in the afternoon, young women vie for the best impersonation.

Women of all ages interpret Frida's personality in different, and very creative, ways. People walk about with colourful flower wreaths they can buy on the street. Some men even accompany their women dressed up as Diego Rivera. All these interpretations and appropriations have one thing in common: eyebrows that are joined together. What's also remarkable is that young women seem to be the most fascinated by the artist.

So I found myself facing an unavoidable question: what makes a woman whose short life was so full of endless pain and physical suffering so attractive to adolescents?

In July 2015, I curated an exhibition called "Ecos de Tinta y Papel" at the Museum Casa Estudio Diego Rivera and Frida Kahlo. The exhibition featured letters Frida wrote to her family and friends, but also photographs which illustrated her period and proclivities as an artist. Not surprisingly, she once again broke all visitor records at the museum in the San Angel district of Mexico City.

I met a young visitor who caught my eye not only because of her pretty appearance and her elegant braids, but also because of the attentive way she was looking at the pictures. Layla (that was her name) told me that because of her, her family had visited Casa Azul, Casa Estudio in San Angel, and every other place that had somehow played a role in the life of the person Layla admired most: Frida Kahlo.

From the photographs that the family sent me later on, I could tell that Layla's room was a veritable shrine to her idol Frida. Bedsheets, cushions, shower curtains and other objects in her room were all decorated with pictures of the artist and her work. Frida Kahlo's iconic image is the first thing Layla sees when she wakes up in the morning and the last thing she sees before she goes to sleep.

To this young friend who appeared to be the most ardent fan of Frida Kahlo that I had met so far, I passed on the question that had been on my mind since Edinburg: what is it that makes Frida so special to you? This is what she replied in her email:

"[...]Frida Kahlo is my biggest role model who isn´t related to me. I admire her self-confidence, her lack of self-pity, her difference and of course her style. She was different. Frida was different and she was different without really even trying. I imagine that there was a point where she realized that she was different, I mean she was the woman Diego Rivera stayed with the longest, she did her hair differently, she wore different clothes, she didn´t have exactly normal house-pets. Most people don't keep birds, deer, hairless dogs, peacocks and monkeys in their house or even a house large enough for them to roam around. Oh, and her house was royal blue. Not exactly the most subtle color. She was confident and she had style. To me confidence is what makes women beautiful. As an artist, I love how in her work there are so many symbols that one would not see at a glance. I could stand in front of a painting for an hour and see new things every minute [...]."

I came to the conclusion that Frida Kahlo is not only appreciated as an artist, but also as a woman—and her paintings undoubtedly reflect a truthful image of herself as a woman. This fascinates older women and young women alike, since they can identify with some part of Frida's life story, be it positive or negative. But her pull is strongest

for young women, because they are only just beginning to understand what an adventure life is.

This identification with Frida Kahlo is related to the rebellious tendencies of adolescence, a rebellion which refuses to give in to mediocrity, a rebellion which forms our identity regardless of who remains with us—as in the case of Frida Kahlo and Diego Rivera—and which insists on its own identity. People identify with her not only because she was 'different' in her youth but because she stayed true to her ideals, throughout her life, despite her physical constitution, and in a way that was visible to everyone. One part of Frida Kahlo's appeal is her cheerfulness which found expression in her very characteristic sense of fashion. This cheerfulness inspires admiration. No matter how tragic her life was, there was always some reason to exclaim: "long live life!"

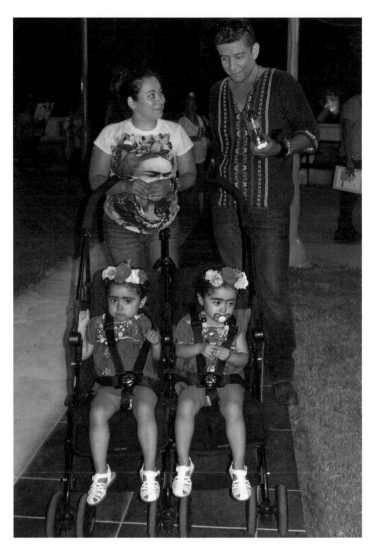

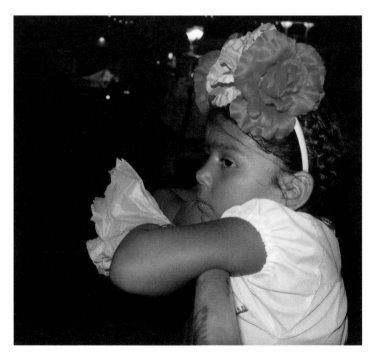

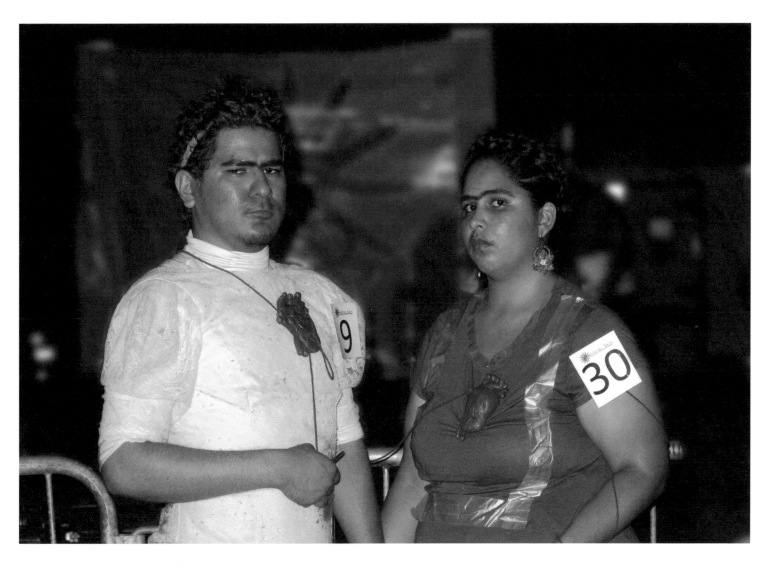

FACING PAGE:

◀ ABOVE:
"The two Fridas" in the pram
Fridafest, Edinburg, Texas, 2016
Photo: Cristina Kahlo

◀ BELOW LEFT:
Fridafest, Edinburg, Texas, 2016
Photo: Cristina Kahlo

◀ BELOW RIGHT:
Fridafest, Edinburg, Texas, 2016
Photo: Cristina Kahlo

▲ Fridafest, Edinburg,
Texas, 2016
Photo: Cristina Kahlo

◀ Layla Felder
(young actor and opera buff)
Photo: Cristina Kahlo

▶ The winner of the Frida look-alike competition in the "Girls" category.

Fridafest, Edinburg, Texas, 2016

Photo: Cristina Kahlo

◀ The winner of the Frida look-alike competition in the "Young Adults" category.
Fridafest, Edinburg, Texas, 2016
Photo: Cristina Kahlo

Chicano
Pride

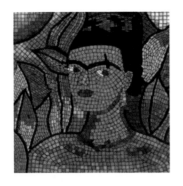

Frida embodies in herself the definition of real culture for Chicano women. She encouraged us. There is no self pity in her art works, only strength.
—Amalia Mesa-Bains, 1978 [58]

IN THE POLITICAL AND AESTHETIC movement of the *Chicanos* in the 1960s and 70s, Frida became an embodiment of rebellion and freedom—a symbol to identify with. Chicano is the original discriminatory term for Mexican citizens living in the USA since the 20th century. The second and third generation of migrants from Mexico—demonstrating their connection to worldwide movements against imperialism and racism—then re-evaluated the term, to signify pride in Mexican culture, its values and strengths. [59]

The Chicano movement for civil rights was not only about political and social claims, but also about resisting dominant social norms and stereotypes. The search was for new forms of cultural autonomy and self-determination, for a consciousness determined to look beyond one's own immediate history and culture. The movement was inspired by the post-revolutionary phase of Mexican art of the 1920s and 30s, by pre-Columbian heritage, by "third-world" identities, and by pan-Latin-Americanism.

This movement thus found its expression through Frida, but was equally associated with cult figures like Emilio Zapata, the hero of the Mexican revolution, Che Guevara, Guerillero and charismatic leader of the revolution in Cuba; as also with Angela Davis, the Black activist, who was an iconic figure of the civil rights movement and the fight for the rights of political prisoners.

Frida was lined up next to these freedom fighters and stood for everything that cultural pride meant. For the women of the Chicano movement, she also represented the search for alternatives against the stereotypical social norms they saw themselves saddled with. Frida validated many of these *Chicanas* with her life and her art:

"The entire feminist movement was enchanted by Kahlo: but for Chicana artists she was a crucial role model, not only because her art was enormously interesting and extremely beautiful. Her entire life was fascinating as a lived work of art. Her brilliant colours, minute details, the plant forms in all their lush profusion, the fusion of pre-Columbian and modern forms... self-portraits as a form of expression began to appear in several works by Chicana artists." [60]

The Mexican minority in the USA sought also to strengthen its position by taking on the symbols of Mexican culture: historic personalities associated with the Mexican revolution, red tin and wooden love hearts, Mexican desert plants like Nogal and Agave—but most of all traditions like the *Day of the Dead*, with its *retablos* (votive offerings) and skulls. It was this traditional festival on November 2nd each year, which became the hub of the new spirit.

An important impetus for this arrived during the beginning of the 1970s, when a gallery called La Raza in California decided to celebrate the family festival of Day

of the Dead with ofrendas along with an exhibition, to enable Mexicans living in the USA to understand Mexican traditions. A new Chicano community rite was invented: family traditions were turned into public events—with altars, art installations, music parades, and costume floats dedicated to people in public life.

At the La Raza gallery in 1976, the Chicana artist Mesa-Bains paid homage to the five most important women in her life: Mariana and Amalia—her two grandmothers, her aunt Angelina, Susan—her best friend from college... and Frida Kahlo.

In 1978, the exhibition for the Day of the Dead was curated and designed entirely by women,and dedicated solely to Frida Kahlo. [61]

Frida was not just honoured at this exhibition, she was viewed and experienced:

"The opening was an evening of rare intensity, defined by respect. People who knew and worked with Frida wore the necklaces she gave them... and those who studied her paintings—and felt connected to her—wore paint brushes as earrings, just like Frida had." [62]

So the myth of Frida the revolutionary, standing by an oppressed nation, recreates itself over and over. She continues to live into the present, on the side of anti-imperialistic movements, on every continent.

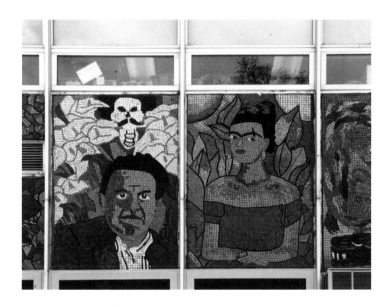

▲ A mosaic of Diego and Frida; potent symbols of Latin-American identity
Spotted at the Cooper School for Bilingual Education, Chicago, 2006

▶ Niche
A niche is a traditional tin shrine, which holds a holy picture or a national hero and is meant to bless the house. This shrine features an image of Frida's self-portrait—the one she dedicated to Leon Trotsky. On the left and right sides are two skeletons, one of whom is a guitar player and the other, Frida herself.
Tin shrine (31x38 cm) by José Antonio, Studio Cielito Lindo
Found in Mexico City, 2011

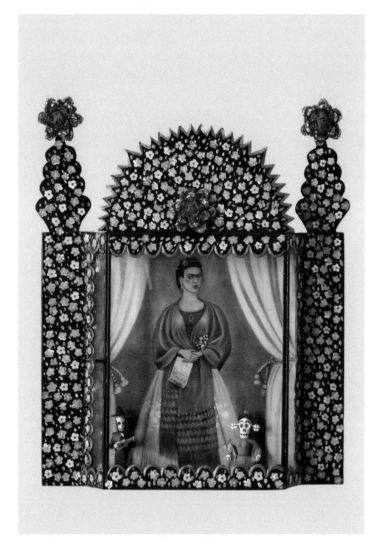

Frida the Revolutionary

Frida's image is a powerful symbol of rebellion in the popular imagination, especially when it is associated with other revolutionary figures who struggled for human rights in various contexts.

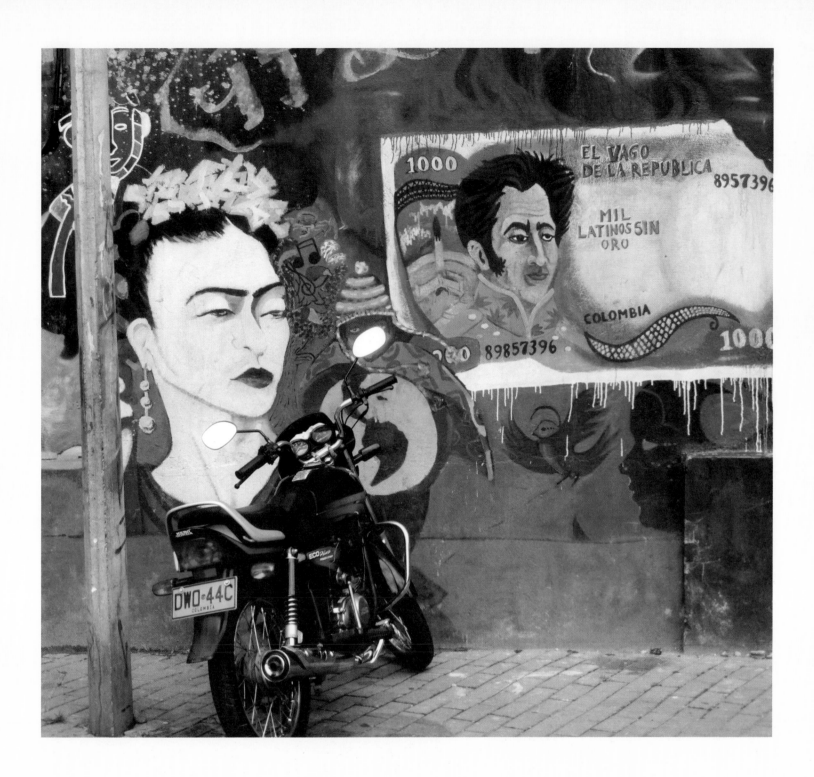

▲ A mural of Frida in
remembrance of the victims of
violence in Colombia

Spotted in Medellin, Colombia, 2014
Photo: Rainer Huhle

◀ The legends: Frida and Emiliano Zapata, the hero of the Mexican revolution

Seen at the market in San Angel, Mexico City, 2013

Photo: Rainer Huhle

▼ The Brigada Cultural Frida Kahlo, an association of young Uruguayans is painting a wall in the "Museum of Memories", in remembrance of the crimes of the Uruguayan dictatorship.

Spotted in Montevideo, Uruguay, 2017

Photo: Santiago Alegre

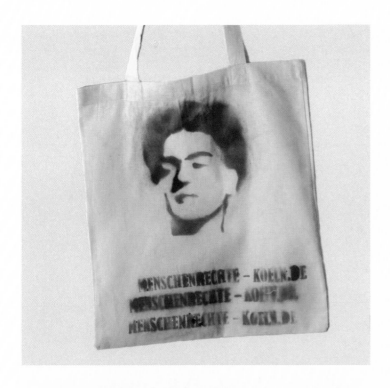

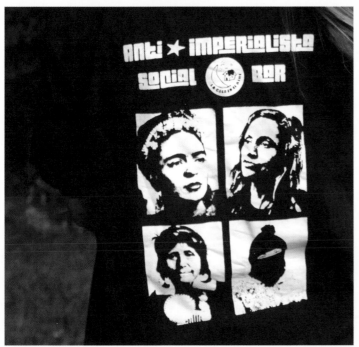

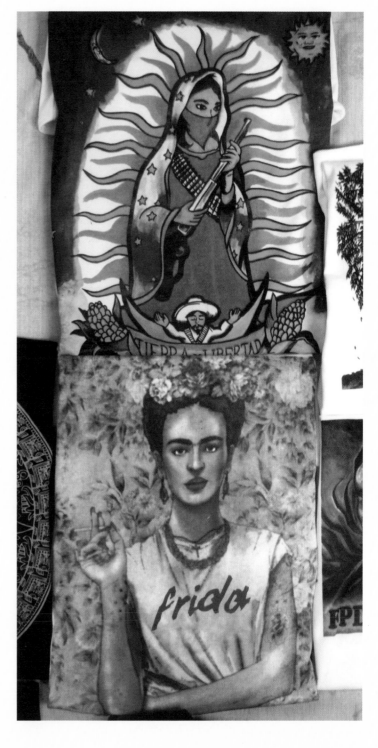

▲ **ABOVE:**
Frida on printed cloth bags

Found at the First Cologne Human Rights Festival, Germany, 2013

▲ **BELOW:**
Revolutionary women on a T-Shirt

Along with Frida are Violeta Parra, a Chilean musician and activist; an indigenous Mapuche woman from Chile; and a Zapatista woman, part of an anti-globalisation group struggling for democracy and land reform in Chiapas, Mexico. The T-shirt promotes La Casa en el Aire, an anti-imperialist social space in Santiago de Chile.

Found in Santiago de Chile, 2013

▲ **T-Shirts spotted in Mexico City: Punk Frida and the Virgin of Guadalupe who is incarnated here as a Zapatista (also seen is the figure of Emiliano Zapata in front of Guadalupe).**

Found at a roadside stall during a demonstration in Mexico City, 2016

Photo: Rainer Huhle

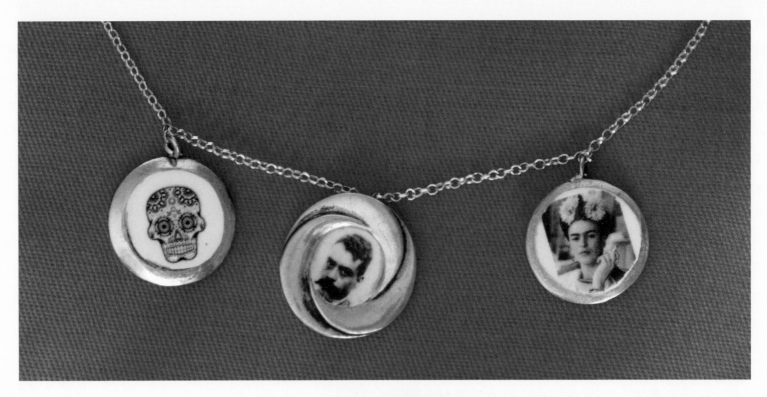

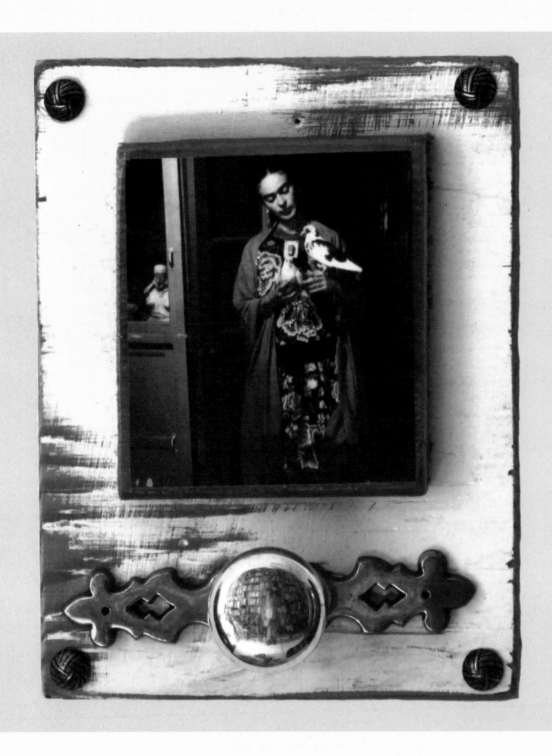

◄ **ABOVE:**
Silver necklace with
medallions showing Frida,
Emiliano Zapata and a skull.
Found in London, 2014

◄ **BELOW:**
The Frida Kahlo House of Art, a traditional Mexican
adobe-style building made with clay, bamboo
and straw, was planned and built as a collective
endeavour by the Brazilian Movement of Landless
Rural Workers and is part of their Floristan
Fernandes National School for political education.
Spotted near São Paulo, Brazil, 2016
Photo: Moritz Krawinkel

▲ Frida with the dove of peace
Image printed on recycled
wooden board with brass knob
Found in Tucson, USA, 2012

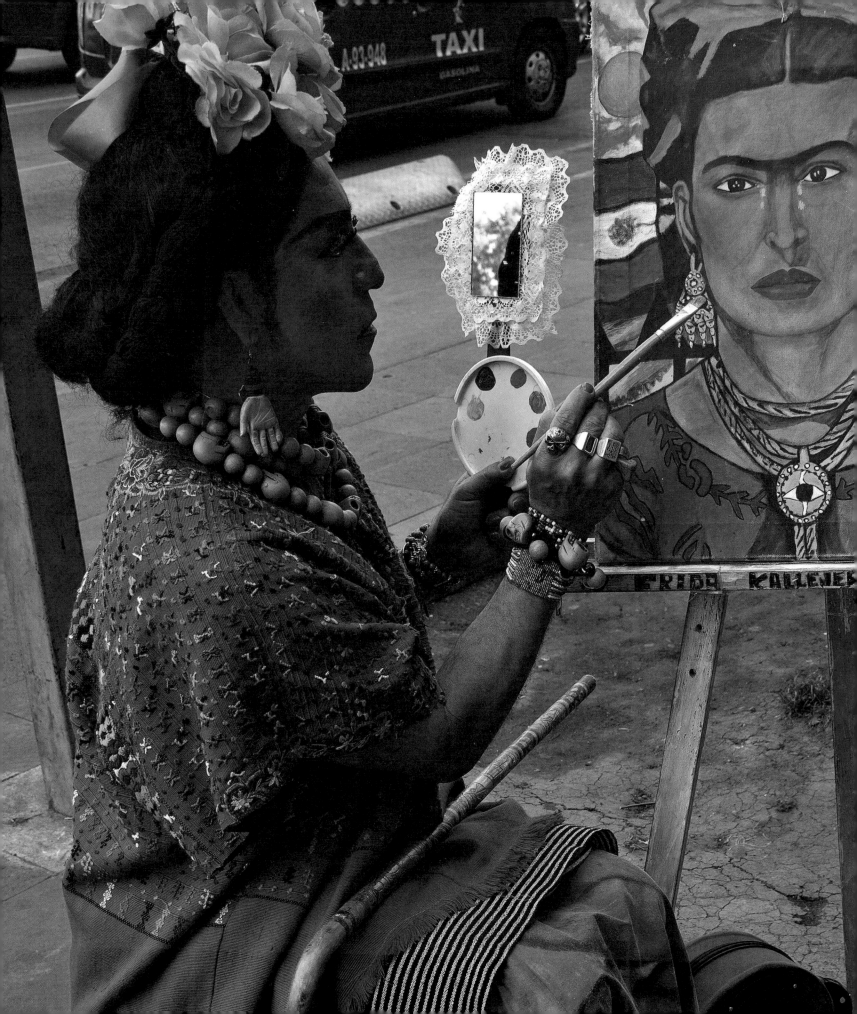

2

FRIDA IN CELEBRATION

The process of appropriating Frida Kahlo's work through the hands of the "people" is both interesting and gratifying at the same time. It seems as if her people want to pay her a kind of tribute. So it looks like the process has come full circle. The close connection between "high" art and folk art becomes circular.
—*Eli Bartra* [63]

The Legacy
of Folk Art

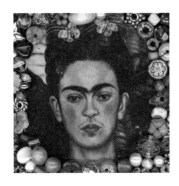

Among the painters listed as such in the superstructure of national art, the only one who is closely linked, without affectation or aesthetic prejudice, to that pure and popular production—in spite of herself, so to speak—is Frida Kahlo.
—Diego Rivera [64]

THE MEXICAN REVOLUTION and the post-revolutionary policy of creating a new national identity was accompanied by the "discovery" of folk art, by urban artists and intellectuals. From the beginning of the 1920s, this form of popular expression began to influence the development of "elite art" [65], practised by leading contemporary artists in Mexico. Folk art was collected, exhibited, and sold—the first major exhibition of what was called "Mexican Popular Art" took place in 1924 in Los Angeles.

Broadly, this art of the everyday was (and continues to be) created by members of indigenous cultures, peasants or other artisanal tradespeople. It is rooted in traditions from particular communities and cultures, expressing shared values and aesthetics. Folk or popular art tends to be functional or decorative, rather than purely aesthetic, and uses all kinds of material—including cloth, wood, paper, clay, and metal.

Folk art has always been—and still is in many circles—considered more craft than art, an inferior form that does not merit serious attention. Diego Rivera put this disdain down to the arrogance of the art establishment:

"The great sycophants of the arts and of art criticism talk of those works as Mexican curios, displaying with utmost clarity the dullness of their sensitivity, the falseness of their criteria, and the terror that a popular work, selling for almost nothing, is not only a threat to them, but to all vested interests and their speculators—vile rubbish and hostile to the art of the people. They are reluctant to give it at a higher rank than that of "curiosities" for tourist consumption, because if they admitted what was really there, they would have no clients, and their own production would have no purchasers, only garbage-men." [66]

For Diego, folk art was the "true art of Mexico". In his reflections on the work of Doña Carmen Caballero Sevilla—the creator of fantastic Judas figures (effigies of Judas Iscariot), made of papier-mâché—he basically speaks for all forms of popular artistic expression:

"The true art of Mexico is called "popular"; it is created by villagers for the people, without any additions or sophistication, and it goes far beyond what school and gallery painters attempt. If a well-known painter had done what Doña Carmen did, everyone including the critics would have sung halleluiahs... proves[...] all of Carmen's work is what the sophisticated artists would like to do, but don't succeed in doing. Anyone who sees these creations of Doña Carmen has to realize that the really astonishing thing—apart from the feeling caused by her sensitivity to form and color—is that of treating each example, one and the same subject—a skeleton, a death figure—absolutely differently, and the difference is nor forced or affected, but vital." [67]

Diego Rivera argues that folk forms—which are often produced in large numbers, and therefore regarded as craft souvenirs for tourists—can actually be very unique individual creations. The best of them show the skill and imagination of the creator in a manner which could be the envy of many fine artists.

He and Frida had a very special relationship with the folk arts of Mexico, considering them the essence of Mexican culture. They supported a number of folk artists, and were at the forefront of the promotion of these forms among urban intellectuals and artists, who began to conceive of them "as a fundamental element of the modern nation-state. Applauding the art of the people is...a necessary step toward unifying a radically diverse country." [68] Mexican folk art contains different worlds—the varied cultures on Mexican soil, as well as the cultures of Spain, with influences from China, Africa, and the Arab world mixed in.

Diego and Frida literally surrounded themselves with Mexican popular art. They lived with and within it, as Raquel Tibol—who was at Frida's bedside for the last time in the Blue House—describes:

"Everything in the house was Mexican with a spark of art—retablos, modeled or decorated sweets, reed grass and glued paper. Judases, toys from a fair, profusely decorated furniture made of pine and fir; skeletons made of plaster, tin, cardboard, sugar and China paper that the people use to scare off gloomy thoughts on the Day of the Dead; paper cutouts; peasant dresses embroidered with an infinite variety of fretwork; floral birds and designs; cushions on which both sentimental and picaresque expressions had been embroidered with threads of all colors; candelabras, thuribles, fans, small boxes, trunks, anonymous paintings, sleeping mats, scrapes, sandals, paper and wax flowers, headdresses, wooden tattles, piñatas, masks... everything was finding its place, acquiring the grace of necessary objects, never the heaviness of useless decoration. The familiarity of one next to the other gave them unexpected power. There the past and present were joined with emphatic naturalness." [69]

The walls of the Blue House are still packed with *Exvotos*, or votive offerings, referred to in Mexico as retablos. These small pictures on wooden or metal plaques chronicle accounts of miraculous healings, happy coincidences or the saving of a difficult situation—thanks to the divine omnipotence and mercy of the Virgin Mary. They are painted as offerings to her. But their charm lies equally in their ingenuous rendering of everyday life and events—the trials and tribulations of ordinary people—both real and other-worldly.[70]

Diego considered these retablos the most genuine pictorial expression of the Mexican nation, especially of the peasant majority. Because of the miracles, every facet of their lives had been depicted.[71]

It was this traditional votive picture form that Frida picked, to paint the deepest pain that she endured after her accident: the miscarriage she suffered on July 4, 1932. In a disturbing little picture called 'The Lost Desire', she shows herself lying on a bed at the Henry Ford Hospital. She gives her unhappiness incredibly large scope, with this small oil painting on metal, and makes her recovery in the hospital public. The painting was shown in her exhibition of 1938:

"[...] The creative characteristics of absolute sincerity and the completely direct expression in those retablos, among which are many masterworks, are the same in Frida's paintings. Therefore anyone who considers her work as most genuinely Mexican is undoubtedly correct." [72]

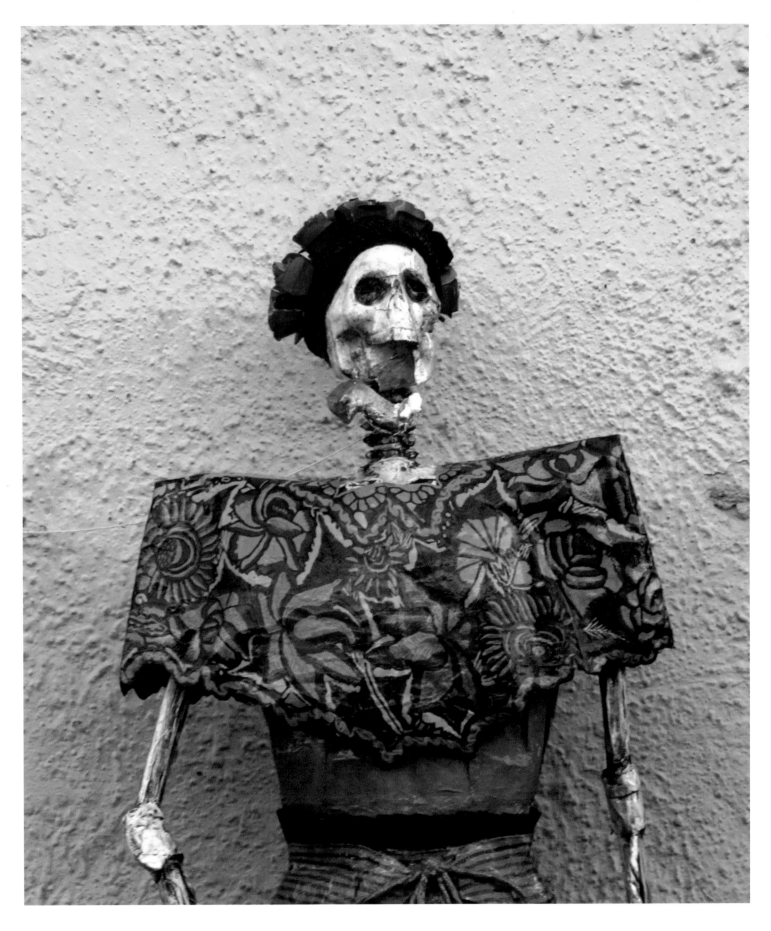

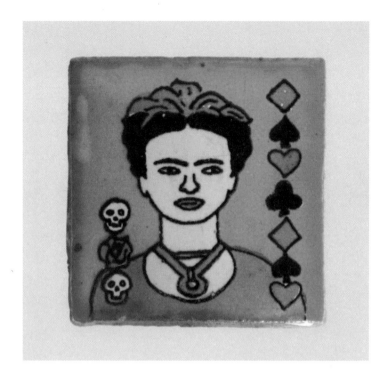

◀ **FACING PAGE:**
Frida Catrina (see page 86) in front of a clothing shop
Found in Tlaquepaque, Mexico, 2017

▶ **Creative interpretation of 'Self-portrait with Monkey'**
Ceramic tile (5x5 cm)
Found by Cristina Kahlo in Mexico City, 2017

▼ **A Frida Catrina pillowcase**
Seen in Tlaquepaque, Mexico, 2017
Photo: Rainer Huhle

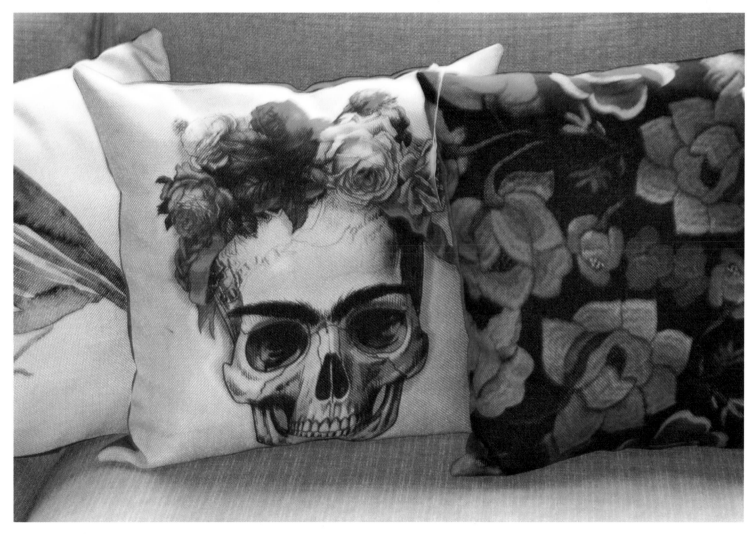

The Day
of the Dead

I hope the exit is joyful and I hope never to return.
—*Frida Kahlo* [73]

OF ALL THE POPULAR INCARNATIONS of Frida, one of the most interesting takes the form of an iconic object which is part of the well-known Mexican folk festival called the Day of the Dead.

Considered the most important festival of the year in almost all regions of Mexico, it falls on November 2nd every year. Souls from the world of the dead appear in the world of the living, to be welcomed and honoured. In the pre-Spanish world, death was regarded as the seed of life, giving it continuity and meaning, and it is this relationship between life and death which is behind the celebration of the Day of the Dead.

Travellers to Mexico as early as the 18th and 19th centuries have described this folk festival, which appeared to have involved candy in many forms—as lambs, small figures, and decorated skulls. Even today, sweets and special food are brought to graveyards, to be eaten 'with' and for the dead.[74] In homes and apartments, ofrendas are specially decorated to commemorate deceased family members and friends.

The various symbols of the cult of the dead—like skulls and skeletons—appear to have developed in the villages almost always in a clash with Catholicism. The spread of this cult—in association with its deadly symbols—also proved to be a source of inspiration to another group: artists and political satirists. In a political situation where the opposition was suppressed, skeletons—with all their cultural implications—became the carriers of satirical criticism in urban newspapers and leaflets. Artists began to use such symbols from as early as the 19th century, but it was in 1910 that a full blown satirical figure emerged. In that year, the lithographer José Guadalupe Posada created the figure of the skeletal *Garbancera*, to caricature the hypocrisy and sanctimoniousness of the so-called 'better' classes. He made fun of the pre-revolutionary upper class, who—ashamed of their indigenous origins—dressed in a French style, and tried to whiten their skins with thick make-up.[75] The skeletons which he created during the first years of the civil war—especially the one called *La Catrina*—can still be seen during community celebrations of the Day of the Dead. The figure of La Catrina was also often 'quoted' by other artists, including by Diego Rivera.

La Catrina, clad elegantly in a feather boa, appears in his monumental mural painted on Mexico's 400-year history, *Dream of a Sunday Afternoon in the Alameda Central Park*. In the mural, Catrina stands shoulder to shoulder with Frida. Diego's *La Catrina*, which in turn has been 'quoted' and transformed many times over, has acquired ever more meanings, including becoming the symbol of how Mexican culture deals with death, and an icon of the Day of the Dead. She continues to be fashioned from all kinds of materials: wood, papier-mâché, paper and even bread dough.

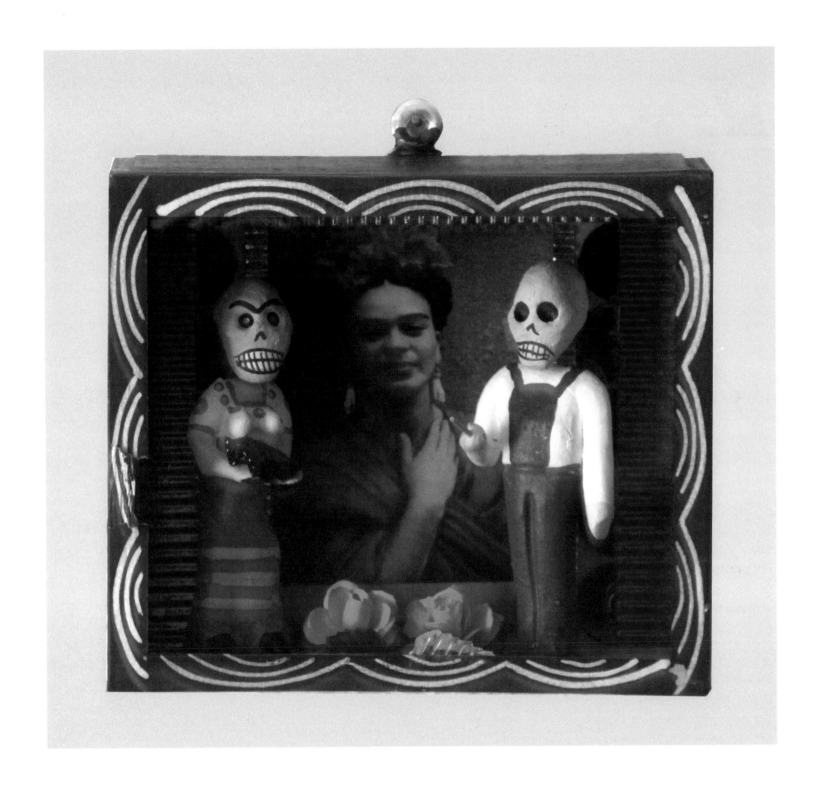

▲ A wooden shrine with a
portrait of Frida by Nickolas
Muray at the back, and
skeletons of Frida and Diego
in front
Found in Mexico City, 2012

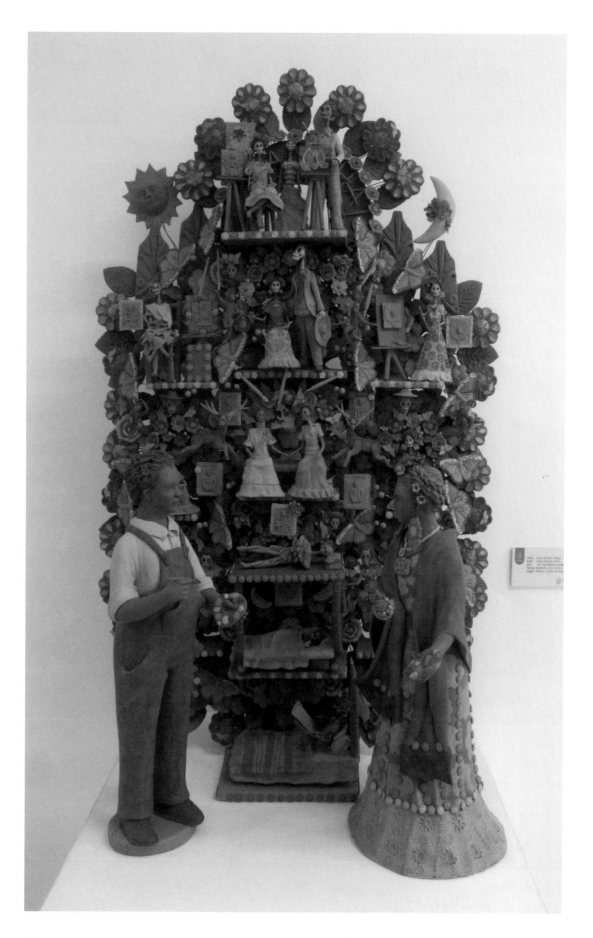

◀ *Tree of Life:*
Tribute to Frida Kahlo

The *Tree of Life* won the artist Cecilio Sánchez Fierro (from Metepec) second place at the National Clay Art competition held in 2015, in the clay figure category. From a family of traditional clay artists, Cecilio Sánchez Fierro started making clay figures since he was eight. Through his award-winning art, Fierro focusses not only on creating something beautiful, but also on ways in which he can both preserve and improve traditions of clay art.

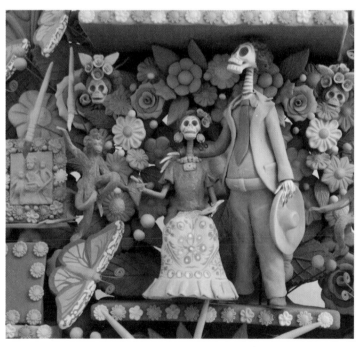
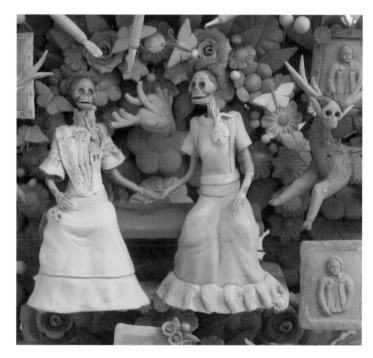

▲ Details from the *Tree of Life*

Frida and Diego stand in front of the Tree of Life, which features aspects of Frida's life along with her artwork. She is always depicted in clay and as a *calavera*—a skeleton.

Each scene is adorned with fruits, animals and plants, which are actually visual quotes from Frida's art that flow into each other. The tree is about 80 cm high.

Exhibited in the Museo Municipal Pantaleon Panduro del Premio Nacional de la Cerámica in Tlaquepaque, Mexico, 2017

Photos: Rainer Huhle

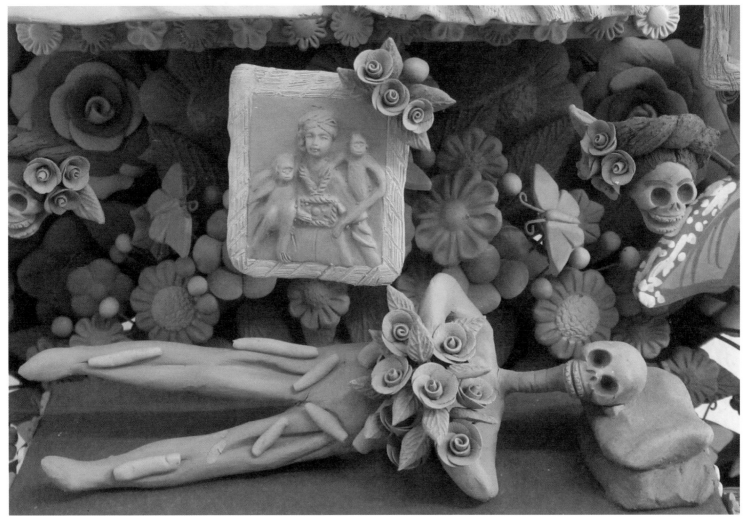

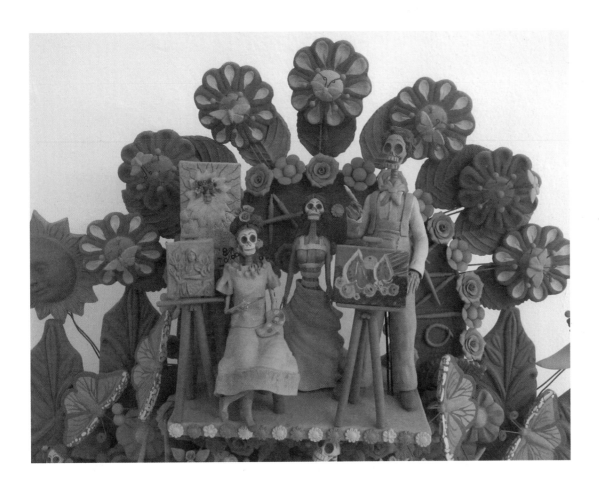

◀ **FACING PAGE AND ABOVE:**
Continuation of the *Tree of Life*

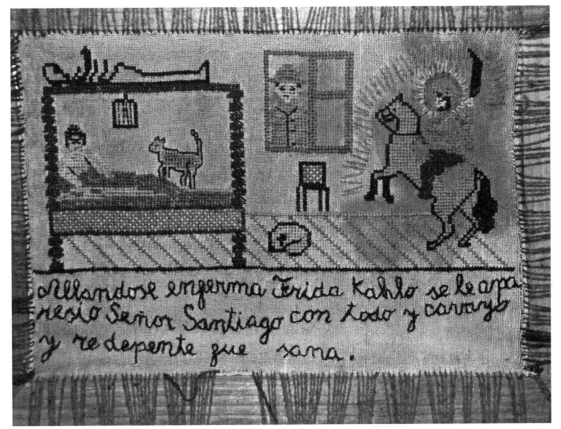

◀ **BELOW:**
Embroidered votive offering,
featuring Frida; includes a rare
depiction of St. Santiago who is
shown arriving to heal her

Spotted in a junk shop in
Mexico City, 2007

Photo: Rainer Huhle

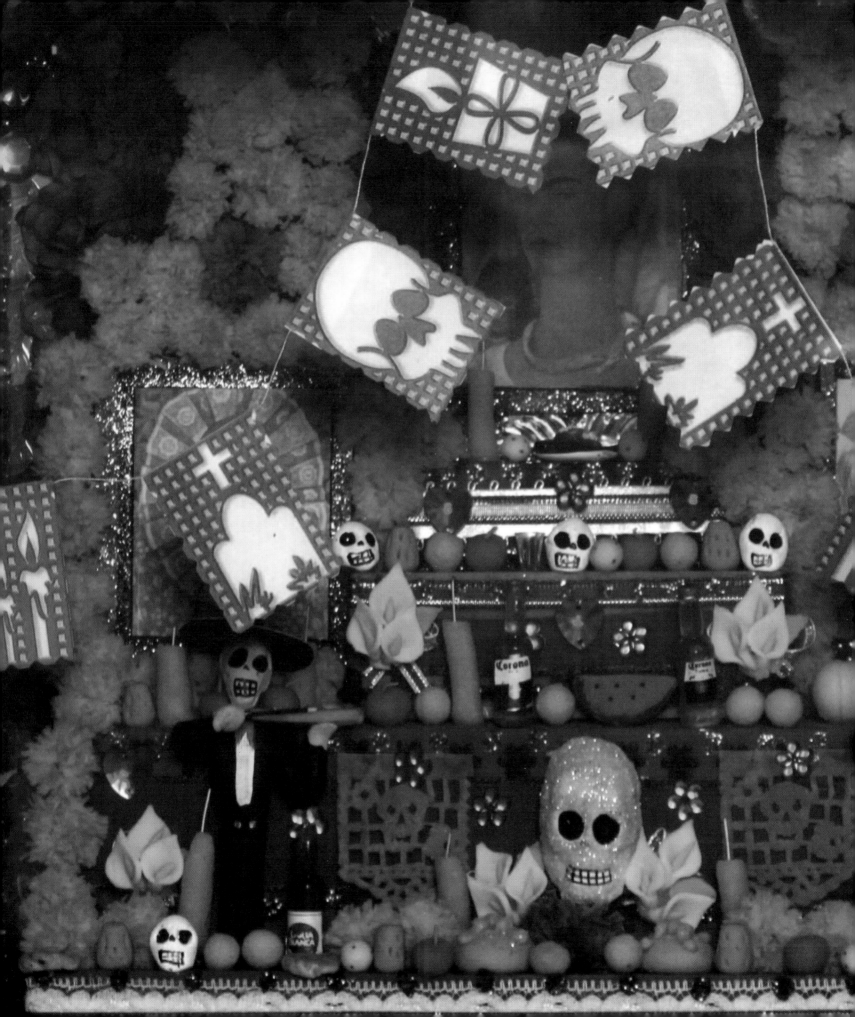

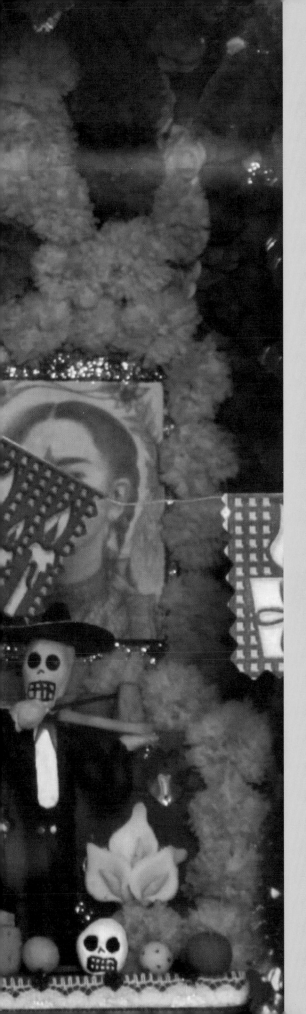

Fridolatría

The love felt by artists, writers and film producers for Frida Kahlo has passed through a long stage of idolatry [...] the need for a mother-god is something that we all carry rooted in our hearts.
—Teresa del Conde[76]

POPULAR PIETY IN MEXICO is expressed mainly through the veneration of the Virgin of Guadalupe. She is considered the religious symbol of the Mexican nation. Her image, in which indigenous elements connect with Christian symbols, is found everywhere in Mexico.

The Virgin of Guadalupe—who allegedly manifested herself four times to Juan Diego Cuauhtlatoatzin on the outskirts of Mexico City in the 16th century—exhorted him to build a chapel at Cerro del Tepeyac, the spot of her visitation. It is a basilica today, one of the largest pilgrimage centres of the Catholic Church in the world.[77]

There is hardly a household in Mexico where the Virgin of Guadalupe—gentle protector of humble people—is not present in some form: as a small shrine, a family altar, a statue or a printed reproduction. Her image is even pasted on stearin-filled glass bottles carried by travellers and migrants when they cross the desert in search of a better world.

Even Frida is protected by Guadalupe—small reproductions and ingenious oblations often have Frida's face overlaid on the countenance of Guadalupe. In some instances, Frida herself becomes an incarnation of Guadalupe—the patroness, the great Mother Goddess, the crucified Virgin. So the offerings are not only to protect Frida, but also demonstrate the love for Frida, the God-mother. [78]

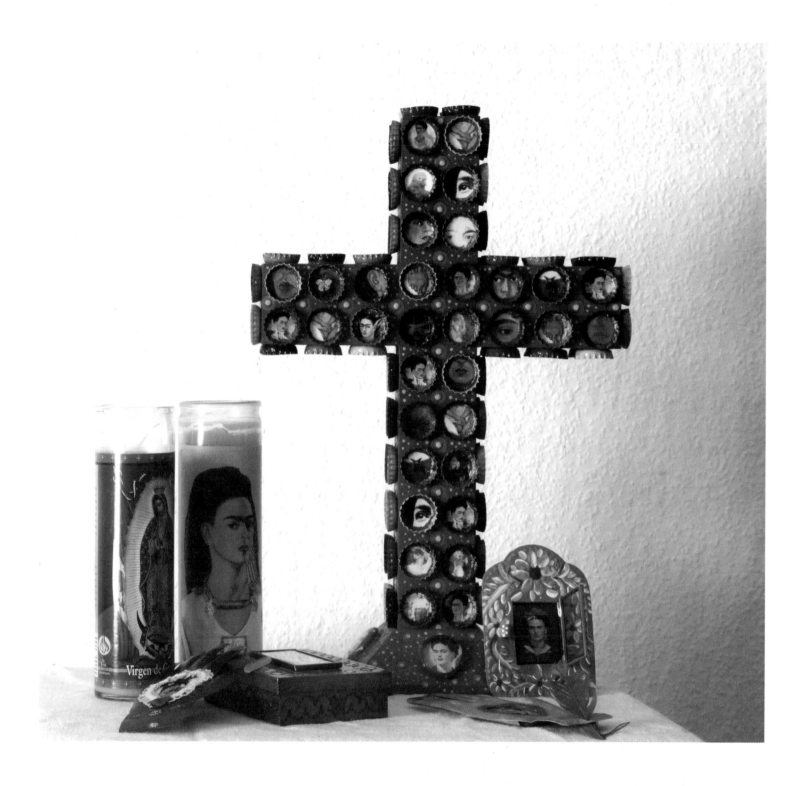

◀ FACING PAGE:
The wooden green cross (14x12 cm) is fitted with bottle caps, each with a miniature portrait of Frida coated with acrylic glass drops.
Found in Albuquerque, USA, 2006

▲ Candles, shrines and a red wooden cross made out of bottle caps with Frida portraits and artworks by Frida.
Found in Mexico and in the USA between 2006 and 2012

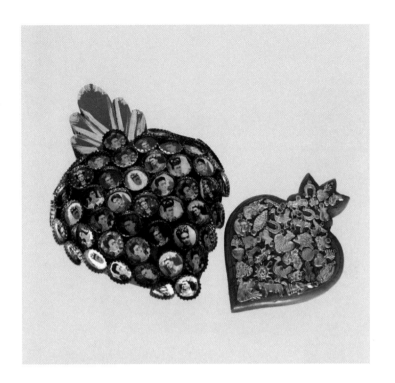

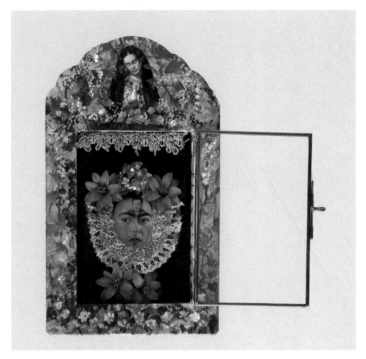

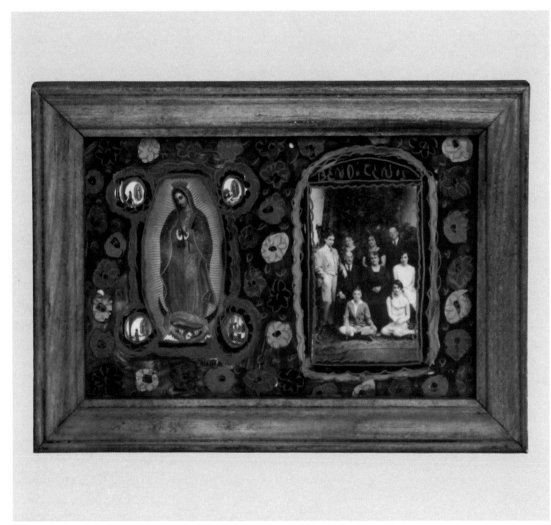

Milagritos or 'little miracles' are religious charms or votive offerings. A milagrito symbolises either a wish that is expressed or is used to express gratitude for a miracle that has already happened. Mounted on a wooden heart, and placed in a house, they are supposed to prevent evil energies. Conchita, a folk artist from Mexico City, creates new milagritos with miniature Fridas on the back of bottle caps.

Found in Ciudadela, Mexico City, 2017

▲ ABOVE RIGHT:

A photo of Frida Tehuana in a tin shrine (14x25x2 cm) entwined by lace; protecting her is the Virgin of Guadalupe with Frida's face

Found in Mexico City, 2009

◀ Exvoto:
'Bendice nos'—Bless us

The Virgin of Guadalupe was asked to bless the Kahlo family (original photograph by Guillermo Kahlo)

Glass painting and composition by Manuel Baumen

Found by Cristina Kahlo, Mexico City, 2014

Frida Ofrendas and Devotionalia

Ofrendas or family altars are created and decorated on the Day of the Dead so that the deceased can find their way back into their homes. Miniature depictions of such altars in the form of wooden shrines have become popular objects in craft markets. They are created with much love for detail and feature miniature depictions of all necessary elements of a family altar, with fruit, cake, skulls made of frosting, flowers and flower garlands, candles and pictures of the revered dead. Frida and Diego images are popular, and in this fashion, are invited into homes and hearts—not only on the Day of the Dead, but also on any other day.

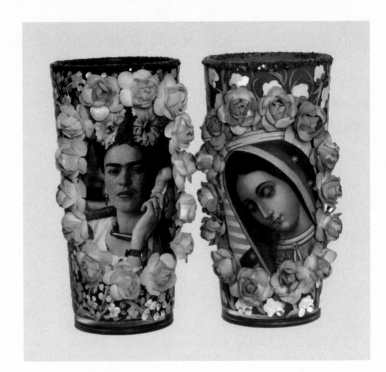

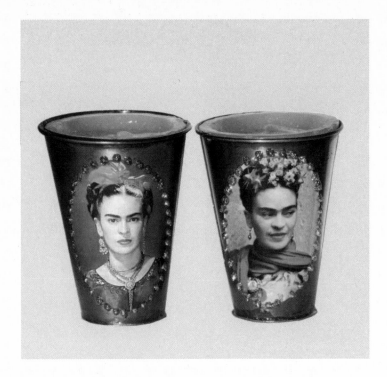

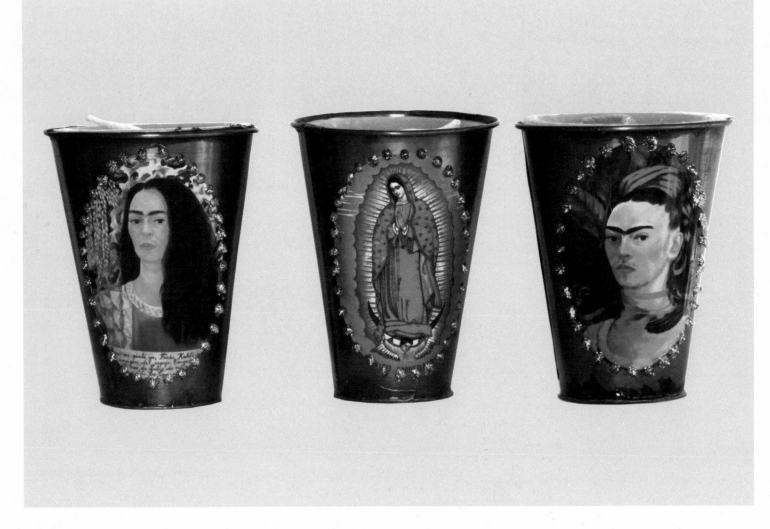

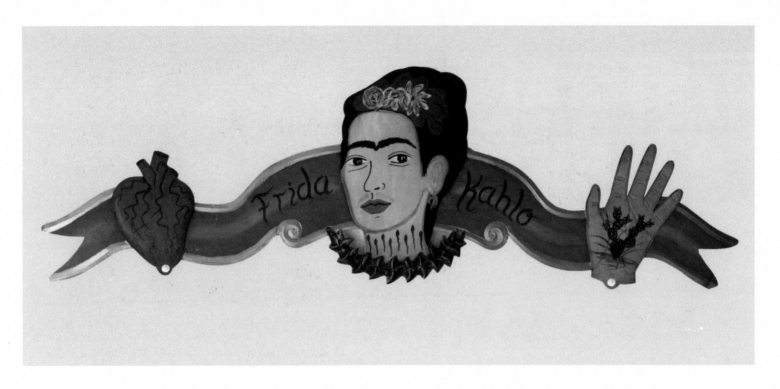

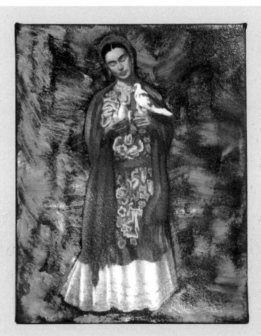

◀ FACING PAGE:
Candles
Found in Bogotá, 2013; Seville, 2014; and Mexico City, 2016

▲ ABOVE:
Frida: the Kingdom of Thorns: painted on tin (100x30 cm)
Found in Cambridge, Massachusetts, 2011

▲ BELOW LEFT:
Frida in Purgatory: figures made of paper in a coloured sardine tin
Found in Mexico City, 2006

▲ BELOW RIGHT:
Frida Kahlo with Birds, based on Juan Guzmán's photograph from 1950
The photo has been coloured green, as part of the stylised depiction of Frida as Madonna.
Oil painting (20x26 cm)
Found in Ciudadela, Mexico City, 2016

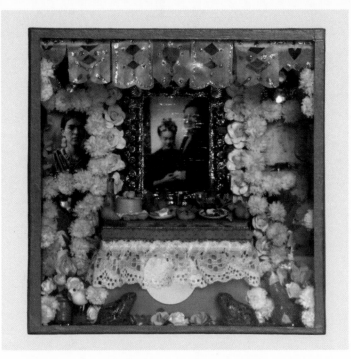

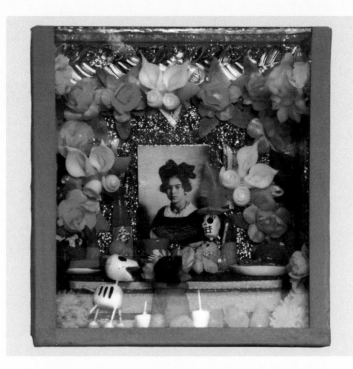

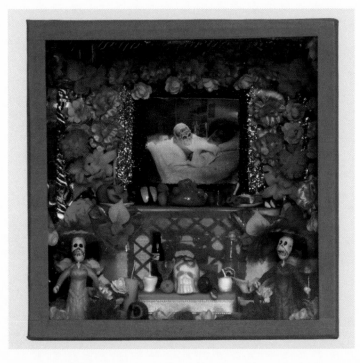

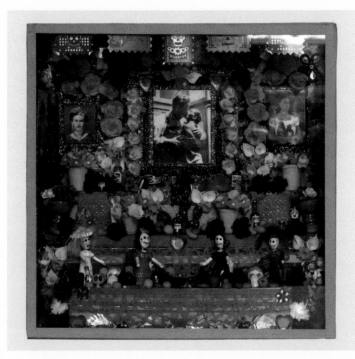

Ofrendas, miniature altars and wooden chests with glass fronts; based on the ofrendas that are offered in houses and graves on the Day of the Dead

▲ **ABOVE LEFT:**
Frida (25x25x7.5 cm)
by Ariela Vio
Found in Mexico City, 2008

▲ **ABOVE RIGHT:**
The Girl Frida (9.5x9.5x5 cm)
by Ariela Vio
Found in Mexico City, 2016

▲ **BELOW LEFT:**
Frida in Bed (15x15x7 cm)
by Ariela Vio
Found in Mexico City, 2016

▲ **BELOW RIGHT:**
Frida and Diego: The Kiss
(24x24x9 cm) by Ariela Vio
Found in Mexico City, 2015

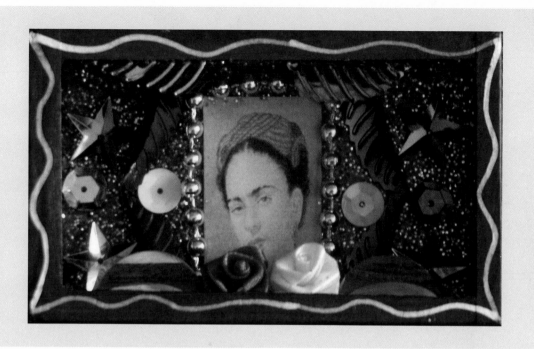

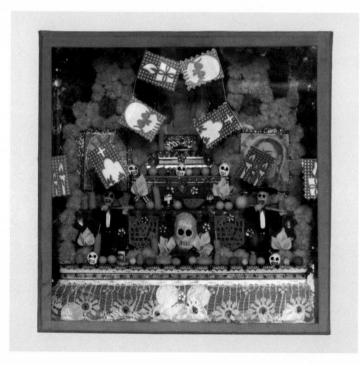

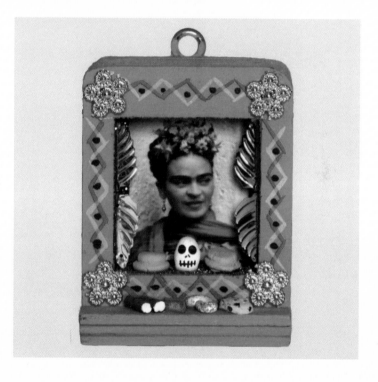

▲ **ABOVE:**
Wooden shrine with yellowed picture of Frida, decorated with buttons, flowers made of fabric, pearls and sequins (8x5.5x2.5 cm)
Found in Mexico City, 2007

▲ **BELOW LEFT:**
Frida Kahlo (25x25x7.5 cm) by Ariela Vio
Found in Mexico City, 2012

▲ **BELOW RIGHT:**
Print of a portrait by Nickolas Muray in a wooden shrine, with fruits as offering for Frida, within a wooden frame (7x8 cm)
Found in Mexico City, 2016

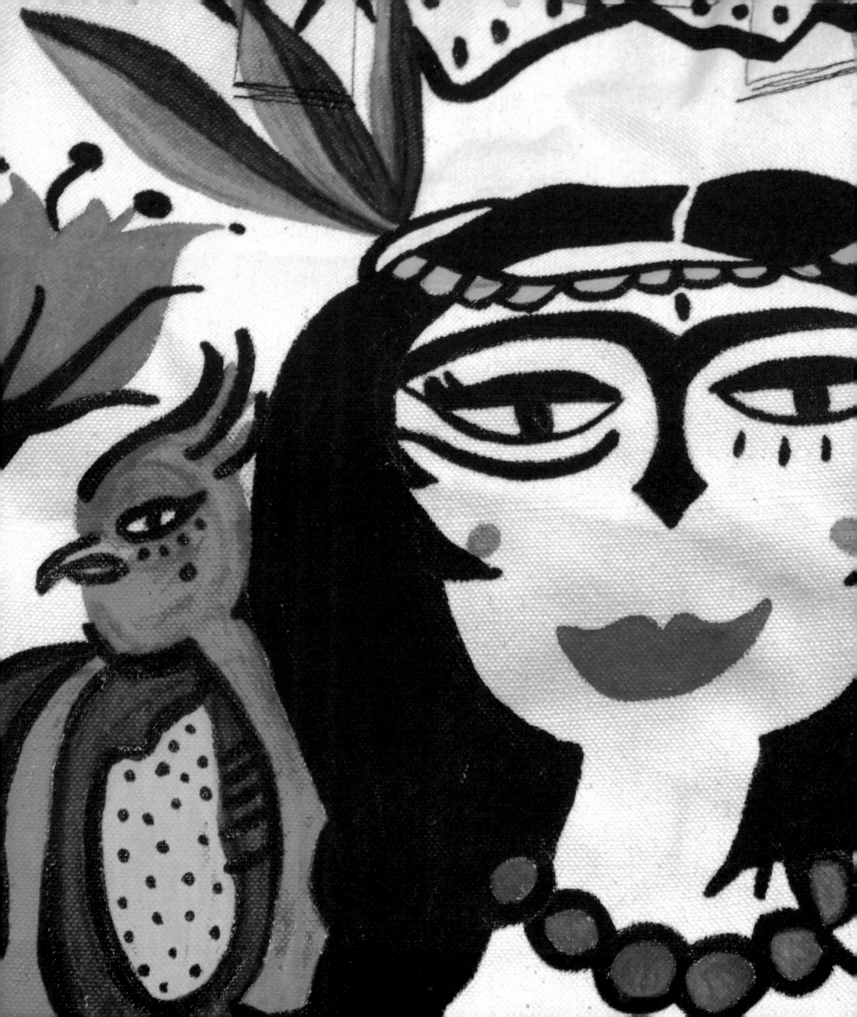

Frida Folk

Frida's art is an individual collective expression.
—Diego Rivera [79]

FRIDA, WHOSE PAINTING was steeped in Mexican folk art and imagery, has herself become part of this popular culture through its many forms of expression—constantly reinvented through and with her. It is an enduring connection which has turned out to be curiously reciprocal. Popular artists—not just in Mexico, but across a range of countries and cultures—have been inspired by her life and persona. To this day, they continue to come up with countless images and objects that evoke and reinvent Frida, keeping her alive in popular memory.

Frida's art continues to have the power to move, disturb, and thrill, even if it is endlessly replicated as a photo, or appears as an image printed on some very curious objects. The global appropriation of Frida—Fridamania—can certainly be viewed as commercialisation, trivialisation or kitsch. But is it merely that? Or is there another way to think about these creations? Could they be seen as witnesses to the times, of ever-changing lifestyles—in the best sense of the term—or things which go on to make history? [80]

▶ **Wooden sculpture in the Regional Ceramic Museum shop**
Tlaquepaque, Mexico, 2017
Photo: Rainer Huhle

Frida in the Marketplace

I have money even to go to the "thieves market" and buy lots of junk, which is one of the things I like best. I don't have to buy dresses or stuff like that because being a "tehuana". I don't even wear pants, nor stockings either. The only things I bought here were two old fashioned dolls, very beautiful ones.

—Letter from Frida to Nickolas Muray from Paris, 1939 [81]

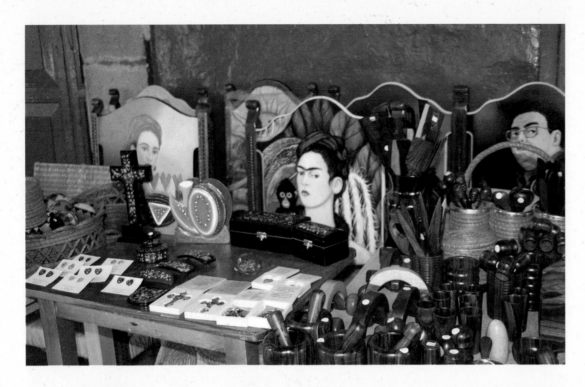

◄ Stall of a wood carver and painter in the arcades of Tzintzuntzan

Spotted in Tzintzuntzan, Mexico, 2009

▼ A wooden spoon with a Nickolas Muray portrait of Frida painted on it (90 cm); a wooden bowl with a reproduction of Frida with a crown of thorns (20x29 cm); some wooden chests with Frida portraits; and her 'Viva la Vida, Watermelons' (1954) on a tray

Found in Sanabria, Mexico, 2009

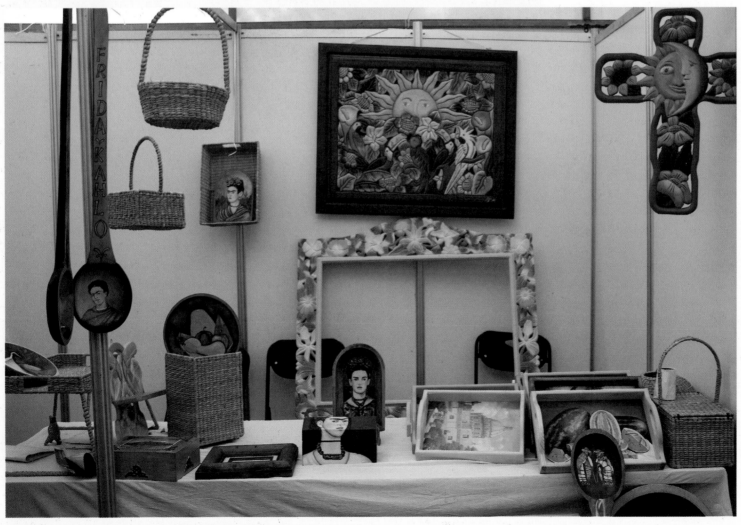

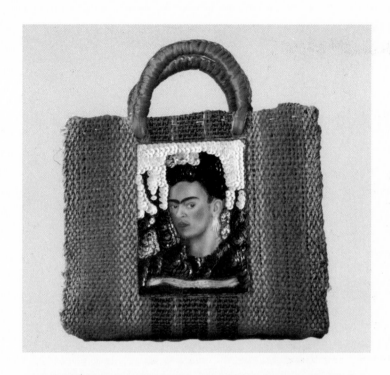

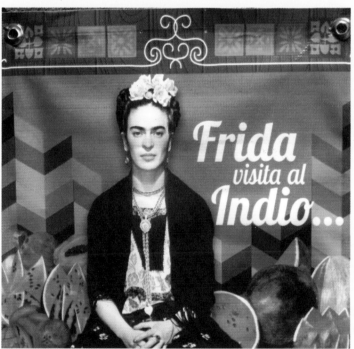

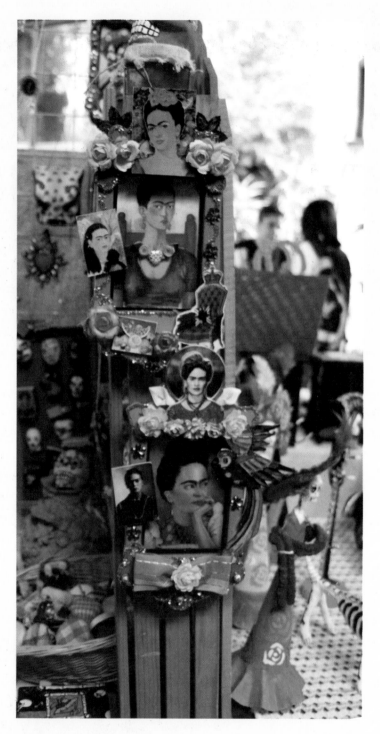

▲ ABOVE LEFT:
Basket with Frida's portrait appliqued with sequins
Found in Mexico City, 2011

▲ BELOW LEFT, RIGHT AND OVERLEAF:

Frida visits the Indio Fernandez

Emilio Fernandez (1904-1986) was a charismatic director and actor of the 40s and 50s. He also lived in Coyoacán, in a fort-like building with a courtyard, theatre and rooms for lectures. His artist friends included Diego Rivera and Frida Kahlo. The fort hosted many plays, like the "Cada quien su Frida" ("Everyone her own Frida"), by Ofelia Media, and it is used frequently as a venue for picturesque markets.

Visit to the Indio, Coyoacán, Mexico, 15-16th June, 2013

Photos: Rainer Huhle, Gaby Franger

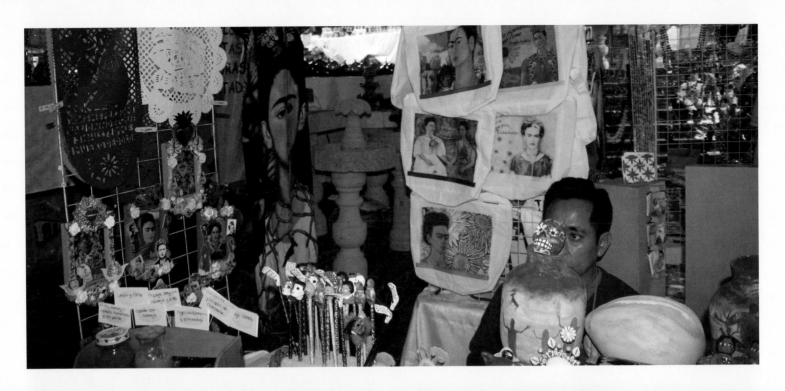

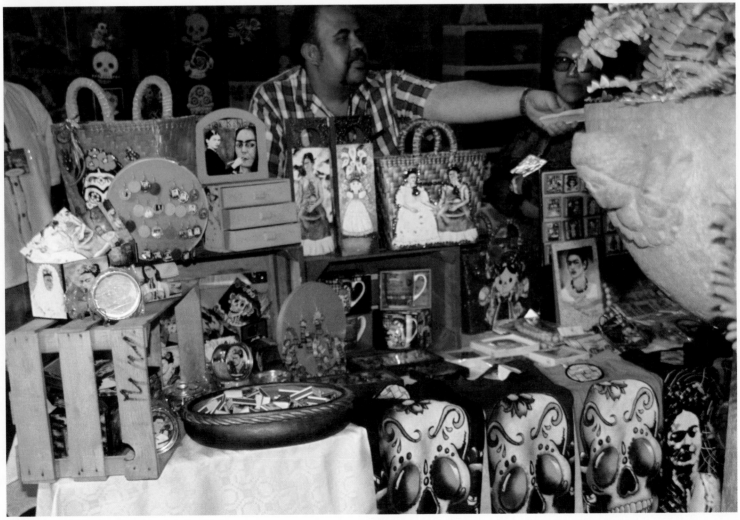

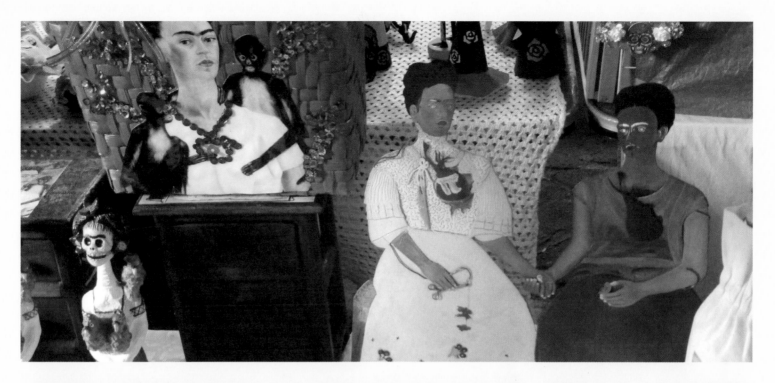

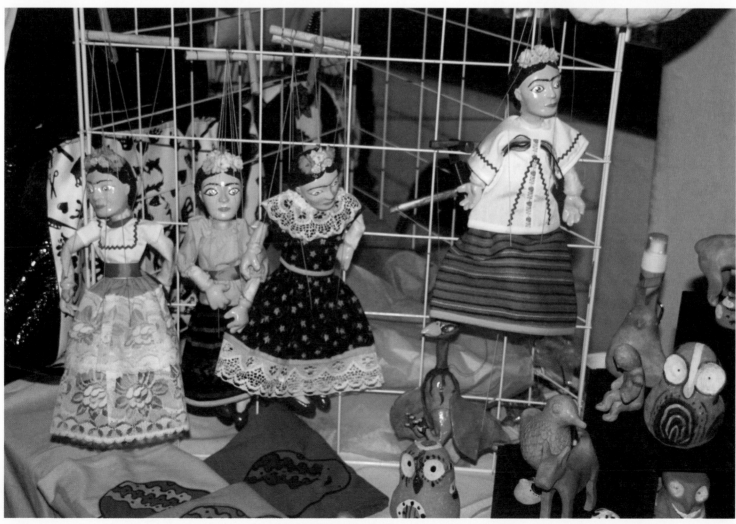

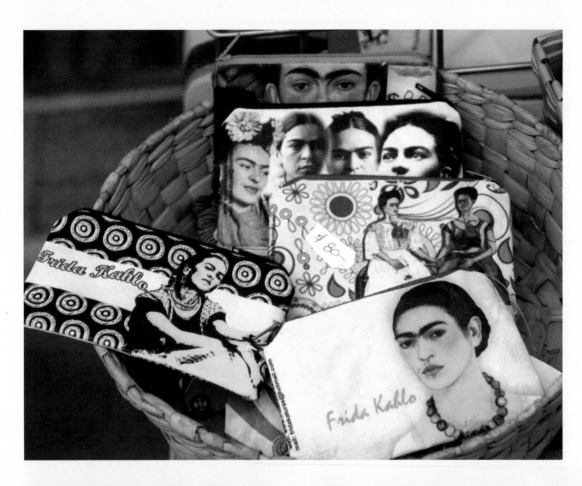

◄ Pencil case
Found in Ciudadela,
Mexico City, 2016

▼ BELOW AND FACING PAGE, LEFT:
The two most famous art and
craft markets in Mexico City
are the Ciudadela (where small
crafts enterprises are still
found) and the market in San
Angel, which has been central to
the Mexican handicrafts scene
from the 1940s.
Visit in 2016

► FACING PAGE, LEFT:
A junk shop in San Angel,
Mexico City
Photos: Rainer Huhle

► FACING PAGE, RIGHT:
Mobile phone covers
Ubiquitously popular, Frida at
the Sunday market in Bogotá
Spotted in Usaquén, Bogotá, Colombia

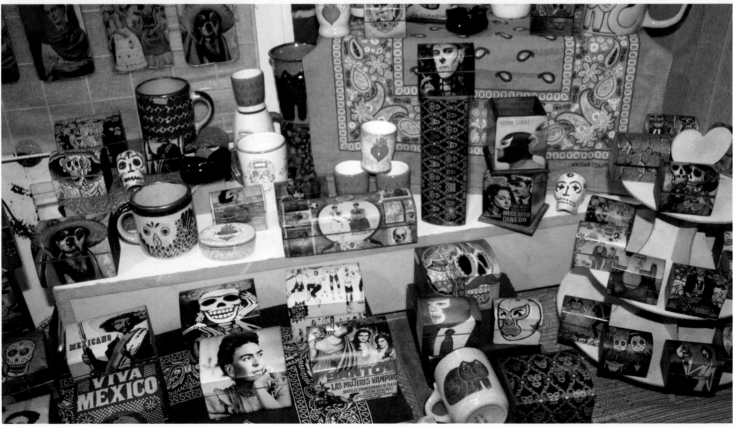

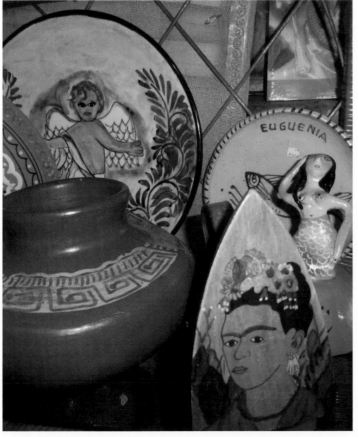

▲ ABOVE:
Frida bags
Spotted in
Barcelona, 2016
Photo: Gita Wolf

▲ BELOW:
Frida Pop: Pedal bin
Spotted in Usaquén,
Bogotá, Colombia, 2013
Photo: Rainer Huhle

▲ ABOVE RIGHT:
Frida on stacked wooden
crates, painted by artist Juana
Huacales, ready for receiving
re-orders
Spotted at the restaurant Frida
in Coyoacán, Mexico, 2017

▶ FACING PAGE, ABOVE:
Tiles
Spotted in a boutique in
Tlaquepaque, Mexico, 2017
Photo: Rainer Huhle

▶ FACING PAGE, BELOW:
Pop-icons at the
Sunday market
Spotted in Usaquén,
Bogotá, Colombia, 2013
Photo: Rainer Huhle

FACING PAGE:

◀ ABOVE:
Painted wooden
sculptures (9x11.5 cm)
Found in Patio Bellavista
in Santiago de Chile, 2016

◀ BELOW LEFT:
Recycled vinyl record
Found in Usaquén,
Bogotá, Colombia, 2017

◀ BELOW RIGHT:
Frida and Dali egg-cups
Found in Barcelona, 2017

▲ Linen bag with Frida pop-art
Found in the La Moneda Palace
Cultural Centre, Santiago de
Chile, 2016

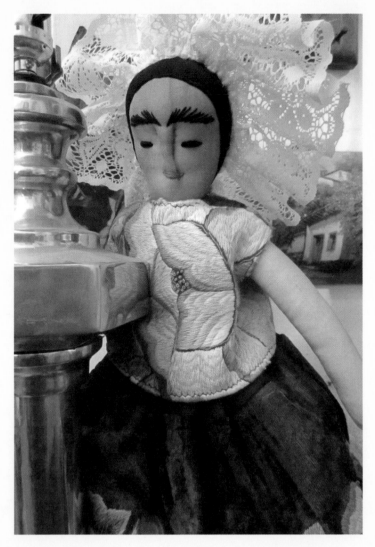

▲ ABOVE LEFT:
Oven mitts
Spotted in Sydney, Australia, 2017
Photo: Gita Wolf

▲ ABOVE RIGHT:
Frida Tehuana doll
Spotted in Sydney, Australia, 2017
Photo: Gita Wolf

◀ LEFT:
Little wooden dolls
Spotted in Barcelona, 2016
Photo: Gita Wolf

Material Tributes

Tributes, references and objects celebrating Frida are created on all kinds of surfaces and materials. Many of these crafts have evolved from older traditions of using particular materials, which have been constantly 'updated' to reflect popular taste.

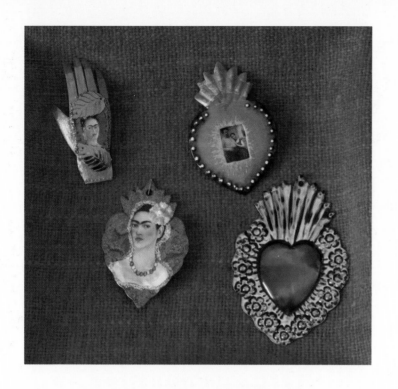

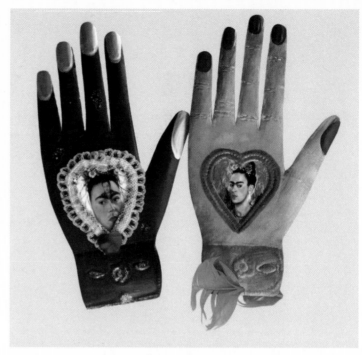

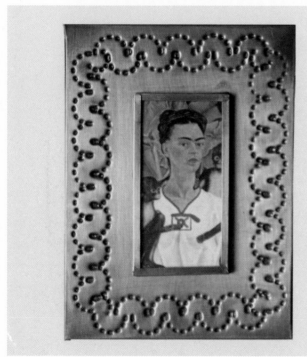

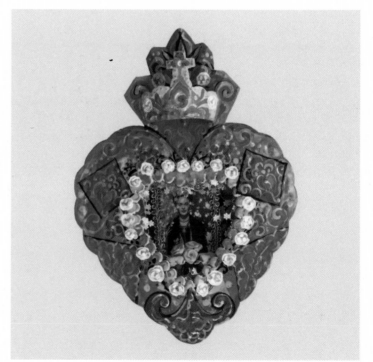

TIN

The art of cutting, stamping and painting tin plates emerged in Mexico as early as the mid-17th century when the Spanish made it hard for the locals to process silver. Tin was a cheap replacement which could also be worked more easily. Tin figurines were cut out first, and then patterns were drawn on them with the help of a pair of compasses or a drawing pin. Each pattern and dot was then hammered onto the plate.

Today, tin figurines are painted, while picture and mirror frames and tin boxes, are left unpainted.

▲ **ABOVE LEFT:**
Miniature tin hand and hearts
Found in Mexico City, 2009-2014

▲ **BELOW LEFT:**
Tin box with 'Self-portrait with Monkey' (1943) print (9x12 cm)
Found in Mexico City, 2009

▲ **ABOVE RIGHT:**
Tin hands (10x18 cm)
Found in Mexico, 2012

▲ **BELOW RIGHT:**
Tin heart with a crown and a Nickolas Muray portrait of Frida at the centre, entwined by fabric blossoms and veils
Found in Mexico City, 2016

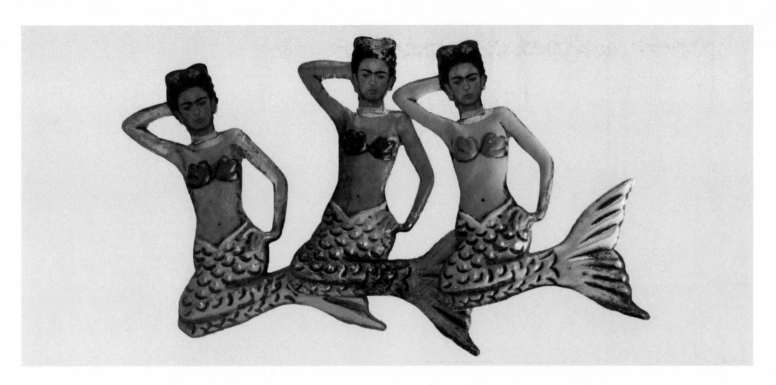

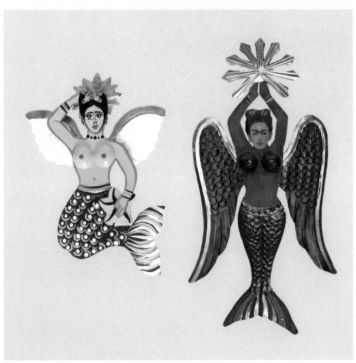

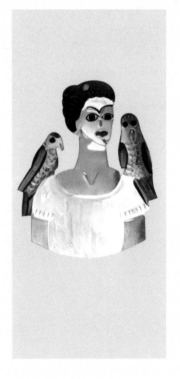

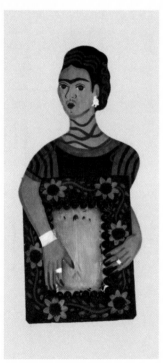

▲ ABOVE AND BELOW LEFT:

Frida: Angel and Siren

3 Frida sirens (each 7x10 cm),
tin with magnets

In Mesoamerican mythology, the
Angel and the Siren are considered
to be goddesses of water
(16x21 cm and 22x42 cm)
Found in Mexico City, 2013-2017

▲ Frida with parrots,
punched and painted on
silver tin (8x11 cm)
Found in Mexico City, 2007

▲ A Frida picturestand
painted on tin (13x30 cm)
Found in Mexico City, 2009

AMATE

Paper made from the bark of wild fig trees—
Amate—has been used by the Mayas, since 300BC.

Nahua potters in the state of Guerrero were the
first to re-discover Amate paper—they started
using it as a background for their traditional clay
paintings.

This new and hybrid craft came into being when
craftsmen met up at the Saturday market in Mexico
City. This was a space not just for commerce, but

also for communication, and for availing support
from government programmes meant to foster
social and economic development in rural areas.

Over time, the original designs began to be
replaced by naïve paintings which revolved around
village life and rural traditions.

Printing photos and reproductions of paintings on
bark paper has become increasingly popular—and
Frida is one of the most popular subjects.

▲ Different motifs on picture
cards and a notebook with
Amate-binding

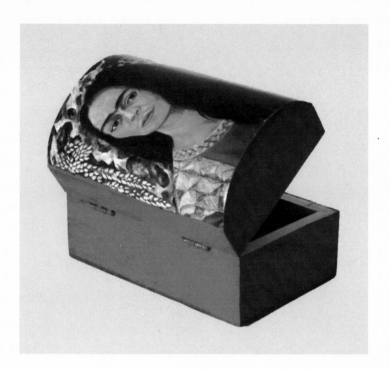

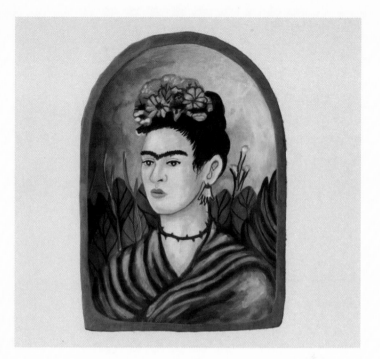

WOOD
Traditional wood items, like bowls, chests and even cooking spoons are now being painted with artwork based on portraits of Frida, or feature something entirely new inspired by her work.

▲ **ABOVE LEFT:**
'Self-portrait with Loose Hair'

Reproduction on a red wooden chest

Found in Mexico City, 2006

▲ **ABOVE RIGHT:**
The painting is a variation of Frida's self portrait from 1940, dedicated to Dr. Eloesser.

Roughly trimmed wooden bowl (20x29 cm), used as wall plate

Found in Sanabria, Michoacán, Mexico, 2009

▲ **BELOW:**
Coloured reproduction of a black and white photo of Guillermo Kahlo (1932), mounted on a wooden board and sprinkled with glitter

Found in Tucson, USA, 2012

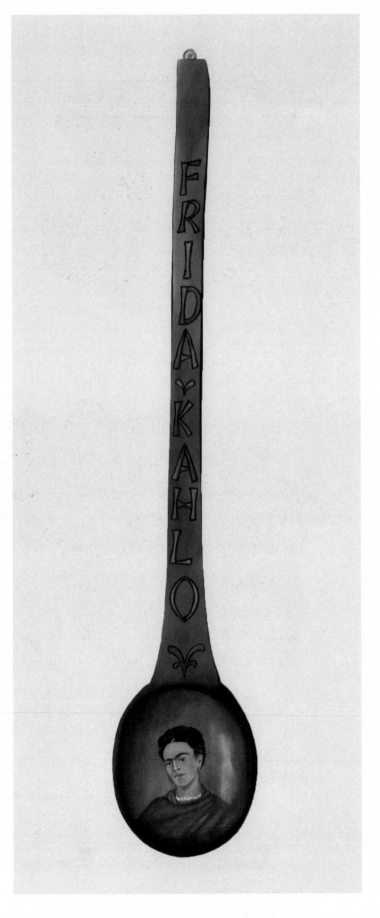

FACING PAGE:

◀ **ABOVE LEFT:**
Wooden bowl (9x18 cm)
Found in Mexico City, 2016

◀ **BELOW LEFT:**
Spoons
Found at the restaurant
Frida in Coyoacán,
Mexico City, 2017

◀ **BELOW RIGHT:**
Wooden spoon with Nickolas
Muray's portrait of Frida
painted (90cm)
Found in Sanabria, Mexico, 2009

▲ **ABOVE:**
Wooden dresser
Spotted in Mexico City, 2015

◀ **BELOW:**
Wooden boxes of different
sizes and shapes
Found in Ciudadela,
Mexico City, 2016

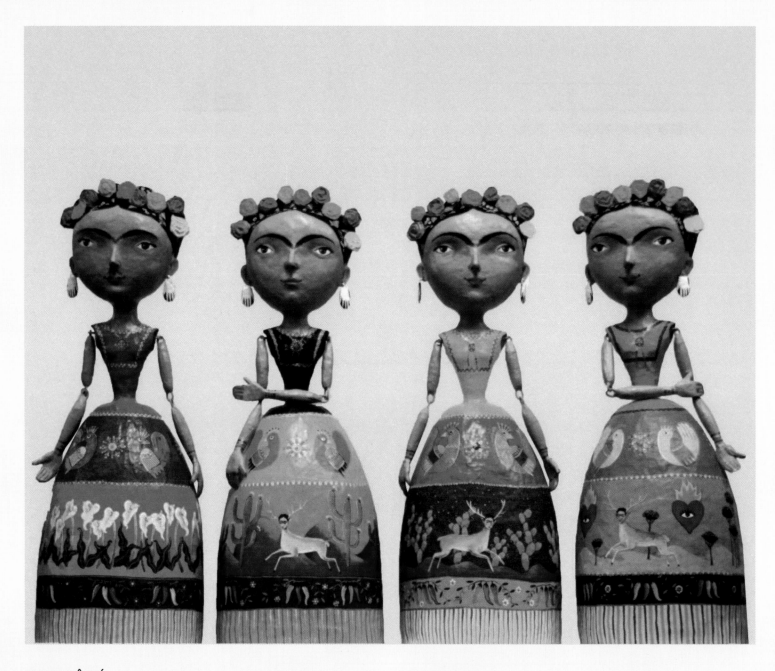

PAPIER-MÂCHÉ

Popular in Europe from the 15th century onwards, papier-mâché has been in use in Mexico for much longer. It is used to make a variety of things, from piñatas (small candy-boxes made with clay and papier-mâché) at children's birthday parties, to masks and functional objects. In traditional folk art calaveras and Judas figures made out of papier-mâché are quite common.

▲ *Four times Frida: Papier-mâché*
Put together from her artworks by Mauricio Pérez Jiménez
Spotted in Bogotá, Colombia, 2017

FACING PAGE:

▶ ABOVE LEFT:
Frida and Diego, newly in love, painted here as driving a Volkswagen made out of papier-mâché; a painting of the Virgin of Guadalupe features on the engine hood, and a happy skeleton on the rear end
Found in Mexico City, 2016

▶ BELOW LEFT:
Larger than life Frida made out of papier-mâché
Spotted in Mexico City, 2014
Photo: Gita Wolf

▶ ABOVE RIGHT:
Frida Tehuana miniature sculpture (10 cm)
Found at the Saturday Market in San Angel, Mexico City, 2018

▶ BELOW RIGHT:
Baby doll with moving joints (14 cm)
Found at the Saturday Market in San Angel, Mexico City, 2018

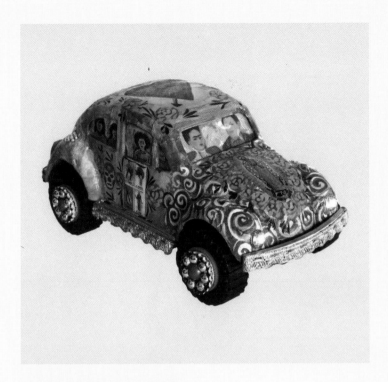

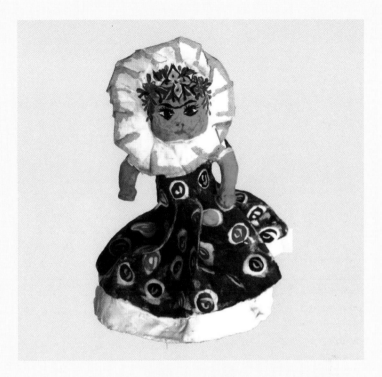

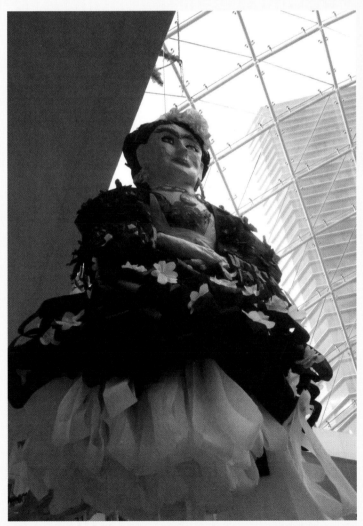

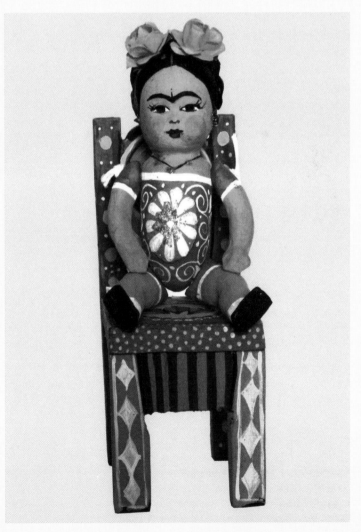

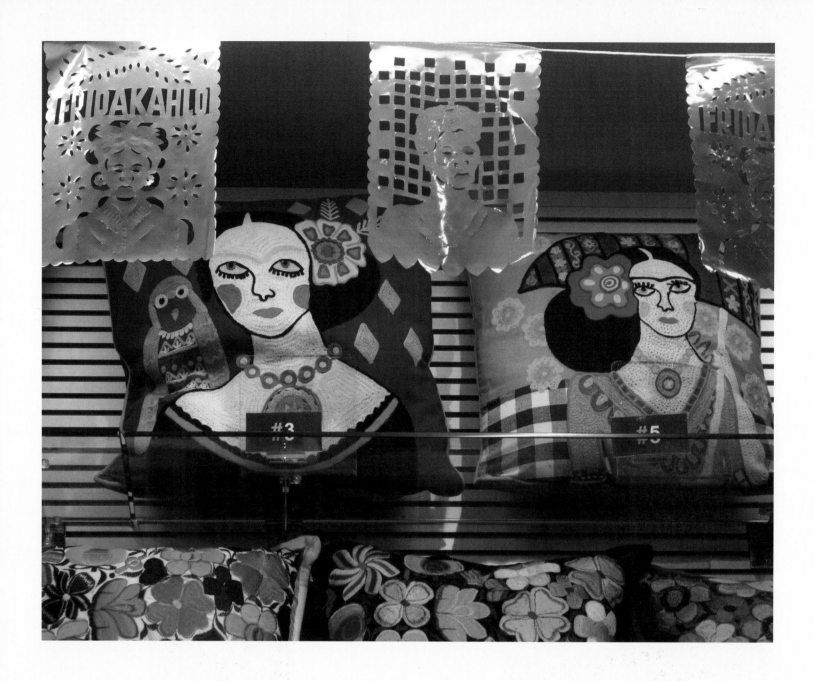

PAPER CUTS (PAPEL PICADO)

No festival in Mexico is complete without these colourful paper cut garlands that flutter in the wind. They are made by punching rolls of tissue and not by cutting them up. Figures and characters are punched out by hand and depending on the occasion, different motifs and colours are used.

▲ Paper cuts and cushion covers

Spotted in a museum store in Sydney, Australia, 2017

Photo: Gita Wolf

▲ Frida Calavera bookmarks:
Viva la vida from the artisan
family Sarapico
Bookmarks (7x19 cm)
Found in Mexico City, 2018

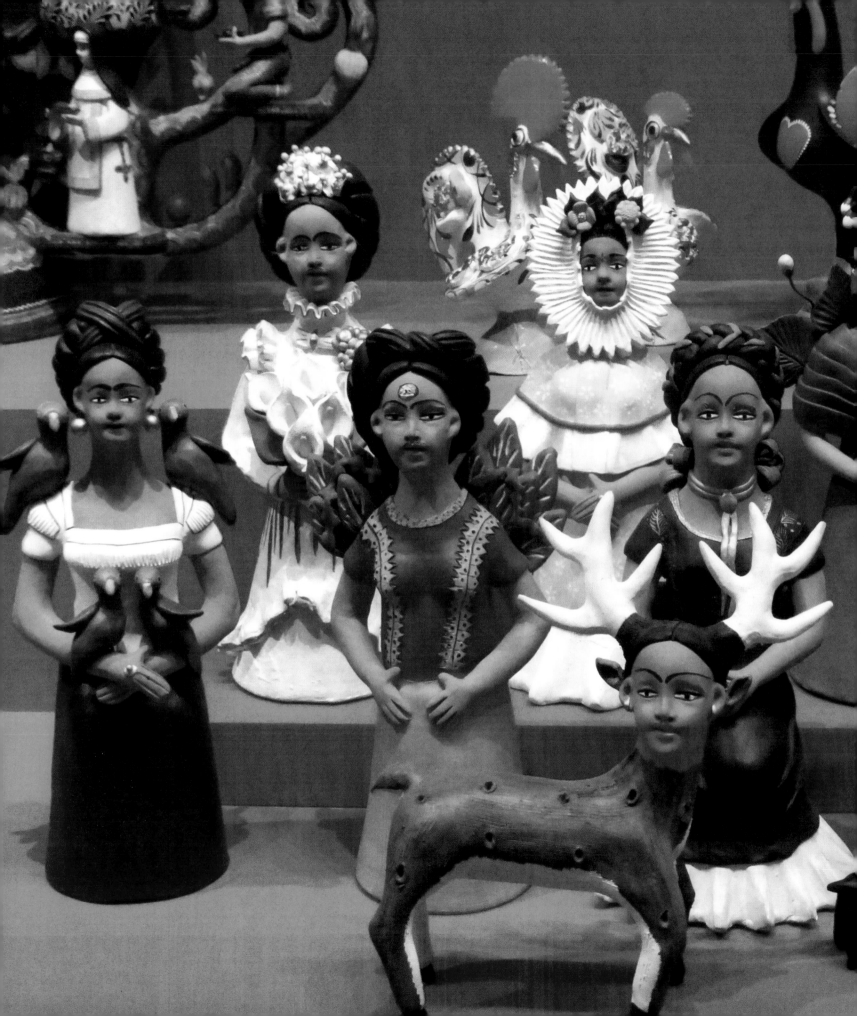

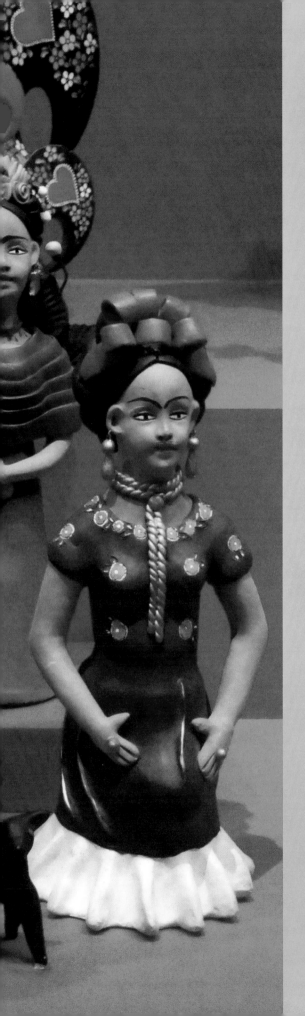

The Art of the Aguilar Sisters

Painting is one thing, clay is another.
—*Josefina Aguilar* [82]

POTTERY IN OAXACA is a female art form. The Aguilar family is particularly renowned. The mother, Doña Isaura, born in 1924, had to struggle hard, with five daughters and three sons. To earn an additional income for her large family, she made clay pots to sell in the market. She was particularly well known for her *Braseros*—flat three legged charcoal containers meant for rituals on the Day of the Dead... but at one point she was overcome by the desire to create figures, like angels or market women. Her creations no longer had a functional purpose—they were meant neither for domestic work, nor for religious rituals. But they did find some buyers, and several of her daughters began to work along with her to produce more.

In the course of time, collectors began to get interested in these 'traditional' folk art figures. Sometime in the 1960s, the most famous of the collectors, Rockefeller, went to Ocotlán de Morelos, and bought almost all the figures that two of Doña Isaura's daughters—Josefina and Guillermina Aguilar—had made. [83]

Ever since then, business has picked up, and the two artists and their sisters Irene and Concepción have received a great deal of recognition in Mexico as well as the USA, through their travelling exhibitions. They haven't become rich yet. They still live in simple houses with work and retail areas attached, and continue to work with their children and grandchildren on scenes and characters from traditional Mexican life, like their mother, Doña Isaura, taught them.

And after Doña Isaura died in 1968 [84], four of her daughters—and occasionally a son—carried forward their mother's art, each in their own way. A new folk style was born.

The sisters came up with scenes and figures that they themselves liked, as well as things that interested buyers. The eldest, Guillermina, seems to be most closely connected with the rich inheritance from the past. She began to work with clay after her mother died. And like her mother, she first tried her hand at braseros. Then, in 1970, FONART—the National Organization for the Advancement of Arts—encouraged her to model skeletons for the Day of the Dead, which went on to sell well. But even then, as now, the family was wary of being entirely dependent on the handicraft market, so they keep a small cattle and bean farm going. Even today, when the children are not helping out in the family business, they take on any job on offer.

The sister with the most economic resources is Irene Aguilar. [85] Her work is built around inherited customs and traditions, but she also loves creating humorous scenes.

Concepción Aguilar is the youngest of the Aguilar sisters, who was just 10 years old when the mother died. There were still two little brothers to provide for, and the father was an alcoholic. He died in 1976, almost nine years after her mother. Unlike her sisters, she learned clay modelling entirely on her own, since she had no memories of how her mother worked.

Josefina Aguilar, another of the sisters, began to model with clay at the age of six. Her mother used to like the figures she made—her mermaids, for example, were a particular favourite. But each of Josefina's figures has its own different posture, unlike her mother's work.

What the sisters are best known for are their Frida figures. All four of them create Friditas—or small Fridas—from clay, some copied from her paintings, others invented by them. Each of the sisters tells her own story about how she came to deal with Frida and her life. Whatever their claims, it is important to all of them that not only are their Fridas big sellers, but they are not all copies of each other: each of them has a curious and very individual charm.

Irene apparently came upon the idea on one of her trips to the United States.[86] Concepción talks about an American who visited her workshop in the 1980s, and suggested that she create Fridas, because they were much loved in the United States. He gave her a book with Frida's paintings, which really opened her eyes. She realised how real Frida was—her wayward eyebrows, her love of traditional clothes and jewellery. But even better were the reproductions of the paintings. They fired her imagination and helped her create the Fridas she desired.[87]

Guillermina not only produces Friditas but also containers painted with Frida images. A bowl with Frida stands at the entrance of her house, filled with arum lilies which immediately conjure up the two main characters: Frida Kahlo and Diego Rivera.[88]

Josefina insists that she was the one to make the first Fridita. She talks about how she saw two reproductions of Frida's paintings in a café in Oaxaca, and had the idea of copying them. And that created the demand for more. She also made the figures because she was touched by the physical resemblance between Frida and herself, especially the braided wreath of hair, which made them look so like each other. Only the eyebrows, of course, were different.

She creates versions of Frida's self-portraits against orders, but also invents her own stories. One day, for example, she gave Frida a baby. Her son told her that Frida had never had a child. "Well, maybe she didn't have one as long as she lived, but now she's dead, and she gets one in my work." Her son said it would never sell, but he was wrong, it was snapped up right away. "You see now?" she said to him.[89]

So aren't her Frida figures entirely new creations, which re-make Frida anew? Her response is tangential: "You can only hang pictures up, but you can move a clay figure anywhere you want, you just push them aside, put them anywhere."[90]

If art is communication, then it happens exactly in this process of merging. Frida's art is translated into a unique language of clay art which has its own particular effect.

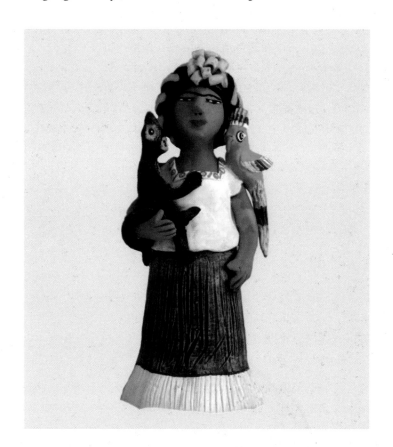

▲ Frida's 'Self-portrait with Monkey and Parrot' (1942) interpreted on clay (15 cm) by Josefina Aguilar

Friditas

Frida's images gain a new dimension in the art of the Aguilar sisters. Even though it is immediately obvious which original portraits are being 'quoted', each figure is by itself a small piece of art—Frida with her characteristic eyebrows, her parrots or monkeys, colour-coordinated and traditionally dressed—all rendered in the way the potters find beautiful.

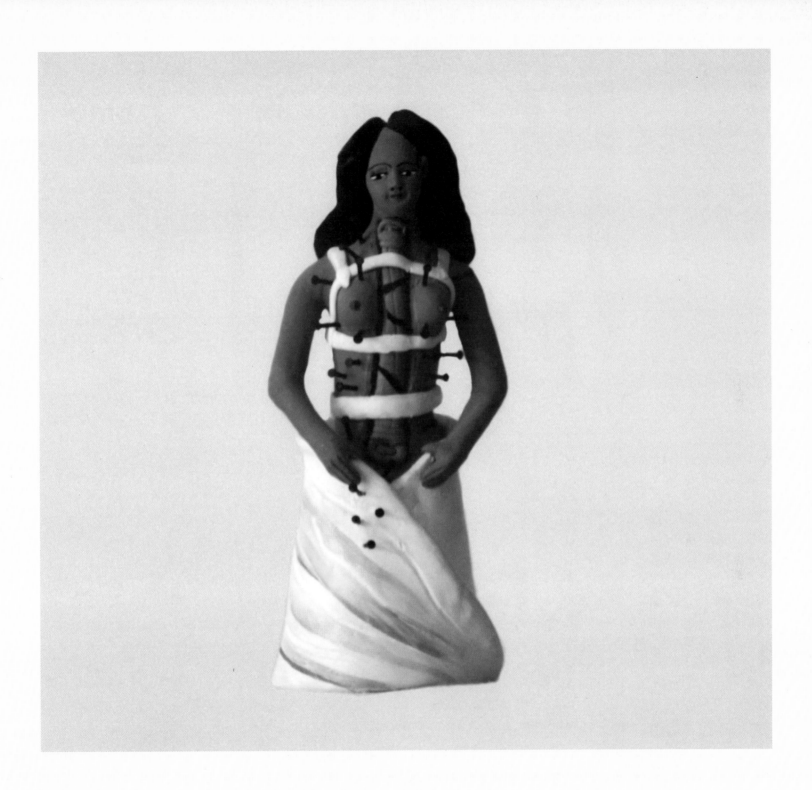

**All figures by the Aguilar sisters
Josefina and Guillermina made
out of painted clay found in
Mexico City, Santiago de Chile
and New York, 2006-2017**

▲ *The Broken Pillar* (16 cm)
by Guillermina Aguilar

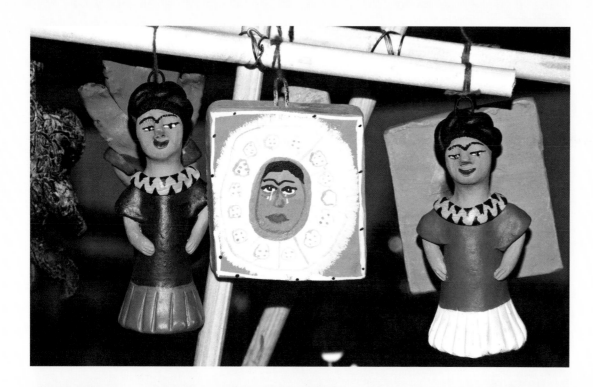

◀ *Oaxaca Fridas III*
Photo: Rafael Doniz

▼ Friditas by Guillermina Aguilar
at an exhibition on the grand
masters of Ibero-American folk art
Spotted at the Museum of Modern
Art, Bogotá, Colombia, 2013
Photo: Rainer Huhle

FACING PAGE:

▶ **ABOVE LEFT:**
Frida with Monkey and Parrot
(24 cm)
by Josefina Aguilar

▶ **ABOVE RIGHT:**
Frida with a Monkey
(24 cm) by Guillermina Aguilar

▶ **BELOW:**
The Fridas
Photo: Rafael Doniz

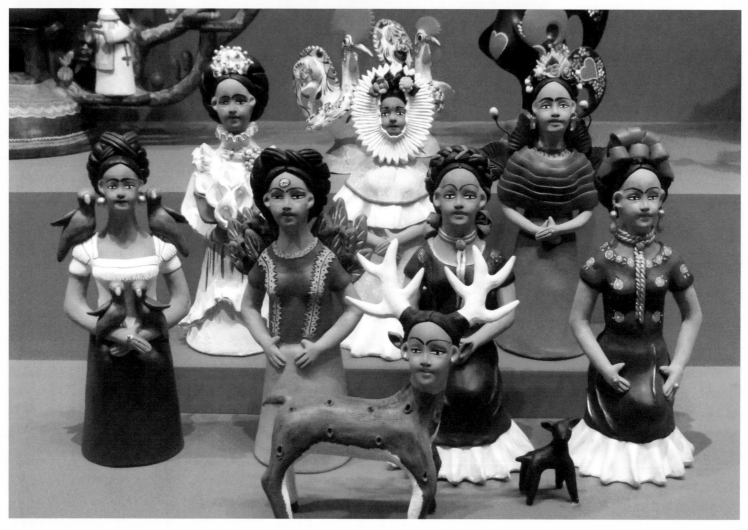

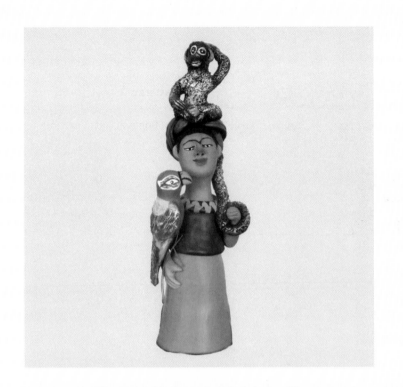

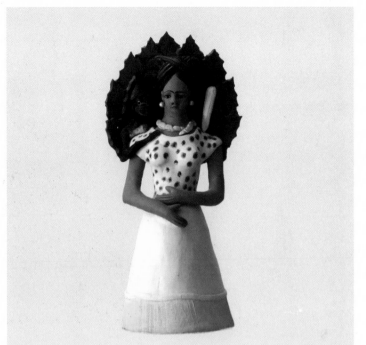

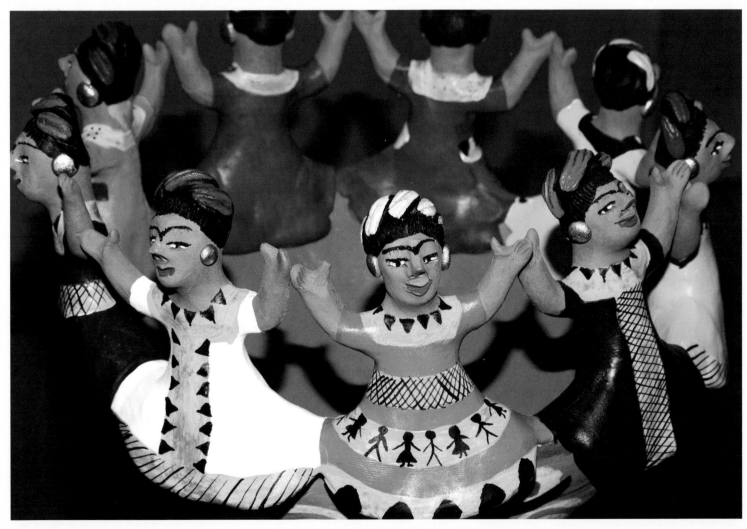

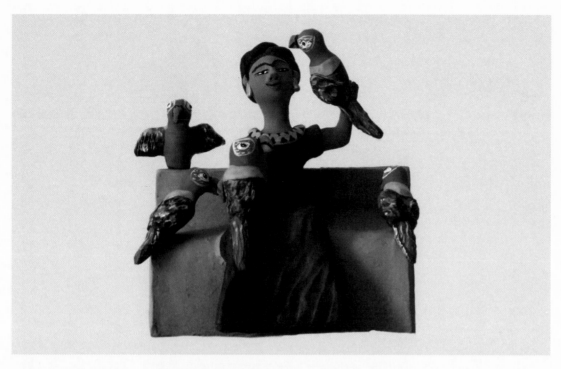

◀ *Frida with Parrots on a Bench* (15x16 cm) by Josefina Aguilar

▼ *Oaxaca Fridas II*
Photo: Rafael Doniz

▶ *Diego and Frida*
Photo: Rafael Doniz

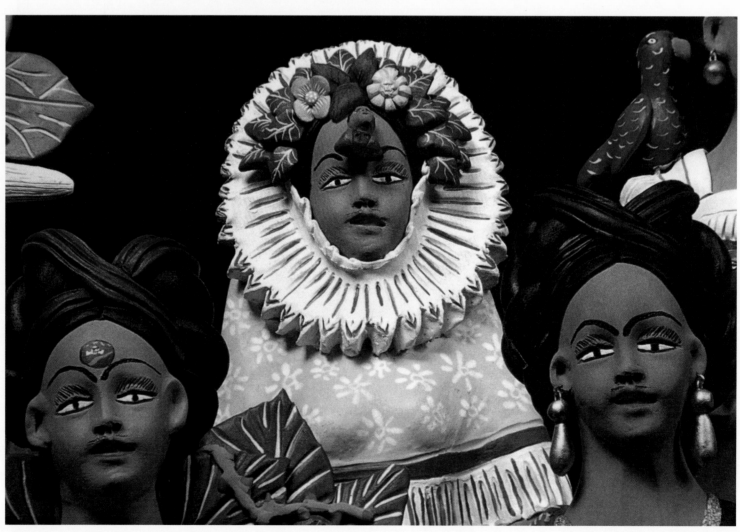

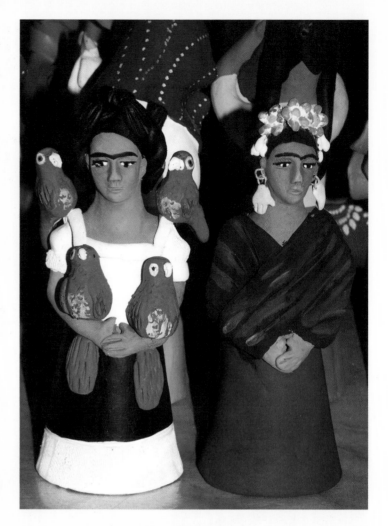

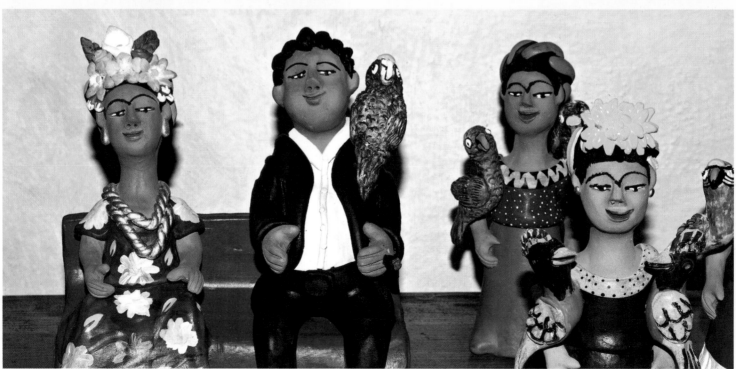

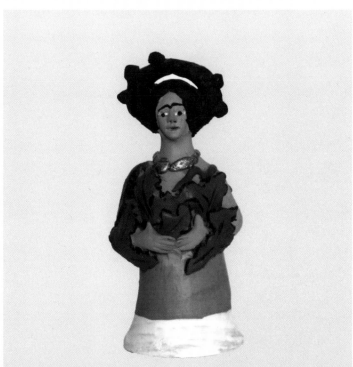

FACING PAGE:

◄ ABOVE LEFT:
Frida and Diego
Photo: Rafael Doniz

◄ ABOVE RIGHT:
Oaxaca. *Frida with Parrots*
Photo: Rafael Doniz

◄ BELOW:
Frida, Diego and Parrots
Photo: Rafael Doniz

▲ ABOVE LEFT:
Frida with a White Bird
(13.5 cm) by Guillermina Aguilar

▲ ABOVE RIGHT:
Frida Kahlo (13.5 cm)
by Guillermina Aguilar

◄ BELOW:
*Frida with Gold Chain
and Plants* (14 cm)
by Guillermina Aguilar

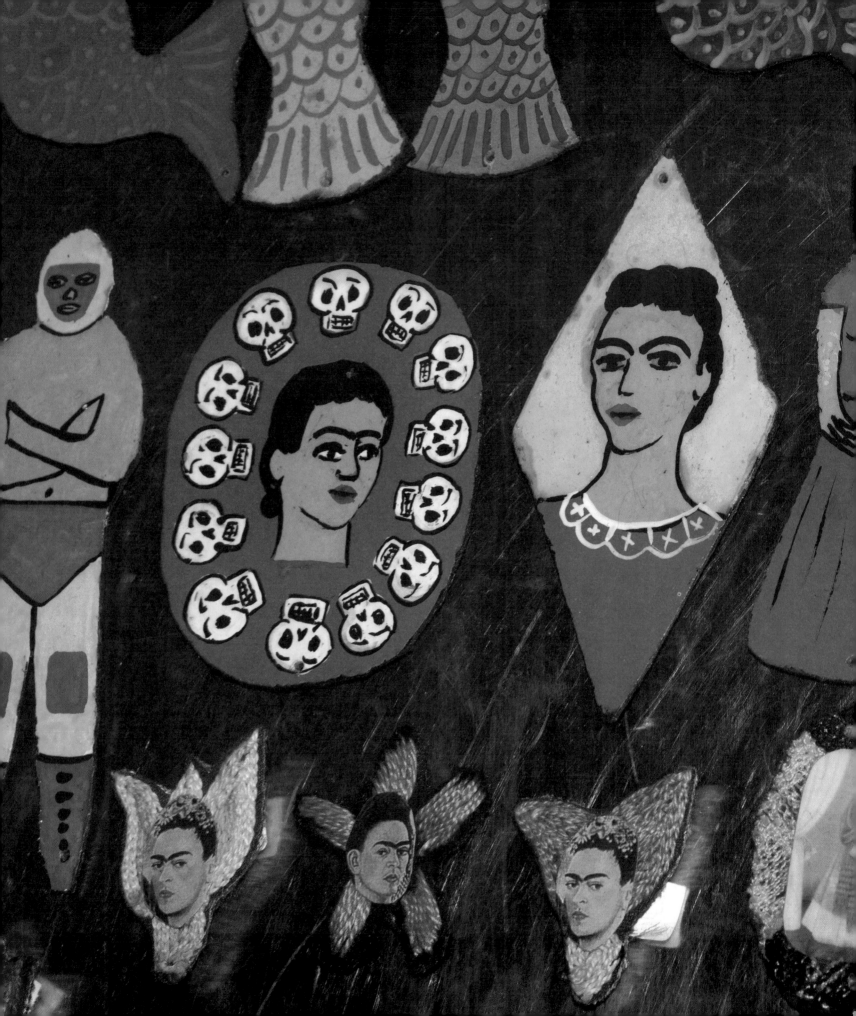

3

RAFAEL DONIZ: FRIDA WAITS AT EVERY CORNER

Fridamania makes us recall Frida at any moment, whether it's her face on a t-shirt, postcards, posters, magazines, key chains, parfume, catalogues or books. She is a cult object for millions of people all over the world.
—Elena Poniatowska [91]

"I have always encountered Frida when I wander through cities, large and small. But from the moment you asked me if I could contribute pictures for *Frida Folk*, it looks like I can no longer escape her. No matter if I'm standing at a bus stop with my son, walking in the street, or roaming around thrift shops and craft markets—Frida jumps out at me, everywhere (...) And by taking note of this, I register and document Mexican everyday life, Mexican liveliness, the joy of colour and of life. My connection with her manifests itself at several levels: I was first introduced to her art and personality through my teacher, Manuel Álvarez Bravo. I studied the photographs which Bravo had taken of Frida and liked his stories about how he would meet with Frida and Diego Rivera. But most of all I feel connected to Frida because I met my wife Andrea Kettenmann through our shared interest in her. Andrea came to Mexico in the late 1970s to do research on the first complete edition of Frida Kahlo's work in German. I accompanied her during this project, as a photographer. We got married, and ever since Frida has been with us."

—*Rafael Doniz*

▶ *Carrier bags with Frida*

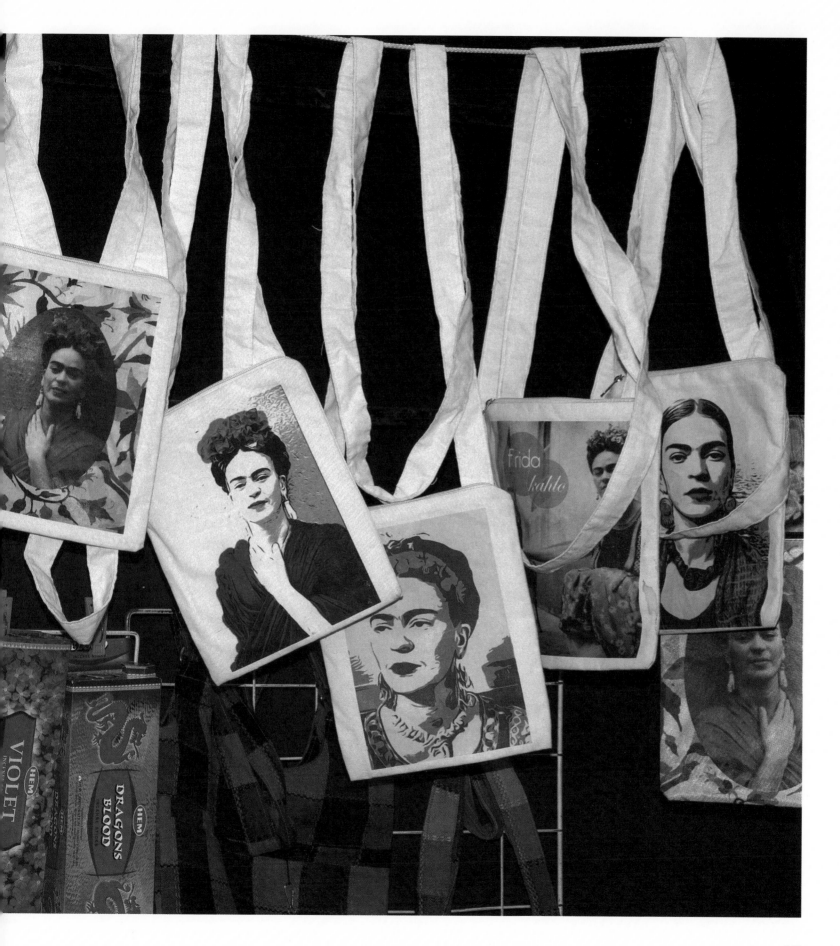

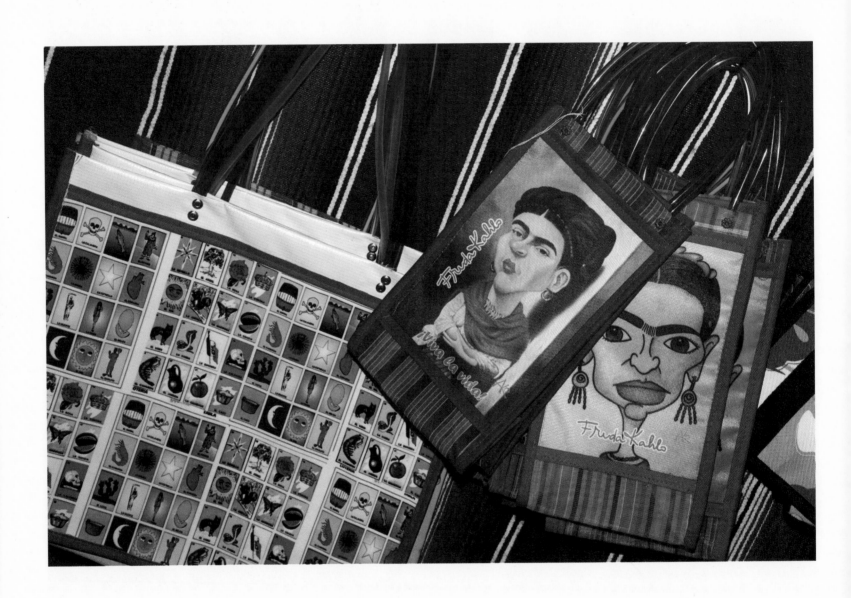

▲ ABOVE:
Two Fridas in the lottery

▶ FACING PAGE, ABOVE:
Frida altar

▶ FACING PAGE, BELOW:
Frida cushion

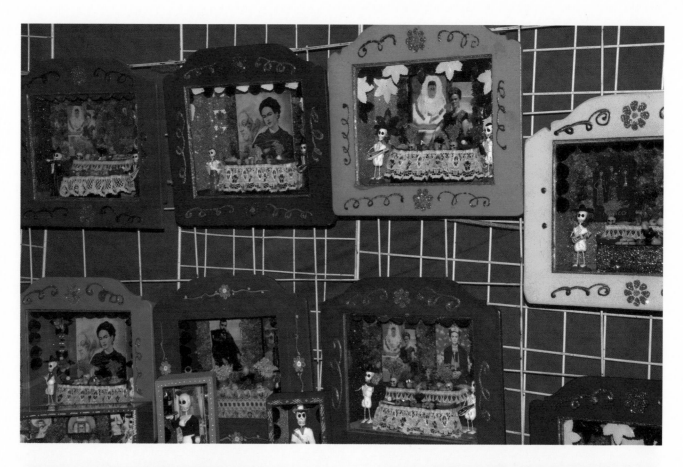

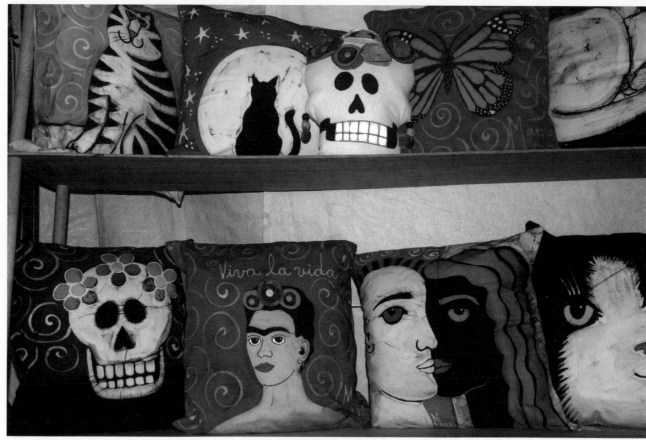

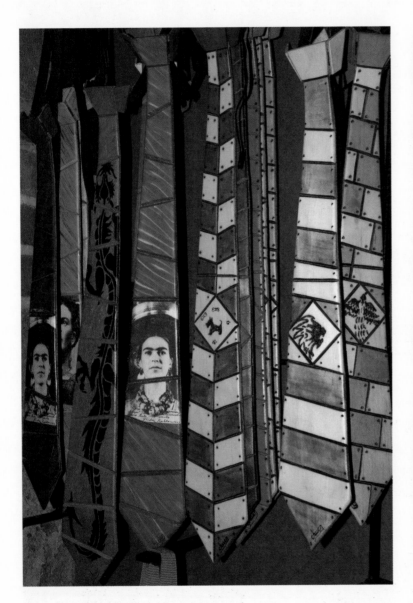

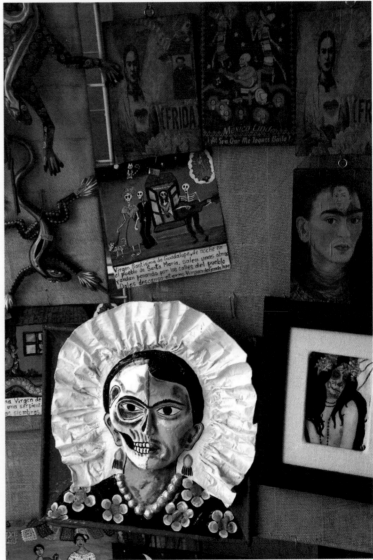

▲ **ABOVE LEFT:**
Frida tie

▲ **ABOVE RIGHT:**
Frida calaca

▶ **FACING PAGE:**
Frida handbag

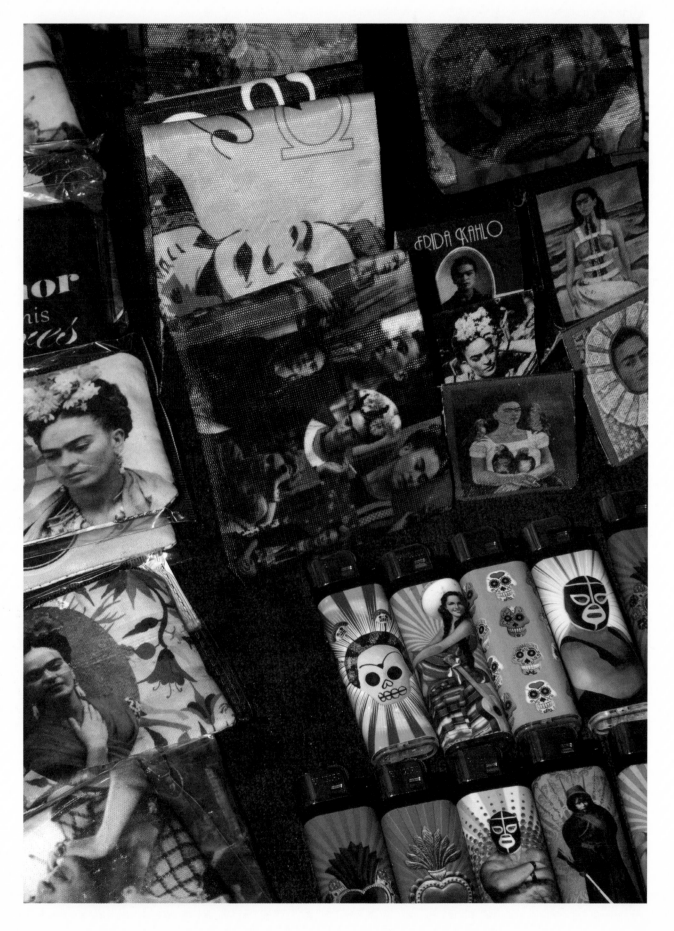

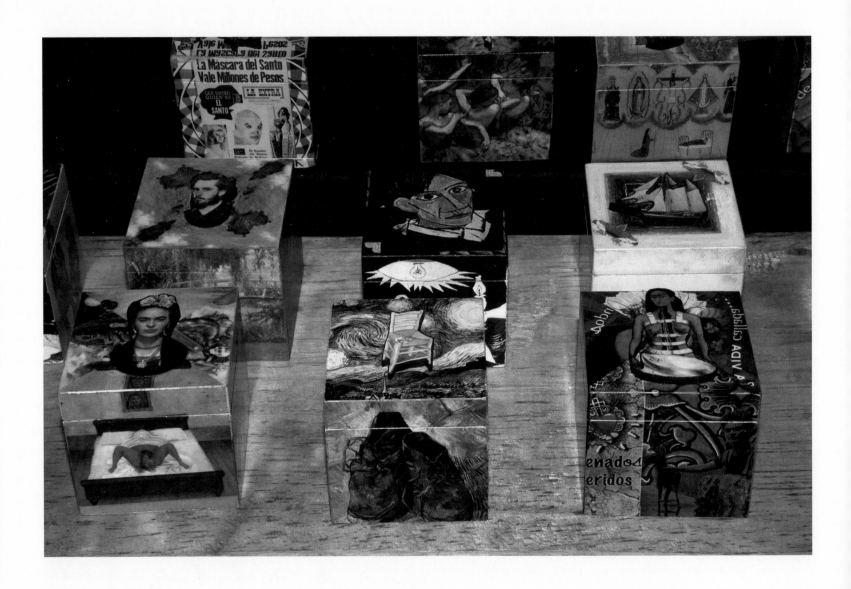

▲ ABOVE:
Frida boxes

▶ FACING PAGE, ABOVE:
Frida angel

▶ FACING PAGE, BELOW:
Frida t-shirt

Frida on matchboxes

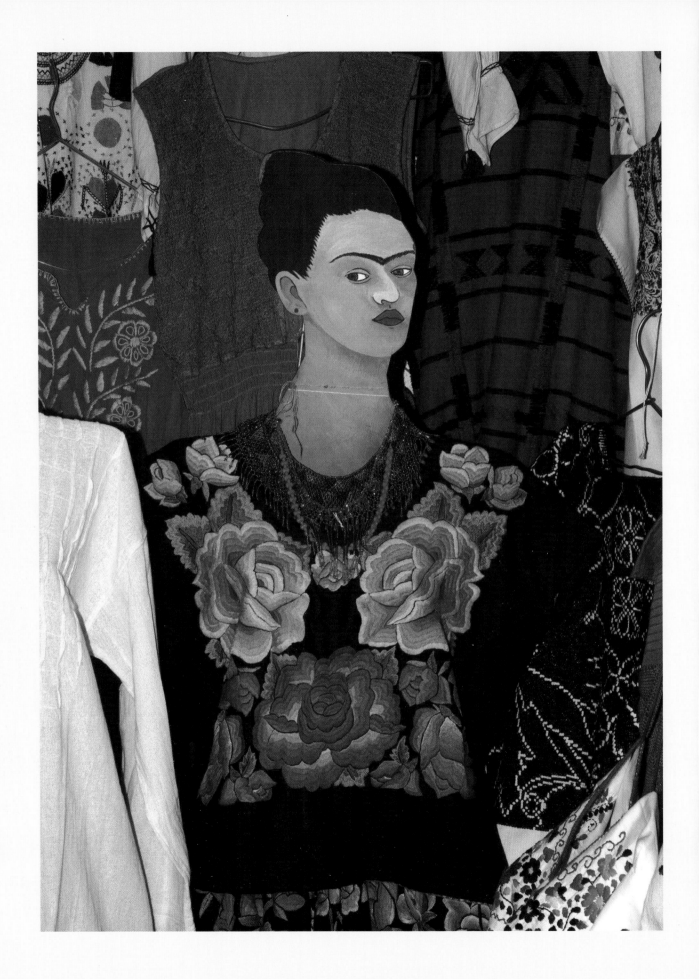

► *Frida at the craft market*

► FACING PAGE: *Frida on sale*

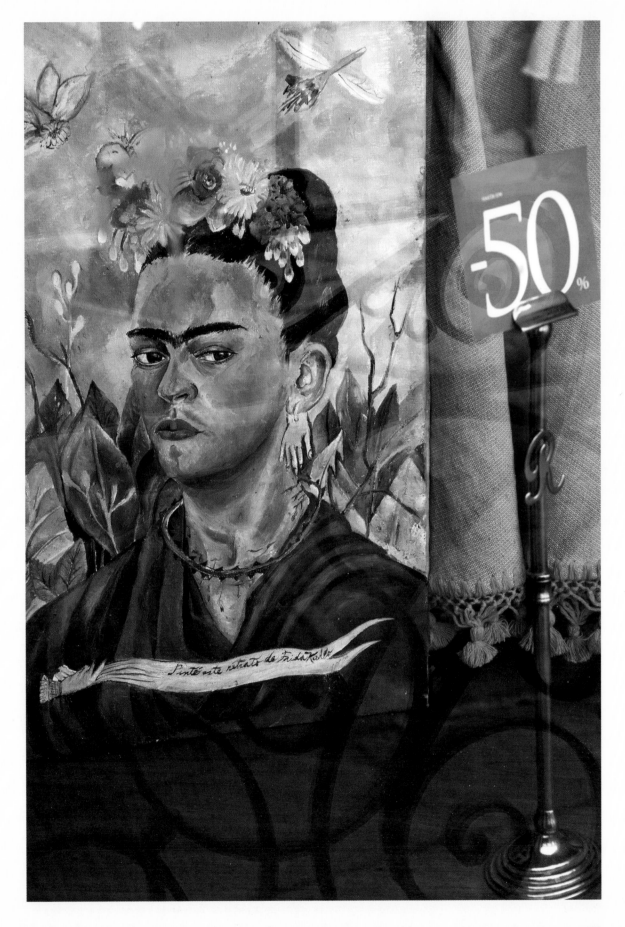

▲ *Frida in art garden*

▶ FACING PAGE:
Frida Eve

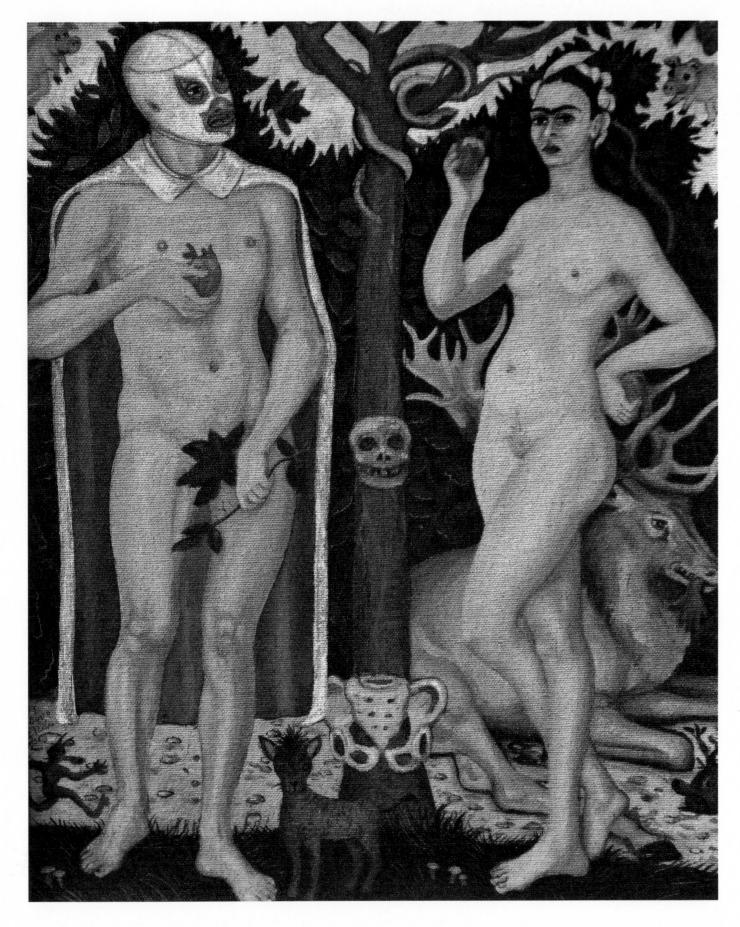

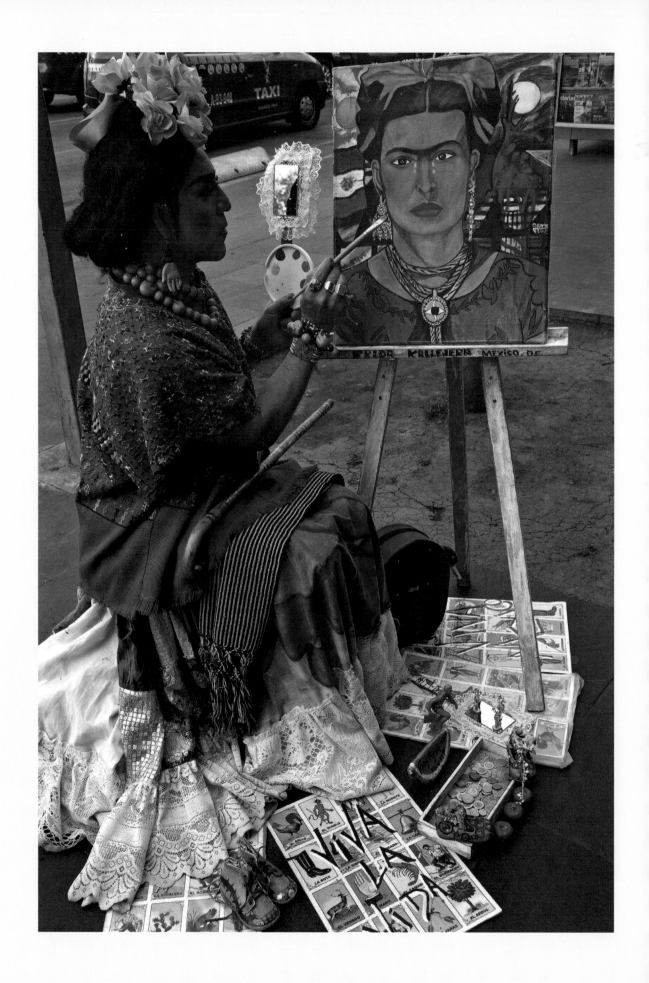

▶ *Frida in the street*

▶ FACING PAGE:
Frida Kahlo 51

▲ Frida on a wall painting

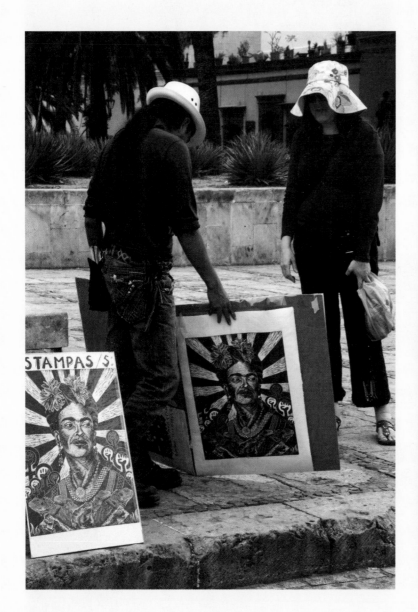

▲ **ABOVE LEFT:**
Frida prints

▲ **ABOVE RIGHT:**
Frida chapbooks

▶ **FACING PAGE:**
Frida and Diego, El Santo and Zapata

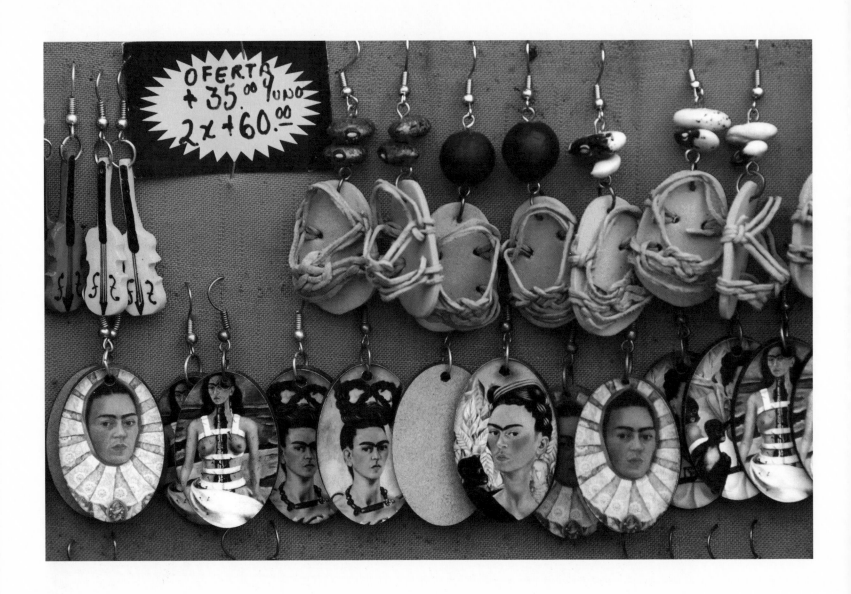

▲ *Frida on offer*

▶ **FACING PAGE:**
Frida key ring

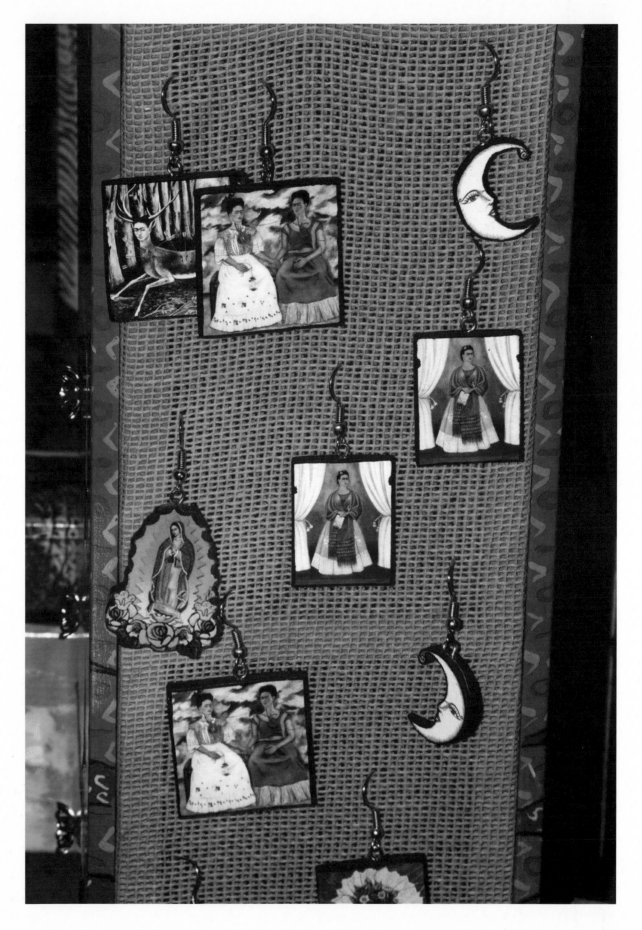

▲ ABOVE:
*Frida in Lagunilla
(flea market)*

▶ BELOW:
Frida and death

▶ FACING PAGE, ABOVE:
Frida on CD covers

▶ FACING PAGE, BELOW:
Frida with books

▲ *Frida in Lagunilla (flea market)*

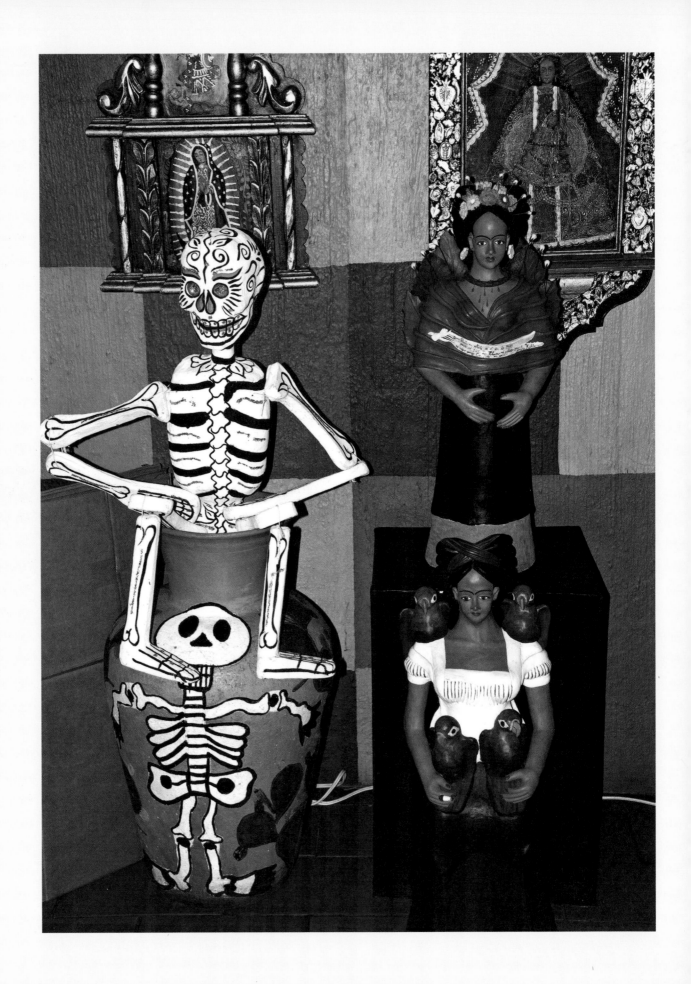

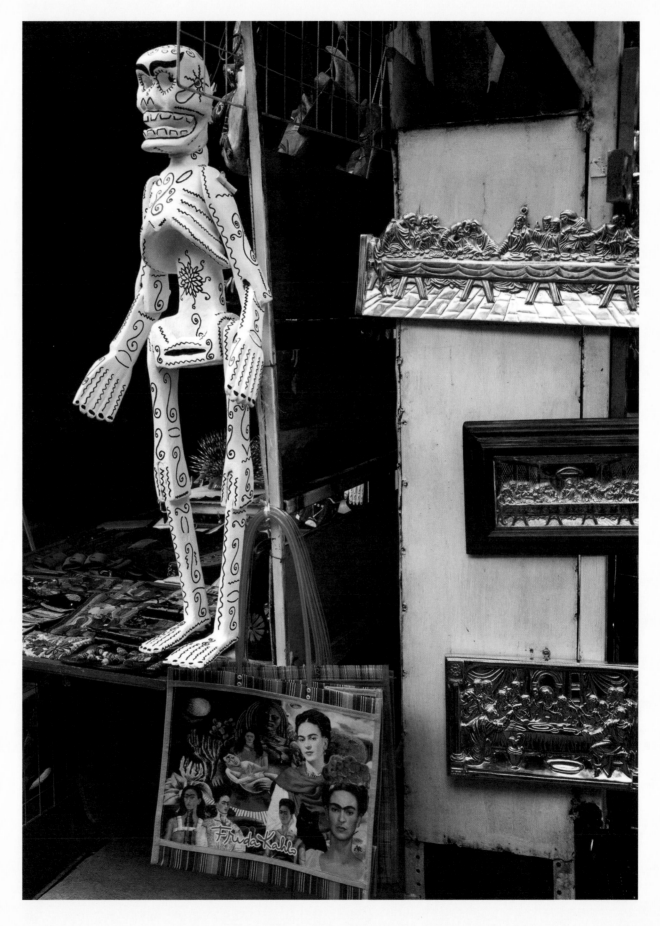

▲ **ABOVE LEFT:**
Frida Oaxaca

▲ **ABOVE RIGHT:**
A new dress from Frida

▶ **FACING PAGE:**
Frida and death

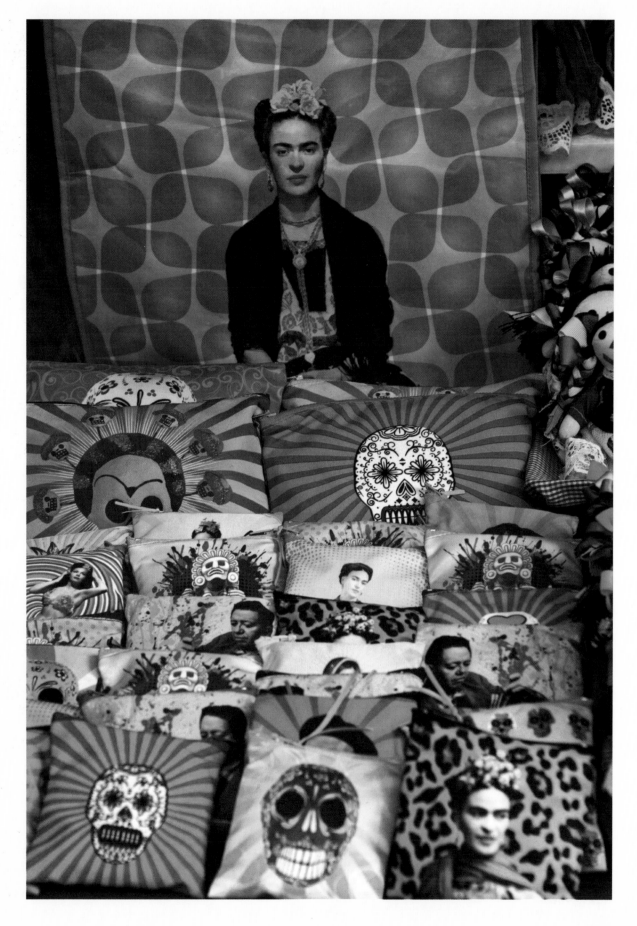

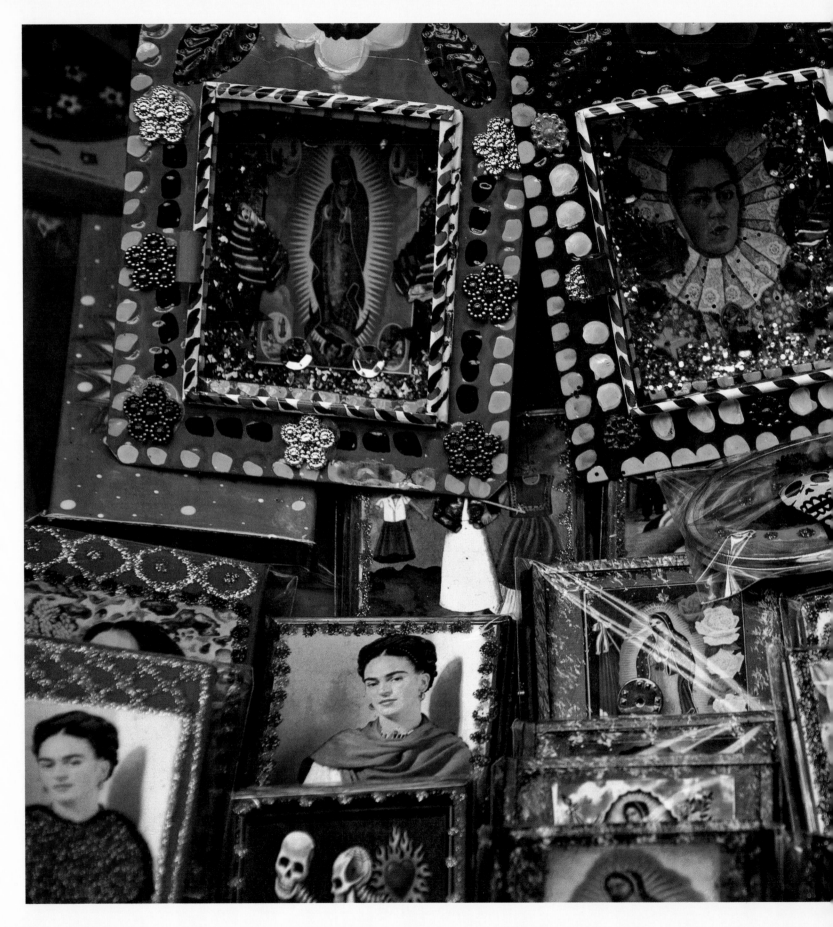

▲ *Frida and death*

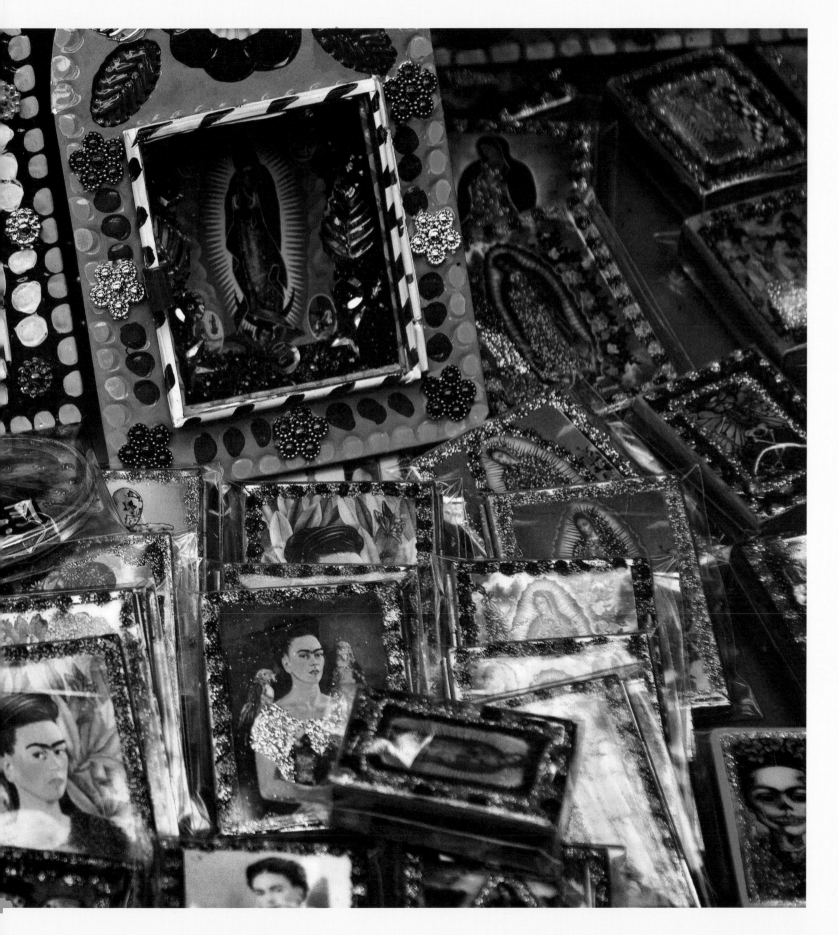

▲ ABOVE:
Frida and death

▶ BELOW:
Legendary Frida

▶ FACING PAGE:
*Frida, the Virgin
of Guadalupe
and the Saint*

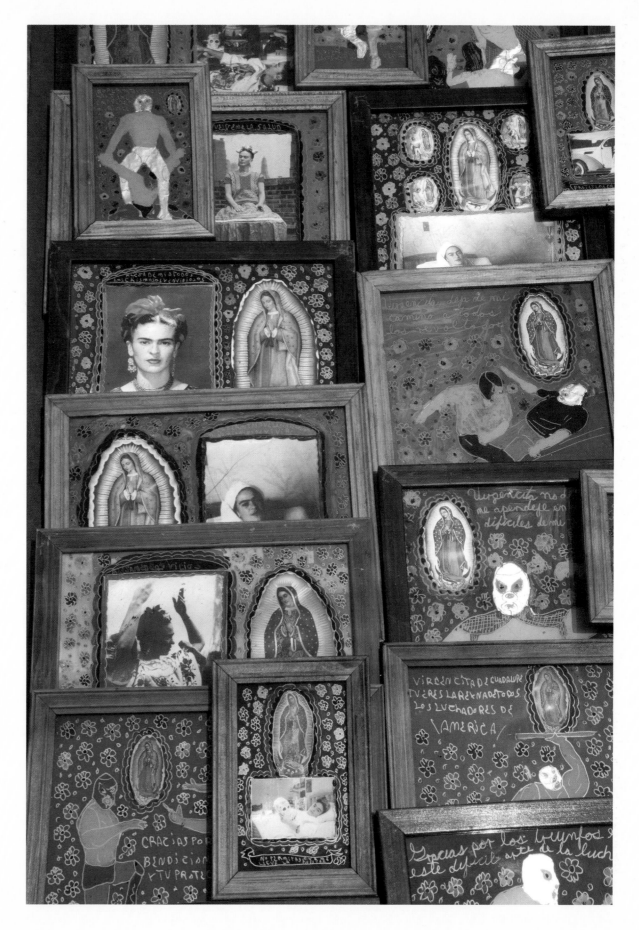

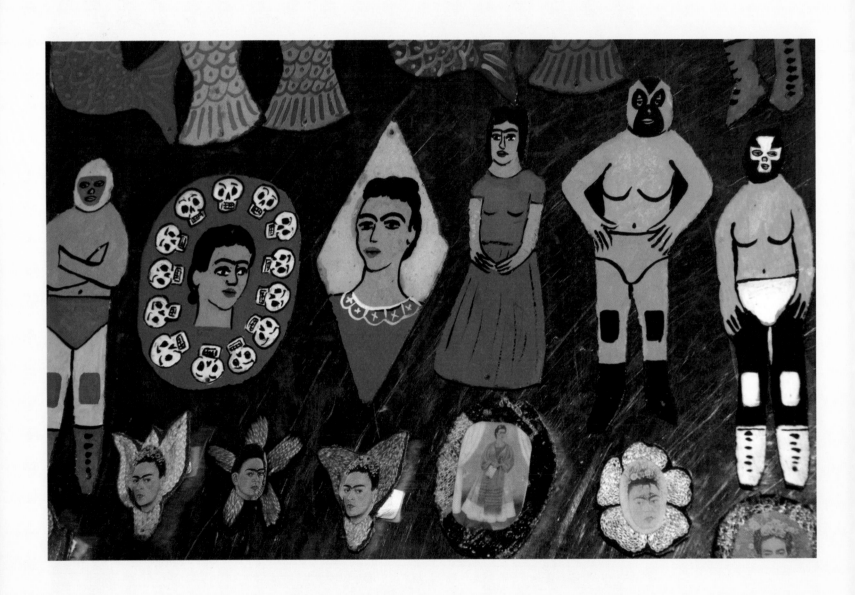

▲ ABOVE:
Frida and fighters

▶ FACING PAGE, ABOVE:
Frida Tehuana

▶ FACING PAGE, BELOW:
Frida and death

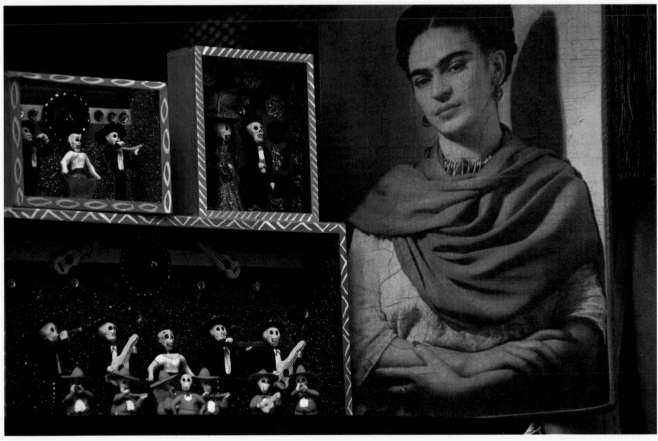

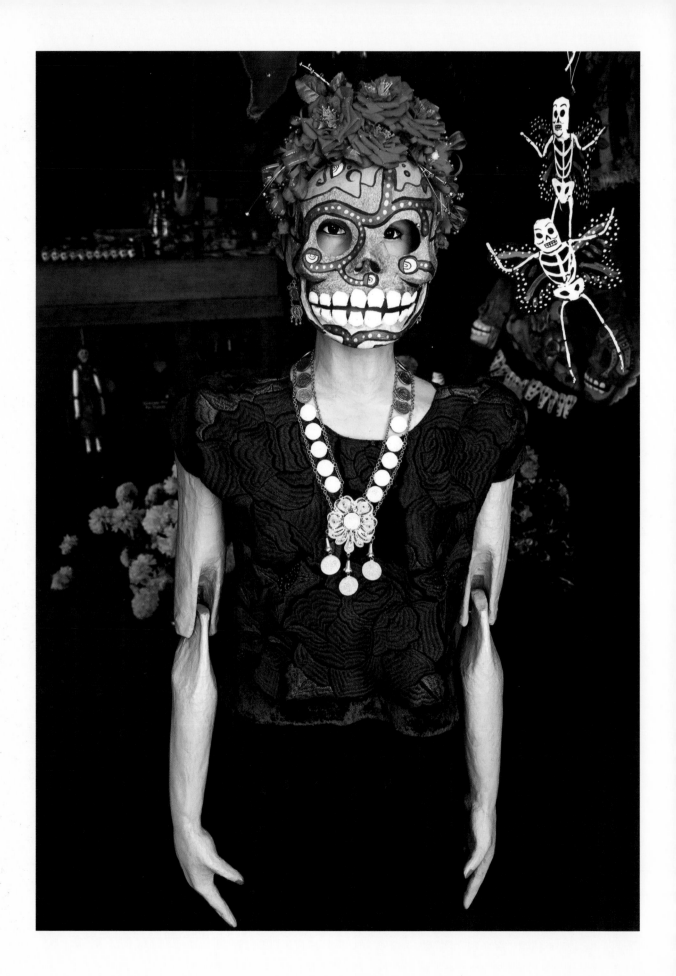

▶ *Frida's death*

▶ FACING PAGE, ABOVE:
Frida, horse and lamp

▶ FACING PAGE, BELOW:
Frida's death

LOS MEXICANOS SI TENEMOS MADRE

LA NOCHE Y TU

▶ *The night and you*

▶ FACING PAGE:
Oaxaca. Frida Calaca

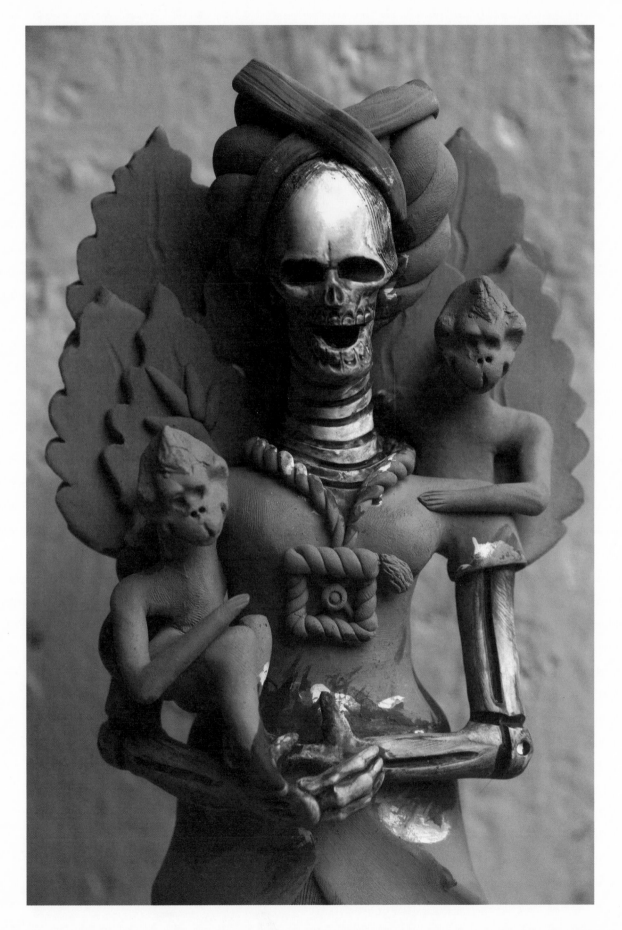

► *Frida's kitchen in Puebla*

► FACING PAGE, ABOVE
AND BELOW:
Frida's kitchen

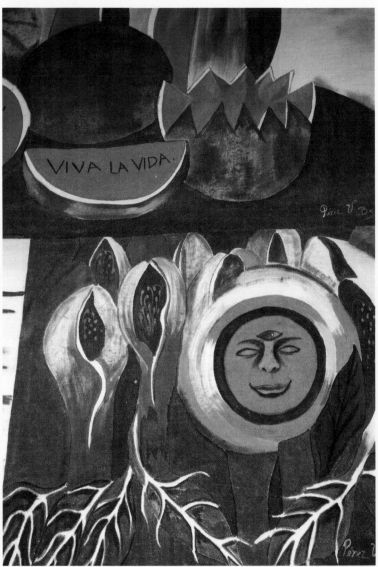

▲ ABOVE LEFT:
Frida cook

▲ ABOVE RIGHT:
Frida's Kitchen

▶ FACING PAGE:
Oaxaca Mexicanisimo

▶ *God's son and Frida*

▶ FACING PAGE:
Souvenir picture with Frida

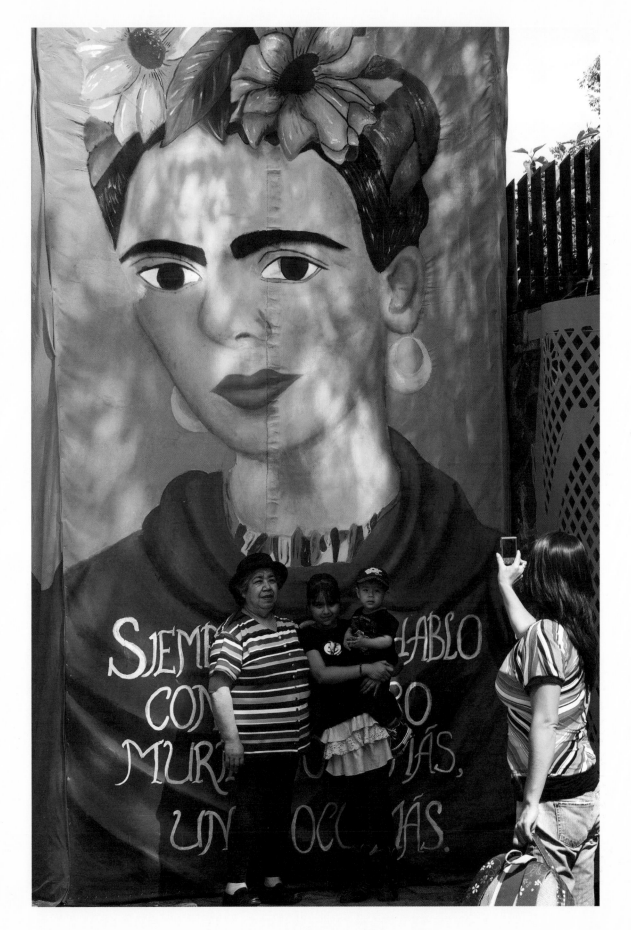

▶ *Self-portrait with Frida*

Notes

1 A touring exhibition of many of the objects shown here accompanies this publication. Please enquire with the publishers at www.tarabooks.com.

2 See Prignitz-Poda, Helga. 'Die Malerin und ihr Werk' In Prignitz-Poda (Ed.), *Frida Kahlo Retrospektive*, München: Prestel Publishing, 2011.

3 For more concerning this discourse, see Bartra, Eli. *Women in Mexican Folk Art: Of Promises, Betrayals, Monsters and Celebrities*, Cardiff: University of Wales Press, 2011.

4 Rivera, Juan Coronel. *Frida, wildes Leben Coyacan* (Feature, BRα), retrieved from [http://www.br.de/br-fernsehen/sendungen/lido/frida-kahlo100.html]; accessed on 18.07.2017.

5 Diego Rivera, cited in Tibol, Raquel. *Frida Kahlo: An Open Life*. Albuquerque, University of New Mexico Press, 1993, p. 133.

6 Monsiváis, Carlos (Ed.). 'Of Frida Kahlo's Stages of Recognition' in *Ciudad de México Museo Frida Kahlo: Los Tesoros de la Casa Azul*, Mexiko: Museo Frida Kahlo, 2007, p. 7.

7 Sara survived with a fractured rib and clavicle, a punctured heart sac and lung, a fractured jaw and pelvis and damaged nerves in her legs. One of her ears was almost fully ripped off (Wolff, Reinhard. 'Wie die Putzfrau zur Zugdiebin wurde', *Taz: Die Tageszeitung*, 5.4.2013; retrieved from [http://www.taz.de/!5069995/]; accessed on 10.11.2017.)

8 Franger, Gaby, Huhle, Rainer. *Frida's Vater: Der Fotograf Guillermo Kahlo, von Pforzheim nach Mexiko*, München: Schirmer/Mosel, 2005; see also: Franger, Gaby & Huhle, Rainer. 'The Mysterious Father' in Ortiz Monasterio, Pablo (Ed.). *Frida Kahlo: Her Photos*, México, Barcelona: Editorial RM, 2010, pp. 71–125.

9 Frida Kahlo in a letter to Antonio Rodríguez, cited without date, in Billeter, Erika. *Einsame Begegnungen: Lola Álvarez Bravo fotografiert Frida Kahlo*, Wabern/Bern: Benteli Verlags AG, 1992, p. 52.

10 For complete works, see Lozano, Luis Martin, Coronel-Rivera, Juan Rafael. *Diego Rivera: The Complete Murals*, Köln: Taschen, 2007.

11 Fuentes, Carlos. 'Introduction' in *The Diary of Frida Kahlo: An Intimate Self-portrait*, New York: Harry N. Abrams, 1995, p. 7; and Monsiváis, Carlos. 'De Todas las Fridas Posibles' in Garduño, Blanca, Rodríguez, José Antonio. (Eds.) *Pasión por Frida*, Mexico City: Instituto Nacional de Bellas Artes, (1991–92), p. 76.

12 Martinez Vidal, Susana. *Frida Kahlo: Fashion as the Art of Being*, New York: Assouline Publishing, 2018, p. 31f.

13 Grimberg, Salomon. *I Will Never Forget you, Frida Kahlo and Nickolas Muray*, San Francisco: Chronicle Books, 2006; Grimberg, Salomon. *Nickolas Muray: Double Exposure*, München: Hirmer, 2015.

14 Tibol, Raquel. *Frida by Frida*, Mexico: Editorial RM, 2006, p. 337.

15 Grimberg, Salomon. *Fridas Freunde sind auch Meine Freunde. Oder: Wer sammelt Kunst von Frida Kahlo?* in Prignitz-Poda, Helga. (Ed.), *Frida Kahlo Retrospektive*, München: Prestel Publishing, 2010, pp. 28–35.

16 San Francisco Women Artists (SFWA) is one of California's oldest arts organisations, dating back to 1887 when it was originally founded by local women as the Sketch Club, who met every month to share and critique each other's work and to make field trips. During the early 1920s, it reorganised as the San Francisco Society of Art, and included men and women. By 1925, the women of the Society branched off as a separate entity: the San Francisco Society of Women Artists. In 1946, it became the San Francisco Women Artists. With a membership of 400 women, the organisation is dedicated to encouraging and promoting the work of women artists.

17 André Breton (1896–1966), French author and theorist of surrealism, was fascinated by Frida's exhibition in the Levy Gallery and invited her to participate in the Mexico exhibition in Paris in 1939. The often cited sentence from the preface in the exhibition catalogue—'the art work of Frida Kahlo is a ribbon around a bomb'—originates from him.

18 Fany Ravinovich, Lidia Briones, María de los Ramos Angeles, Arturo Garcia Bustos, Guillermo Monroy, Tomás Cabrera, Erasmo Vazquez and Ramón Victoria were part of this group.

19 Spanke, Johanna. 'Biografie' in Prignitz-Poda, Helga. (Ed.), Op. cit, pp. 236–242.

20 Prignitz-Poda, Helga. 'Die Himmlische Liebesge- schichte und chiffrierte Geheimschriften im Werk von Frida Kahlo' in Prignitz-Poda, Helga. (Ed.), Op. cit, p. 19.

21 Carlos Monsiváis in the movie, 'The Life and Times of Frida Kahlo', as cited in Gates, Anita. *The Many Fascinations of Frida Kahlo*, The New York Times, 23.03.2005; retrieved from [http://www.nytimes.com/2005/03/23/arts/television/23gate.html?_r=0]; accessed on 21.04.2014.

22 Brenner, Anita. 'Partial Retrospective at Bravo Gallery', *Art News*, Vol. 52, 1953, p. 55.

23 Steininger, Florian. "Frida Icon": Das autoritäre Auge bei Frida Kahlo' in Prignitz-Poda, Helga. (Ed.). Op. cit, pp. 44–51.

24 The Unión Democrática de Mujeres Mexicanas [Democratic Union of Mexican Women] organised a homage to Frida Kahlo, *The Frida Kahlo Salon* in the Gallery of Lola Álvarez Bravo. 40 works were submitted by artists as diverse as Remedios Varo, Machila Armida, Celia Calderón, Lucinda Urrusti, Olga Costa, Alice Rahon, Andrea Gómez, Leonora Carrington and Fanny Rabel. Four paintings of Frida Kahlo were also exhibited, which had not been shown in public before.

25 Raquel Tibol (1923–2015) accompanied Frida throughout her last year and had many conversations with her next to her bedside. As an important author, art critic and scholar of Mexican art and the Mexican art scene, she curated many exhibitions on Latin-American art. She wrote a biography on Frida, for which she collected letters written by Frida, so that she could also represent her subject as a writer.

26 Tibol, Raquel. 'Artes Plásticas: Primer Salón Frida Kahlo', *México en la Cultura: Suplemento Cultural de Novedades*, 22.07.1956, p. 5.

27 Sullivan, Edward J. 'Frida Kahlo in New York' in Garduño, Blanca, Rodríguez, José Antonio. (Ed.), Op. cit, pp. 182–184.

28 See Fuentes, Carlos et al. 'Introduction'. Op. cit; Monsivaís, Carlos. *Frida Kahlo: Un Homenaje*. Mexico: Artes de Mexico, 2004; Poniatowska, Elena. 'Diego ya no estoy sola: Frida Kahlo' in Poniatowska, Elena. (Ed.), *Las Siete Cabritas*, Mexico: Editorial Txalaparta/Ediciones Era, 2000, pp. 11–22.

29 An example is Marceloa Rodríguez's opera, *Las Cartas de Frida* (Premiere 2011). In August 2017, a scenic reading of Cuban-American author and Pulitzer prize-winner, Nilo Cruz's *El último sueño de Frida y Diego* was held in Mexico-City. Gabriela Lena Frank, a Peruvian pianist, composed the music for this, and in a new reading of Frida's character

imagined her as a composer herself. An instance of a musical on Frida's life is Carlos Liguori and Javier Raffa's *Frida entre lo absurdo y fugaz* [Music: Agustín Konslo and Carlos Liguori], featured in Martínez Torrijos, Reyes. 'La intimidad de Kahlo y Rivera articulaópera', *La Jornada* (26.08.2017); retrieved from [http://www.jornada.unam.mx/2017/08/26/cultura/a03n2cul]; accessed on 10.11.2017.

30 Natalya Zaykova's *Frida* (Flamenco); Myra Beltran's *Frida en el espejo*; Marco Santi, *Frida* (for Theatre St. Gallen) and Race & Rhythms' *Frida*.

31 Medina, Ofelia. *Cada quién su Frida*, 2008.

32 Herrera, Hayden. *Frida: A Biography of Frida Kahlo*, New York, Harper & Row, 1983, p. 263.

33 Mural displayed in the Office of Public Education (Secretaria de la educacion publica) in the second courtyard; see also '*Mural Visiones de la historia de México 1929–1934*' in Lozano, Luis Martin, Coronel-Rivera, Juan Rafael. Op. cit, p. 111.

34 ibid. p. 227.

35 The long regime of Porfirio Díaz was called 'Porfiriat'.

36 José Clemente Orozco (1883–1949), Alfaro Siquieros (1896–1974) and Diego Rivera (1886–1957) were called 'The Big Three'.

37 The popular photograph shows Frida with Diego Rivera, Juan O'Gorman and others in July 1954 (published in Herrera, Hayden. *Frida Kahlo: Die Gemälde*, München: Schirmer/Mosel, 1991, p. 121.)

38 Poniatowska, Elena. 'Diego, I am not alone: Frida Kahlo' in Poniatowska, Elena. (Ed.), *Frida Kahlo: The Camera Seduced*, San Francisco: Chronicle Books, 1992, p. 20.

39 Turok, Marta. 'Frida's Garderobe: Ethnische Trachten und Ethno Mix' in *Fridas Kleider: Museo Frida Kahlo, Mexico City*, München: Schirmer/Mosel, 2005, pp. 51–57.

40 Tibol, Raquel. *Frida by Frida*. Op. cit, p. 164.

41 See Camarillo Duque, Renato. 'Los rebozos de Frida Kahlo' in *Todo el universo, Frida Kahlo: El mundo México*, Vogue México y Latinoamérica, 2013, pp. 65–70.

42 Appleton Read, Helen. 'Diego Rivera Heads Group of Painters Who are Rewriting Mexican History from the Revolutionary Standpoint', *Brooklyn Daily Eagle*, 5.10.1930; p. 37.

43 Letter to Matilde Calderon, 21.11.1930, in Ankori, Gannit. *Frida Kahlo*, London: Tate Publishing, 2013, p. 10.

44 Weston, Edward. *The Daybooks of Edward Weston* (Vol. 2) New York: Aperture, 1973, p. 198.

45 Modotti, Tina. *Photographien & Dokumente* (Vol. 1). Berlin: Sozialarchive.V., 1991.

46 Baddeley, Oriana. 'The Dress Hangs Here: De-Frocking the Kahlo Cult' in *The Oxford Art Journal*, Vol. 14, Issue 1, 1991, pp. 10–17; See also: Hedrick, Tace. *Mestizo Modernism: Race, Nation, and Identity in Latin American Culture*, 1900–1940, New Brunswick: Rutgers University Press, 2003, pp. 167–169.

47 Juan Coronel, cited in Tajonar, Héctor. *Yo soy Frida*, México: Milenio, 2007, p. 40.

48 Cardona Peña, Alfredo. 'Frida Kahlo' in *México en la Cultura: Suplemento Cultural de Novedades*, Mexico City, 17.7.1955.

49 Fola (Fototeca Latinamericana), *Frida Kahlo por Leo Matiz*, Buenos Aires, 2015, p. 14.

50 Hilda Trujillo, director of the Blue House, discovered a photo with André Bretón, Frida Kahlo and Diego Rivera in the house of an artisan in Huejutla, Hidalgo, while visiting textile artisans. She was looking for clothes for an ofrenda. See, Trujillo, Hilda. 'La construcción de una identidad a través de vestir Frida Kahlo', 2012; retrieved from [www.museofridakahlo.org.mx/.../FILE_2_2.pdf]; accessed on 30.03.2014.

51 Wolfe, Bertram D. 'The Rise of another Rivera', Vogue México y Latinoamérica, 1.11.1936, p. 64, cited in Ankori, Gannit, Op. cit, p. 13.

52 Herrera, Hayden. Op. cit, p. 235.

53 No draft of the figure seems to exist. On Elsa Schiaparelli see, Watt, Judith. *Vogue on Elsa Schiaparelli* London: Quadrille Publishing Ltd, 2013 and Schiaparelli, E. *Shocking Life*, London: Victoria & Albert Museum, 2007.

54 A special Frida collection was put together by well-known shoemakers Chuck Taylor Converse.

55 The Italian company La Perla came out with a collection of Frida Kahlo basques.

56 Some of these creations were on show in the exhibition "Las apariencias engañan"—Appearances are Deceiving—in the Blue House (2012).

57 Martinez Vidal, Susan. *Frida Kahlo: Fashion as the Art of Being*, New York: Assouline Publishing, 2018, p. 10.

58 Exhibition Catalogue text {a work in progress} of 'Galería 4.0, A Retrospective', a commemorative exhibition spanning 40 years of Chicano/Latino Art (September 25, 2010–January 29, 2011), Galería de la Raza, San Francisco, September 25, 2010–January 29, 2011, p. 29.

59 Cordova, Cary. *The Heart of the Mission: Latino Art and Identity in San Francisco*, Dissertation, The University of Texas at Austin, 2005, p. 234; retrieved from [https://www.lib.utexas.edu/etd/d/2005/cordovad06814/cordovad06814.pdf]; accessed on 31.12.2015.

60 Goldman, Shifra M. 'Introduction' in *Chicano Voices and Visions: A National Exhibit of Women Artists*, Exhibition Catalogue, Social & Public Art Resource Center (SPARC), 1983, p. 7.

61 The exhibition was curated by Carmen Lomas Garza, Amalia Mesa-Bains and María Piñedo. In the same year (1978) an exhibition titled "Frida Kahlo" was hosted at the Museum of Contemporary Art in Chicago. This cleared the way for a smooth international reception.

62 Drescher, Timothy. *The Galería de la Raza/Studio 24 Culture and Community*, from the Tomas Ybarra-Frausto Collection, Archives of American Art, Box 9; cited in Cordova, Cary. Op. cit.

63 Bartra, Eli. Op. cit, p. 111.

64 Diego Rivera, cited in Tibol, Raquel. *Frida Kahlo: An Open Life*. Op. cit, p. 131.

65 Léon, Portilla Miguel. 'Arte Popular: Cultura e Identidad' in Iturriaga, J. N. (Ed.) *Arte del pueblo, manos de Dios: Colección del Museo de Arte Popular*, Mexico-City: Oceano de Mexico, 2005, pp. 41–53.

66 Diego Rivera, cited in Tibol, Raquel. *Frida Kahlo: An Open Life*. Op. cit, p. 171.

67 ibid. p. 168

68 Bartra, Eli. *Crafting Gender. Women and Folk Art in Latin America and the Caribbean*, Durham/London: Duke University Press, 2013, p. 6.

69 Tibol, Raquel. *Frida Kahlo: An Open Life*. Op. cit, p. 163; see also, Trujillo, Hilda. 'El arte popular: Aportes a la identidad desde lo cotidiano', in Vogue México y Latinamericano, (Ed.), Op. cit, pp. 185–198.

70 Westheim, Paul S. 'Frida Kahlo: Una investigación estética', *La Jornada Semanal*, Domingo 17 de Octubre de 2004, núm. 502; retrieved from [http://www.jornada.unam.mx/2004/10/17/sem-paul.html]; accessed on 1.09.2013.

71 See also Westheim, Paul. 'Frida Kahlo: Una investigación estética', translated by Mariana Frenk, *Novedades: México en la cultura* (Mexico City), June 10, 1951.

72 Rivera, Diego. 'Frida Kahlo y el arte mexicano', *Boletin del Semanario de Cultura Mexicana*, Mexico City, 1, no. 2, October 1943, pp. 89–101.

73 Cited in Billeter, Erika (Ed.) Op. cit, p. 38.

74 Carmichael, Elizabeth, Sayer, Chloe. 'The Skeleton at the Feast: The Day of the Dead in Mexico', Austin: University of Texas Press, 1991, pp. 14-58; and also Billeter, Erika. *Imagen de Mexico. Der Beitrag Mexikos zur Kunst des 20. Jhds*, Frankfurt: Schirn Kunsthalle, 1987, pp. 45–52.

75 Jähn, Hannes. *Das Werk von José Guadalupe Posada*, Frankfurt: zweitausendeins Verlag, 2000.

76 Del Conde, Teresa. 'Fridolatría' in Garduño, Blanca, Rodríguez, José Antonio (Ed.), Op. cit, pp. 179–181.

77 Our Lady Guadalupe was declared the patron saint of Latin America by Pope Pius X in 1910. Juan Diego Cuauhtlatoatzin was the first indigenous person to be declared a saint (2002).

78 Del Conde, Teresa. *Frida Kahlo y el fenómeno Fridomaniaco*, 2007, p. 77. Through her deep engagement with Frida Kahlo's work, Del Conde discovered a religious connection, and building on this aspect, she came up with

the figure of Frida as a Mother Goddess. See also, Garduño, Blanca, Rodriguez, José Antonio. (Eds.), Op. cit, pp. 32-45.

79 Rivera, Diego. Op. cit, pp. 89–101.

80 Peñaloza, Porfirio Martinez, 'Volkskunst in Mexiko' in Billeter, Erika. (Ed.), Op. cit, pp. 422–426.

81 Frida to Nickolas Muray, February 27, 1939, in Grimberg, Salomon. Op. cit, p. 23.

82 'Frida Kahlo on a Visit to Ocotlán: "The Painting's One Thing, The Clay's Another"', in Bartra, Eli. *Women in Mexican Folk Art: Of Promises, Betrayals, Monsters and Celebrities.* Op. cit, p. 97.

83 Wasserspring, Lois. *Traditional Folk Art by Oaxacan Women*, San Francisco: Chronicle Books, 2000, p. 10.

84 ibid. p. 23

85 Bartra, Eli. *Women in Mexican Folk Art: Of Promises, Betrayals, Monsters and Celebrities.* Op. cit, p. 98.

86 De Calderón, F., Sarmiento, A., Sarmiento, C. *Grandes Maestros del Arte Popular Mexicano*, Mexiko: Fomento Cultural Banamex, 2001, pp. 67–71.

87 Wasserspring, Lois. Op. cit, p. 46.

88 Bartra, Eli. *Women in Mexican Folk Art: Of Promises, Betrayals, Monsters and Celebrities.* Op. cit, pp. 97–111.

89 ibid. p. 102

90 ibid. p. 102

91 Poniatowska, Elena. 'II y ultima', La Jornada, July 7, 2004, México, retrieved from [http://www.jornada.unam.mx/2004/07/05/03aa1cul.php?origen=opinio]; accessed on 14.07.2013.